Paintings by Fitz Hugh Lane

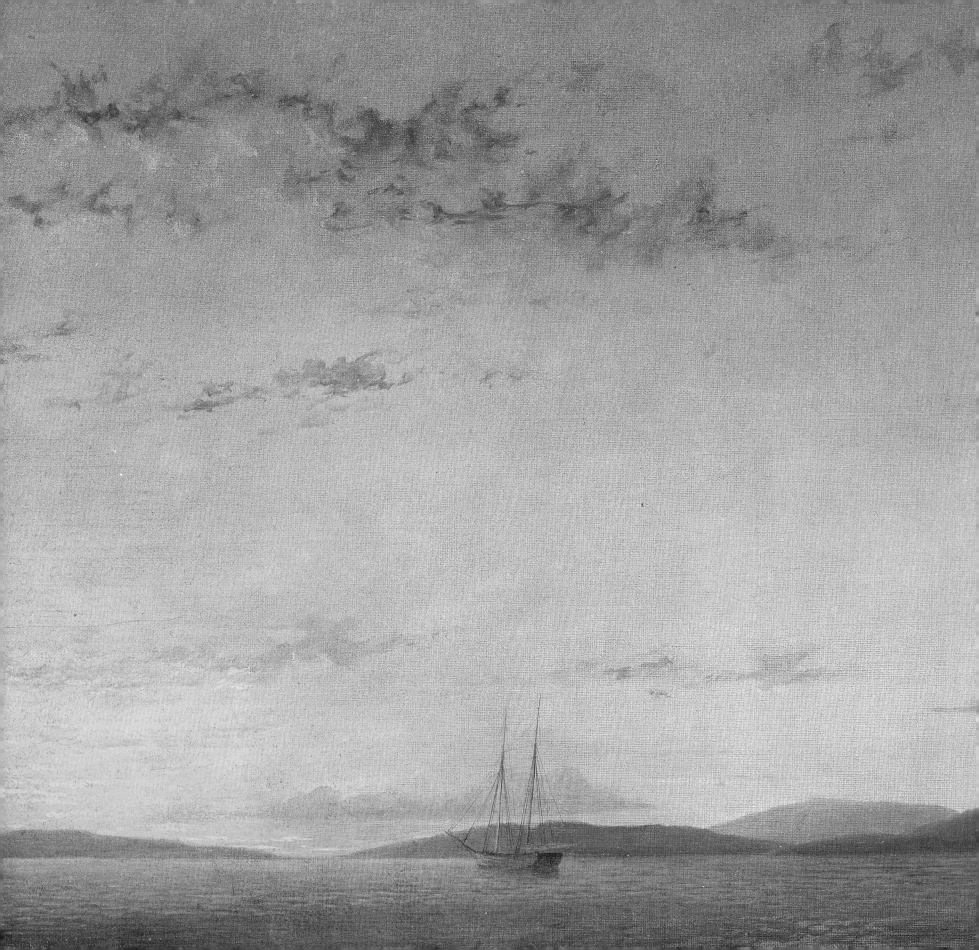

Paintings by Fitz Hugh Lane

JOHN WILMERDING

with contributions by

ELIZABETH GARRITY ELLIS
FRANKLIN KELLY
EARL A. POWELL, III
ERIK A. R. RONNBERG, JR.

National Gallery of Art, Washington
Harry N. Abrams, Inc., New York

The exhibition is made possible by a grant from GTE Corporation

Exhibition dates:
National Gallery of Art, Washington
15 May 1988–5 September 1988
Museum of Fine Arts, Boston
5 October 1988–31 December 1988

This book was produced by the editors office, National Gallery of Art.
Editor-in-chief, Frances P. Smyth

Designed by Frances P. Smyth
Edited by Mary Yakush
Typeset by BG Composition, Inc., Baltimore, in Electra
Printed by Princeton Polychrome Press, a division of Village Craftsmen,
on 80 lb Lustro Dull text

Cover: cat. 41, detail
Frontispiece: cat. 61, detail

Library of Congress Cataloging-in-Publication Data
Wilmerding, John.
 Paintings by Fitz Hugh Lane / John Wilmerding ; with contributions
by Elizabeth Garrity Ellis . . . [et al.].
 p. cm.
 ISBN 0-89468-117-6
 1. Lane, Fitz Hugh, 1804–1865—Exhibitions. 2. Landscape
painting, American—Exhibitions. 3. Landscape painting—19th
century—United States—Exhibitions. 4. Luminism (Art)—
Exhibitions. I. Lane, Fitz Hugh, 1804–1865. II. National Gallery
of Art (U.S.) III. Title.
ND237.L27A4 1988
759.13—dc19

The clothbound edition published in 1988 by Harry N. Abrams, Inc., New York
A Times Mirror Company

ISBN 0-8109-1272-4(cloth)

Contents

Foreword

THE NATIONAL GALLERY OF ART IS PLEASED TO SHARE with the Museum of Fine Arts, Boston, the opportunity to present the most comprehensive exhibition ever assembled of the paintings of Fitz Hugh Lane. For anyone who has sailed the coastal waters of the northeastern United States, visited harbor towns such as Gloucester or Camden, or simply enjoyed a splendid view of sea and sky from a quiet beach, Lane's paintings will be at once familiar in what they depict and deeply evocative in the associations they engender. No other American painter of the nineteenth century matched him in capturing the character of maritime New England, in portraying the reflective sheen of calm water or the agitated surface of wind-blown waves, the clarity of light-filled still air or the moist atmosphere of cloudy, humid days. Only a few others, such as his fellow marine painter John F. Kensett, ever created compositions as refined and as elegantly simplified as Lane's late masterpieces, and certainly none did so before him.

Lane's best works, with their calm order, serene light, and almost magical balance of elements, achieve a quiet, elegiac effect that can only be described as movingly poetic. Surely few other American artists have ever said quite so much, using quite so little. Lane could still a moment of time with such flawless certainty as seemingly to fix it for all eternity.

For years the National Gallery had no painting by Lane in its own collection. In the 1970s, the Acquisitions Committee of the Trustees set aside a sum of money, on the director's recommendation, to remedy this, if and when a suitable Lane should become available. We were fortunate to be able to acquire, in 1980, one of Lane's masterpieces, *Lumber Schooners at Evening on Penobscot Bay.*

Lane is today firmly established as one of the masters of nineteenth-century American painting. That this is so, and that we now have the opportunity to appreciate his achievement in such depth, is thanks largely to John Wilmerding, deputy director of the National Gallery and the foremost expert on Lane and his art. In over twenty-five years of work he has assembled the biographical details of Lane's life, examined virtually every one of his known works, charted the development of his style, and solved many cases of misattributed works. His research has been published in several important studies, most notably *Fitz Hugh Lane* of 1971, which remains the standard monograph on the artist. More recently, in 1980, he organized the landmark exhibition *American Light: The Luminist Movement, 1850–1875,* the first ever devoted to Lane and all of his contemporaries. *American Light* confirmed Lane's position as perhaps the first key artist of that group, and it is appropriate that we turn now to a focussed reappraisal of his art. The present exhibition and publication thus represent the culmination of Mr. Wilmerding's work on Lane, fitting testaments both to his own scholarly enterprise and to the creative attainment of the painter he has taught us all to admire.

The exhibition has been generously supported by a grant from the GTE Corporation. To Theodore F. Brophy, former chairman and chief executive officer of GTE, and to his successor, James L. Johnson, go our sincere thanks for their continuing support of the National Gallery's exhibition programs.

To part with paintings as beautiful as Lane's, even briefly, requires tremendous generosity on the part of their owners. We have been especially fortunate in the responses of the lenders to this exhibition, both private and public, who have unselfishly allowed us to borrow their treasures. To all of them we are deeply grateful.

We are also indebted to our colleagues at the Museum of Fine Arts, Boston, who not only agreed to lend ten works to this exhibition, but who also assisted in the early stages of its organization. In particular, we thank Alan Shestack, director; Jan Fontein, former director; Theodore E. Stebbins, Jr., curator, and Carol Troyen, associate curator, department of American paintings. We also owe special thanks to Harold Bell, president, and Martha Oaks, curator, of the Cape Ann Historical Association of Gloucester, Massachusetts, who have eagerly supported the exhibition since its inception and who have lent nine paintings from their superb collection of Lane's works. Here at the National Gallery we thank Franklin Kelly of our American art department for his assistance and for contributing an essay to this publication; Deborah Shepherd of our exhibition office, who skilfully and cheerfully handled countless organizational details; Michael Swicklick of our conservation laboratory, for helping with information about Lane's technique and answering questions about the treatment of his paintings; Frances Smyth and Mary Yakush of our editors office, for editing, designing, and producing this handsome book; and the staff of the design and installation department for their sensitive presentation of the works here at the Gallery. To Earl A. Powell, III, director of the Los Angeles County Museum of Art, Elizabeth Garrity Ellis, assistant professor of art history, Southern Methodist University, and Erik A. R. Ronnberg, Jr., distinguished scholar of ship and maritime history, go our grateful thanks for their contributions to this publication.

J. CARTER BROWN
Director

Square-rigged Topsail, 1850s, pencil on paper, 7³/₄ x 11¹/₄ in. [Cape Ann Historical Association]

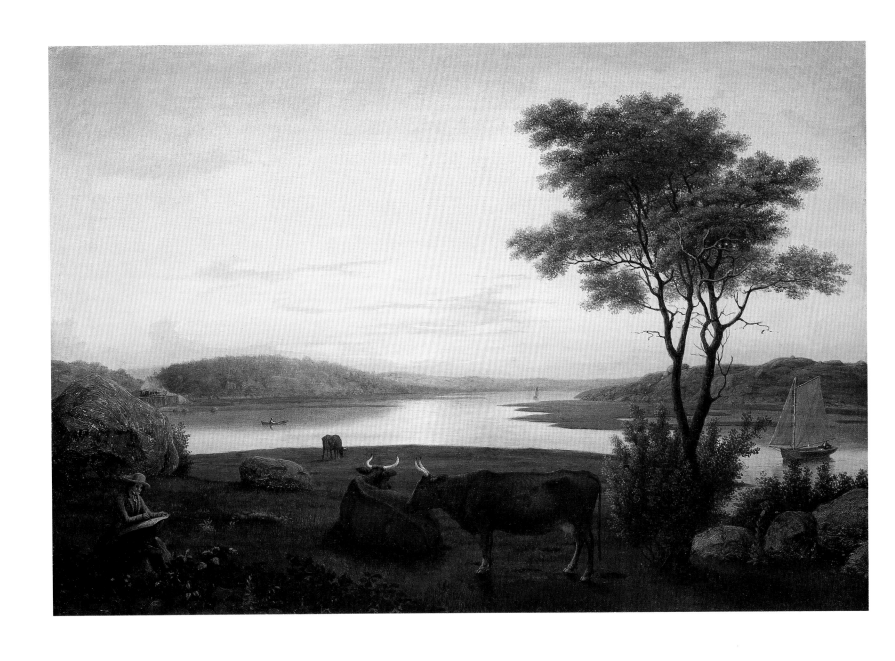

cat. 1. *New England Inlet with Self Portrait*, 1848, oil on canvas,
17³/4 x 25⁷/8 in. [Royal A. Basich]

Chronology

19 December 1804 Nathaniel Rogers Lane born in Gloucester, Massachusetts. Name so recorded in town records, but soon after changed by his family to Fitz Hugh. Ancestors among first settlers on Cape Ann in 1623. Father, Jonathan Dennison Lane, a sailmaker.

1806 Partially paralyzed in legs, probably from infantile polio; family believes he was poisoned by "apple of Peru" (tomato) plant.

1816 Death of Lane's father. Family moves from Middle Street to house on Washington Street near entrance to Oak Grove cemetery. Learns rudiments of drawing and sketching. One of his first dated works was a watercolor after a drawing by E. D. Knight of the *Burning of the Packet Ship "Boston."*

1832 Works part-time as a shoemaker. Brief job with Clegg and Dodge, local lithographers on Sea Street, Gloucester. To Boston for formal instruction and apprenticeship with William S. Pendleton, proprietor of most important lithographic firm of the day.

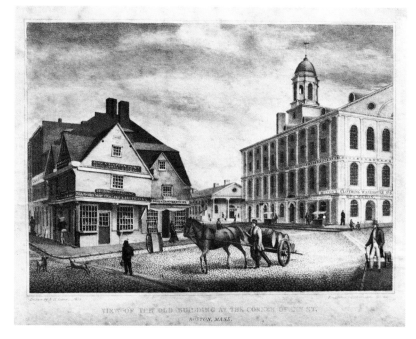

View of the Old Building at the Corner of Ann Street, 1835, lithograph

1835 First dated lithograph, *View of the Old Building at the Corner of Ann Street.* Produces trade card signs, advertisements, and sheet music cover illustrations.

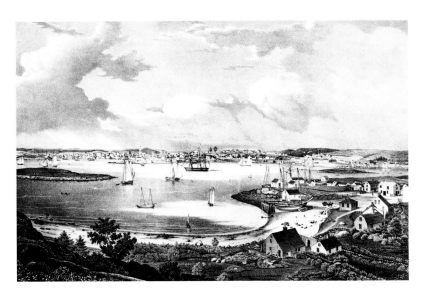

View of the Town of Gloucester, Mass., 1836, lithograph, 13 x 19³/₄ in.
[Cape Ann Historical Association]

1836 Thomas Moore succeeds Pendleton as
 head of the lithographic firm. Lane pro-
 duces two illustrations for sheet music, *The
 Salem Mechanick Light Infantry Quick Step*
 and *The Nahant Quadrilles,* and his first
 major landscape print, *View of Gloucester.*

later 1830s Publishes sheet music cover for *Captn.
 E. G. Austin's Quick Step,* and a number of
 scenic views, for example, of St. John, New
 Brunswick; Washington, D. C.; Norwich,
 Connecticut; Boston Common and Boston
 harbor.

1840 First oil paintings, including shoreline
 views around Cape Ann and *The S. S.
 "Britannia" in Boston Harbor.* Draws litho-
 graphs of figures, portraits, and interior
 scenes.

1841 Listed in the *Boston Almanac* under "Ma-
 rine Painters," address: 17 School Street.
 Exhibits for sale an oil, *Scene at Sea,* at the
 Boston Athenaeum, and submits *Ship in a
 Gale* for exhibition at the Apollo Associa-
 tion in New York.

mid-1840s Completes oil views of Gloucester and Bos-
 ton harbors, reflecting early influence of
 Robert Salmon's marine painting style.
 Publishes three-lithograph series, of views
 in similar format, of Gloucester, New
 Bedford, and Newburyport.

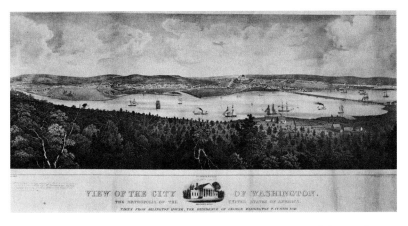

View of the City of Washington, 1838, lithograph

1848 Reputation fully established. Returns to
 Gloucester permanently. Sets up studio on
 first floor of the old Whittemore house on
 Washington Street.

late 1840s Paints extensively around Gloucester Har-
 bor and Cape Ann. First visit to Maine in
 summer of 1848. Pictures on view at the
 Art-Union in New York.

1849–1850 Purchases property on Duncan Street, overlooking water on Gloucester inner harbor. With his sister Sarah and brother-in-law, Ignatius Winter, begins designing and constructing a seven-gable house of granite. Moves in with the Winters just after New Year's, 1850.

Lane's Stone House, Duncan's Point Gloucester, 1850

1850s Active in local civic affairs, participates in organizing Fourth of July celebrations, painting banners and signs.
Extensive travel, including visits to New York and possibly San Juan, Puerto Rico.

summer 1850 Extensive sailing and sketching trip to Maine with his friend, Joseph L. Stevens, Jr. Paints in Castine, and sails aboard chartered sailboat *General Gates* to Mount Desert Island. Produces first major luminist paintings of Somes Sound.

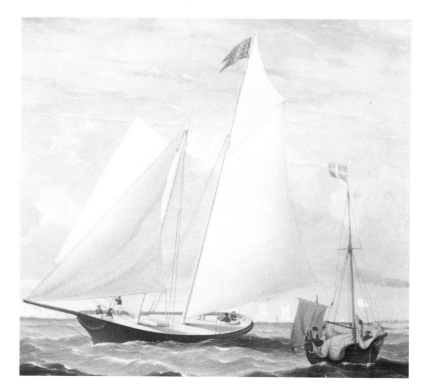

Catalogue no. 35, *The Yacht America,* detail

1851 Beginning of the America's Cup competition. Lane paints at least two pictures of the yacht *America.* Continues with harbor scenes and ship portraits; receives favorable criticism for work exhibited at the American and New England art unions.

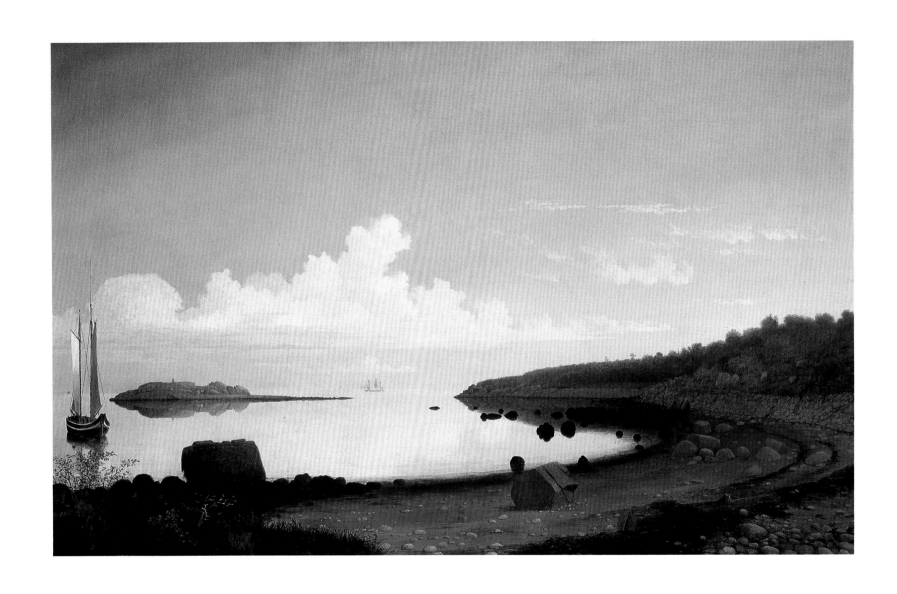

cat. 17. *The Western Shore with Norman's Woe*, 1862, oil on canvas, 21¹/₂ x 35¹/₂ in. [Cape Ann Historical Association]

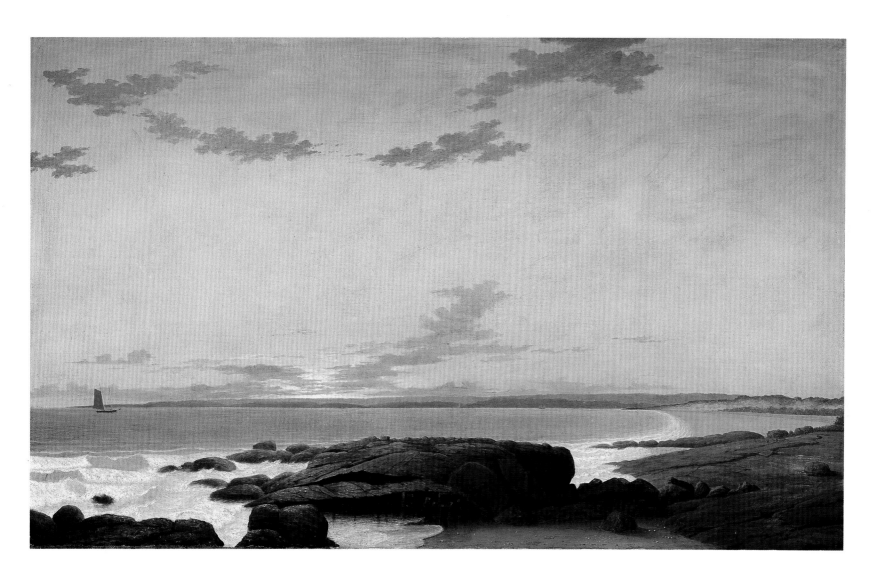

cat. 18. *Ipswich Bay*, 1862, oil on canvas, 20 x 33 in. [Museum of Fine Arts, Boston, Gift of Mrs. Barclay Tilton in memory of Dr. Herman E. Davidson]

mid-1850s	Creates an important series of Boston harbor views; new variety in landscape and shoreline combinations of Gloucester harbor pictures. Second extensive sailing trip to Penobscot Bay and Mount Desert areas.
summer 1855	Third Maine cruise with Stevens, resulting in paintings of Owl's Head, Camden hills, Blue Hill, and Mount Desert areas.
late 1850s	Emergence of late style, new severity and serenity, more open and poetic compositions. Takes on pupils, notably Mary B. Mellen, in painting lessons.
1860	Start of American Civil War. Lane paints *Lumber Schooners at Evening on Penobscot Bay* (cat. 61) and *Approaching Storm, Owl's Head* (cat. 51).
1862	Late style marked by greater openness and lucidity. Notable oils of this year include *Ipswich Bay* (cat. 18), *"Dream Painting,"* and *The Western Shore with Norman's Woe* (cat. 17).
summer 1863	Last visit to Maine. Paints *Christmas Cove* (cat. 53); also two unusual Gloucester landscapes: *Riverdale* (cat. 19) and *Babson and Ellery Houses, Gloucester* (cat. 20).
1863–1864	Final series of paintings: *Brace's Rock* (cats. 21 and 23). Devastating fire along Gloucester waterfront.
July 1864	Last sketching expedition around Cape Ann, accompanied by Joseph and Caroline Stevens. Last dated drawings: *Eagle Cliff at Old Neck Beach, Manchester* and *Folly*

Photograph of Lane late in life, c. 1860 [Cape Ann Historical Association]

	Cove, Lanesville. Becomes ill, remains in poor health through the spring of 1865.
6 august 1865	Following a bad fall, has a major setback (presumably a heart attack or stroke).
12 August 1865	Lane dies in Gloucester. One Boston paper noted, "The death of this gifted artist may almost be considered a national loss, at least so far as art is concerned."

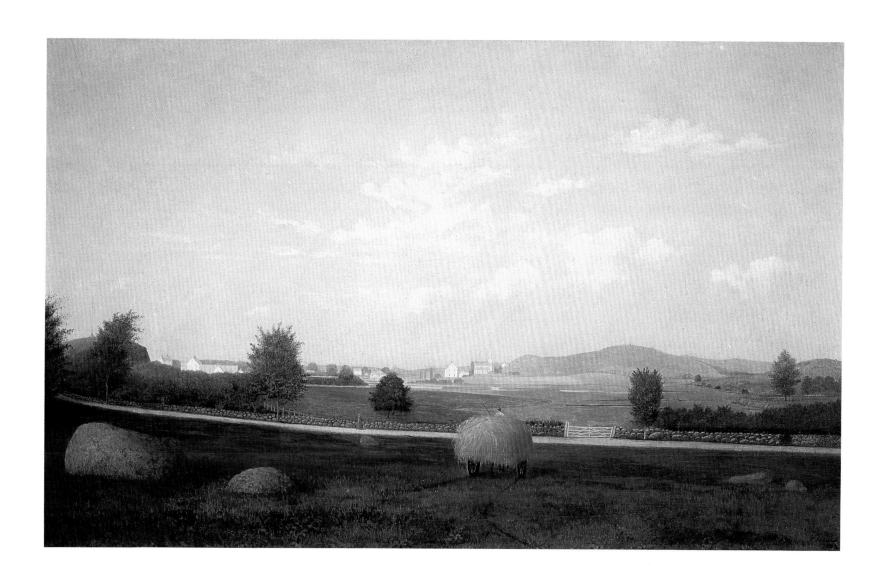

cat. 19. *Riverdale*, 1863, oil on canvas, 21½ x 35¼ in. [Cape Ann Historical Association]

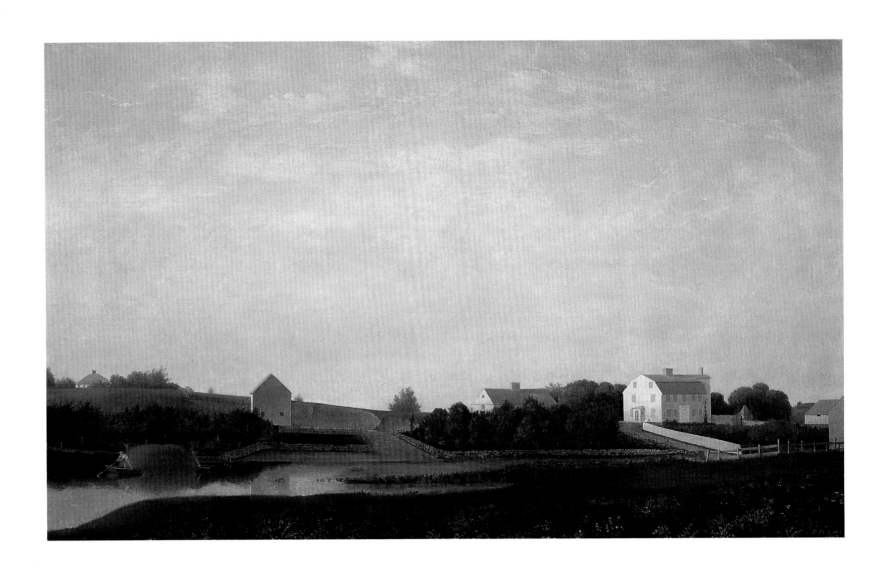

cat. 20. *Babson and Ellery Houses, Gloucester,* 1863, oil on canvas, 21¼ x 35¼
in. [Cape Ann Historical Association]

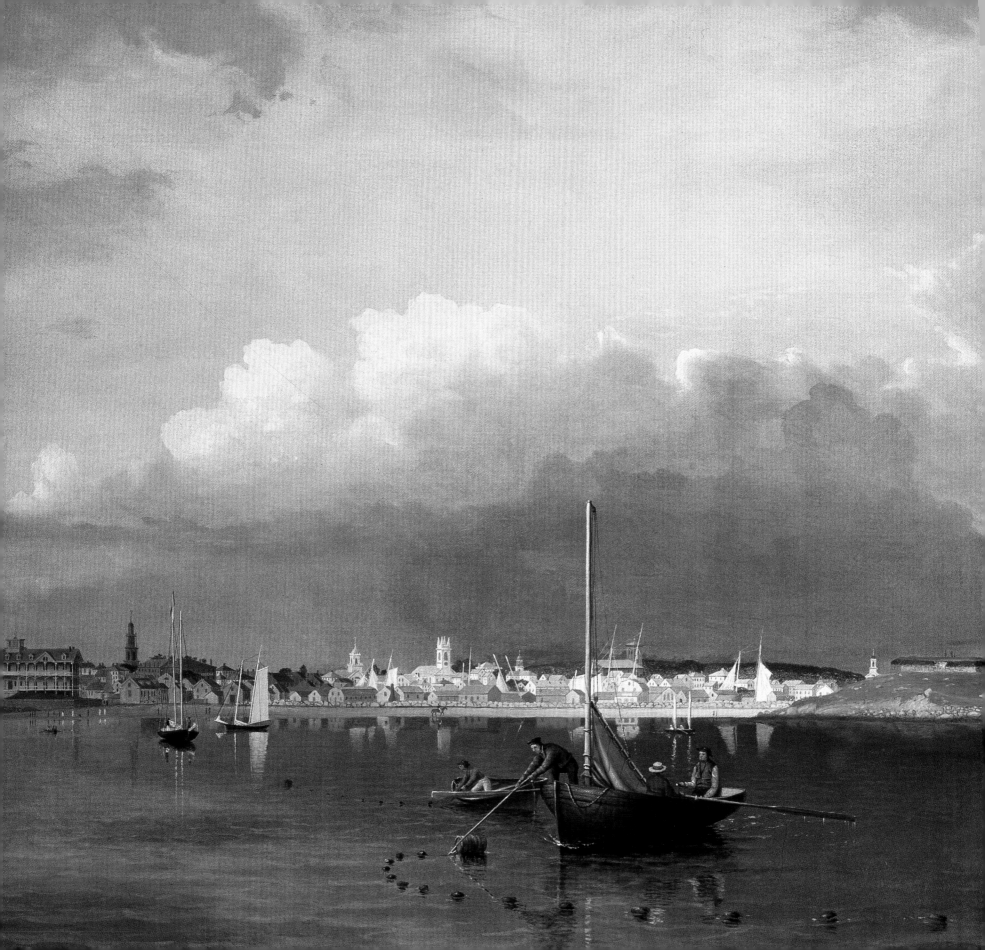

Cape Ann Views

ELIZABETH GARRITY ELLIS

IT IS UNLIKELY THAT FITZ HUGH LANE KNEW Christopher Cranch's *Illustrations of the New Philosophy*. Sketched on scraps of paper and enclosed in letters of the late 1830s and early 1840s, the cartoons circulated among a small band of Harvard graduates who had journeyed West during the years of political and religious crisis and rallied to the new faith of Ralph Waldo Emerson.[1] The most amusing of the drawings were based on *Nature* of 1836, Emerson's first declaration of the Transcendentalist program. Four years earlier he had resigned from the Unitarian ministry, repudiating the "dead forms" of its "historical Christianity." Instead, he proposed a new revelation, founded not in doctrine or tradition but in the immediate apprehension of the divine in nature. Cranch seized on Emerson's anecdotes of beholding God and nature face to face and in January 1839 sketched *Nature*'s most famous passage (fig. 1):

Standing on bare ground,—my head bathed by the blithe air, and uplifted into infinite space,—all mean egotism vanishes. I become a transparent eyeball; I am nothing; I see all; the currents of the Universal Being circulate through me; I am part or particle of God.[2]

Emerson had borrowed the image from Plotinus, adapting the ancient mystical harmonies to the American condition of newness.[3] For a country still inventing itself from a miscellany of facts, he revealed an intrinsic spiritual order in a sublime act of perception.

If Cranch's top-hatted creature towering over field and hills was unknown to Lane, the image has nonetheless dominated discussions of the luminist paintings the artist produced from the mid-1850s until his death in 1865. It is in Emerson's account of these decades of "a new consciousness" that art historians have found the language and meaning of Lane's radiant coastal views. The crystalline light and patterned geometries of shoreline and boats in such paintings as *Brace's Rock*, 1864 (cats. 21, 22, and 23) and *Stage Rocks and the Western Shore of Gloucester Outer Harbor*, 1857 (fig. 2) have come to assume the order and spiritual tenor of the Transcendentalist's vision.[4]

Lane's luminist style had, of course, a history of its own—having evolved over a period of almost two decades, from the conventions of Anglo-Dutch marine and landscape paintings seen by the young artist in Boston and formalized in the illustrations of drawing books[5]; from the "graphic power" and implicit design of John Ruskin's descriptions of nature[6]; and, especially, from Lane's work throughout his career as a lithographer making topographical views of his native Gloucester. The maplike accuracy of the prints and paintings on which they were based, like *Gloucester Harbor from Rocky Neck* of 1844 (cat. 2) had established Lane's local reputation and gained him notice in Boston newspapers. "Select your own subject, some point of interest upon our ocean borders, and set the artist at work," advised the *Evening Transcript* in October 1850.[7] In preparation, Lane navigated the beaches and granite outcroppings of Cape Ann, making pencil sketches of outlines and details that he transferred to canvas along a measured grid. He became the taxonomer of the Gloucester coast.

In the process, Lane took possession of it. The compositions of *Brace's Rock* and *Stage Rocks* derive from sites on the Massachusetts shoreline but are conceived in pictorial terms, as Lane adjusted the elements of the scene away from the specific toward abstract patterns of shape and thin color. Thus his art of

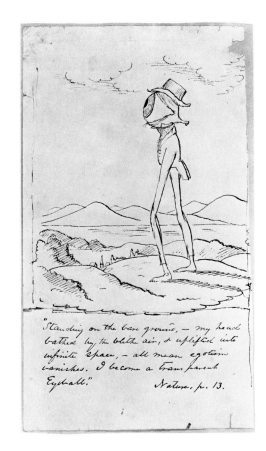

fig. 1. C. P. Cranch, *The Transparent Eyeball from "The New Philosophy" Scrapbook*, 1839, pen on paper [Harvard College Library, Cambridge, Massachusetts].

"Standing on the bare ground, — my head bathed by the blithe air, & uplifted into infinite space, — all mean egotism vanishes. I become a transparent Eyeball." *Nature, p. 13.*

fig. 2. Lane, *Stage Rocks and the Western Shore of Gloucester Outer Harbor*, 1857, oil on canvas, 15¹/₂ x 23¹/₂, [Cape Ann Historical Association]

description yielded to a formal style that was at once intensely objective and suffused with feeling: the ordinary, familiar shapes of the shore world are immediately recognized, but their meaning is released by their ordering on the canvas. Barbara Novak has likened this paradox to the "Emersonian tolerance of contradiction."[8] Whether there is direct connection with Emersonian Transcendentalism is, however, uncertain. Rather, as Novak has argued, we can claim affinity.[9] But to align the structured vision of Lane's small paintings only with Emerson's record of "consciousness" is an incomplete study of both artists, for it tends to remove them from history and to emphasize form over content. It is in terms of their historical context that Lane's Gloucester subject matter and his relationship to Emersonian ideas can be more fully discussed.

In his study of the period of American romanticism, Michael T. Gilmore observed that what established Emerson "as a truly 'representative man' of Jacksonian America" was his ambivalence toward a world that had become a marketplace.[10] From

about 1815 to the Civil War, the scale and character of American enterprise were radically and permanently transformed. The rise of manufacturing and a national network of railroads, the expansion of banks and of credit, and the shift of population from farm to factory and city produced a new economic order and market society in which "people and their surroundings were brought under the dominion of exchange."[11] Under this market regime, labor became a commodity. Land came to be seen as an object of speculation. Even literature was part of trade, promoted and circulated by publishing houses. The young Emerson recoiled from the "noisy readers of the hour" and defined the "*new views* here in New England" as a reaction against the instability of the market: "What is popularly called Transcendentalism among us, is Idealism." In other times the hunger for spiritual truth made philosophers or prophets; "falling on . . . commercial times" this hunger "makes the peculiar shades of Idealism which we know."[12] The later Emerson found reassurance in the market system and defended "the laws of nature" that "play through trade . . . The counting-room maxims liberally expounded are laws of the Universe."[13] Throughout his life, in different and complex ways, Emerson confronted and was deeply marked by his "commercial times."

Indeed, the very first "use" of nature that Emerson considered in *Nature* appears under the heading of "Commodity." As

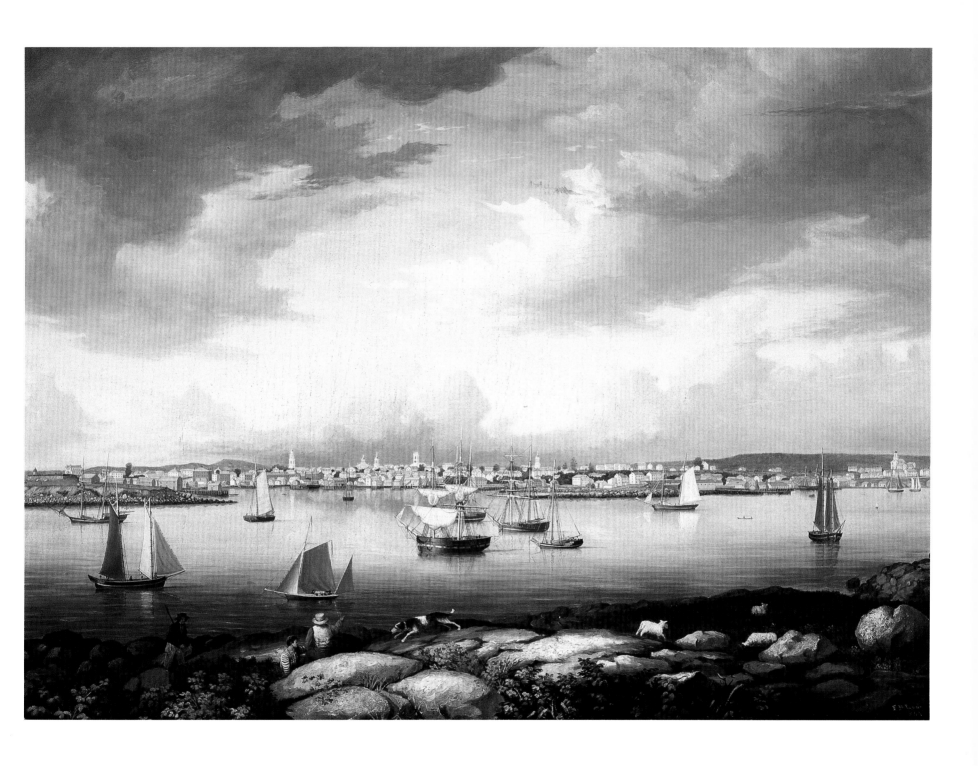

cat. 2. *Gloucester from Rocky Neck*, 1844, oil on canvas, 29¹/₂ x 41¹/₂ in. [Cape Ann Historical Association]

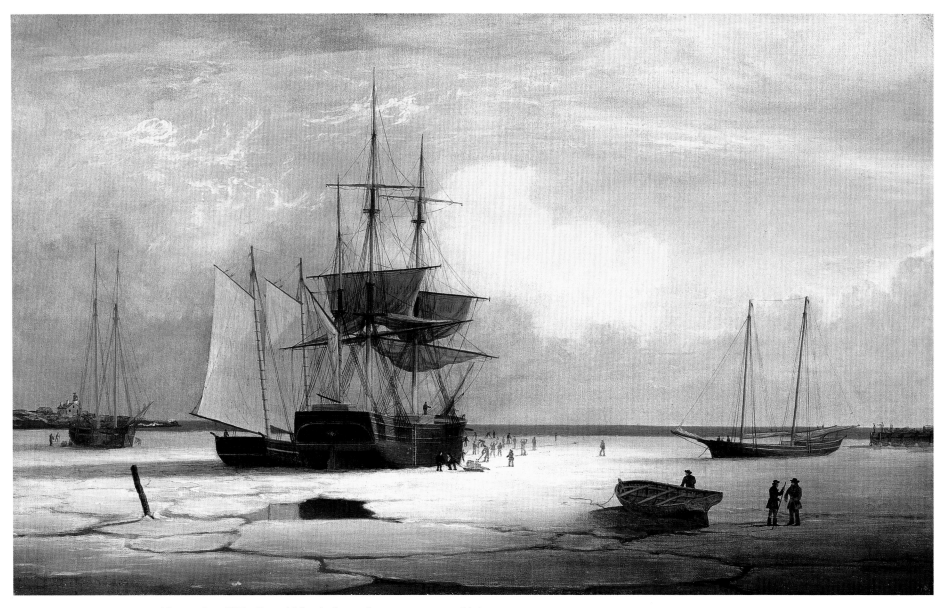

cat. 3. *Ships in Ice off Ten Pound Island*, 1850s, oil on canvas, 12 x 19³/₄ in.
[Museum of Fine Arts, Boston, M. and M. Karolik Collection]

commodity—"cities, ships, canals, bridges, built for him"[14]—
nature was briefly reconciled with man. But the union was temporary and its value artificial; in the mart of trade, all of nature,
all meaning, was negotiable. The fault lay within. Because men
generally relate to nature as commodity (if men "looking at the
ocean can remember only the price of fish," Emerson later

wrote[15]), they fail to see its spiritual side and "are as much
strangers in nature, as [they] are aliens from God."[16] It is this
sense of alienation that the sublime intimations of *Nature* finally overcome: in dazzling moments, the influx of spirit reveals
a "radical correspondence between visible things and human
thoughts" and prophesies "a correspondent revolution in
things." By grasping "that wonderful congruity" between mind
and nature, man can change and impose absolute order on the
world.[17] Yet, as Gilmore noted, even here, Emerson was impli-

cated in the marketplace: revelation is a transaction, an exchange of matter for meaning.

This equivocal harnessing of "economic categories . . . to the operations of the Soul" persisted in Emerson's later writings but grew gradually less critical, as, with age and prosperity, he acceded to the processes of the market.[18] Indeed, after 1840, he would come to rely less on the self, as his Transcendentalism shaped its "radical thrust to the curve of earth."[19] R. A. Yoder's beautiful image charts the shift in Emerson's thought: his retreat from the power of visionary moments toward a kind of truce with "eternal Fact" that acknowledged an unalterable disparity between the mind and nature. He wrote in "Experience" in 1844:

I know that the world I converse with in the city and in the town is not the world I *think*. I observe that difference, and shall observe it. One day I shall know the value and law of this discrepance.[20]

Having renounced the power to redeem nature, Emerson took up a detached position from which to observe it. His reach diminished, he patiently collected glimpses of the world around him and discovered that "Metamorphosis or Flux" was its "true pattern:" "That rushing stream will not stop to be observed."[21] The processes of nature and society demanded a conscious effort extended in time. Thus, as Emerson came to terms with his "commercial times," he also turned increasingly to the historical imagination, to history conceived as the process of events. It was only through time and in time that meaning could be found.

In 1849 Lane permanently left Boston for the town of his grandfathers. His return was speeded by a branch of the Eastern Railroad that was extended to Gloucester in 1846 and opened the port the following year to commercial development. After years of declining fishing revenues, the construction of the railway formed a critical link with the new technology of icing the catch aboard vessels when they were at sea. It connected the fisheries with western markets, attracted capital that gradually transformed the industry into an entrepreneurial venture that by 1860 would eclipse the Surinam trade as the town's economic mainstay, and led to a boom in the construction of wharves and factories along the waterfront. A "slight advance . . . in the value of real estate" noted by the *Gloucester Telegraph* in June 1846 marked the beginning of two decades of specula-

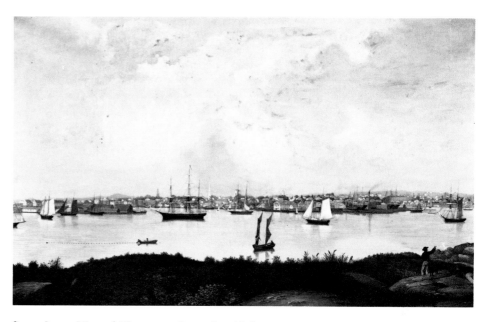

fig. 3. Lane, *View of Gloucester*, 1855, colored lithograph, 21³/4 x 35¹/2 [Cape Ann Historical Association]

tion and rising land prices.[22]

The views Lane made after his return were part of this market economy and activity. They were, in effect, articles of commerce, whose value and meaning depended on the circumstances in which they were produced and of the visible world they recorded. Underwritten by subscriptions advertised in the newspaper, lithographs like *View of Gloucester*, 1855 (fig. 3) were distributed from the bookstores and printing shops of friends. The paintings occasionally were sold by lottery. On 21 September 1859 the *Gloucester Telegraph* reported a drawing of "five oil paintings" among the subscribers to the print: "No. 125 took the first picture, being the original from which the view of Gloucester was engraved." (The second picture raffled was possibly *Ships in Ice off Ten Pound Island*, 1850s (cat. 3), described as "a winter scene, giving a representation of cutting vessels out of the ice.")[23]

View of Gloucester describes a world of exchange. From the shadowy pasture of Rocky Neck, the figures at lower right direct our attention to a panorama of harbor activity. As they point both within and beyond the edges of the scene, the print seems a fragment of a world ordered around human measure and use. The patterned shapes of sails, riggings, and boats stretching across the Inner Harbor are repeated in the steeples

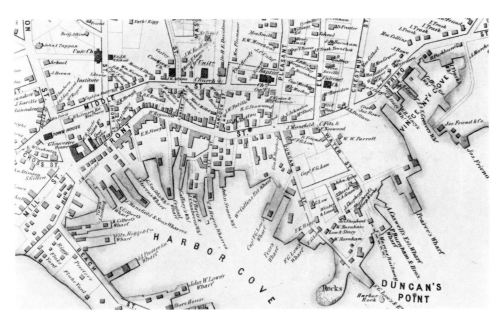

fig. 4. Map of *Gloucester Harbour Village*, 1851 [Cape Ann Historical Association]

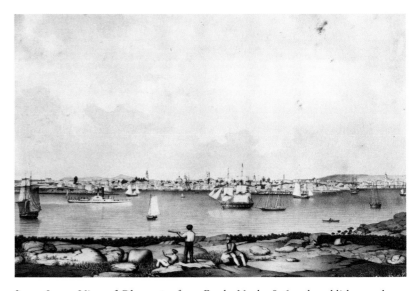

fig. 5. Lane, *View of Gloucester from Rocky Neck*, 1846, colored lithograph, 21½ x 35½ [Cape Ann Historical Association]

and gambrel roofs of the buildings set in terraced rows along Front and Middle Streets (fig. 4). Masts line up with chimneys; caulking and fish glue factories, marine railways and fishing schooners are clearly and evenly illuminated as harbor and shore work in tandem. *View of Gloucester* was an update of the harbor inventory found nine years earlier in *View of Gloucester from Rocky Neck* (fig. 5) (based on *Gloucester Harbor from Rocky Neck*.) Lane profiled the town from the same vantage point, retaining the same balance of shore to sky, of particular buildings to geometric boxes, but he carefully, and knowingly, added the new construction on Fort Point and Duncan's Point. The artist's studio on the top floor of his house on Duncan's Point had put him at what a local historian would describe in 1860 as "the centre of a seat of the fishing business, which, for activity, enterprise, and extent, has no equal on this continent."[24]

Lane's commercial vision was made explicit by the genre elements that he introduced into many of his Gloucester views of the 1840s and early 1850s. In *The Fort and Ten Pound Island, Gloucester, Massachusetts*, 1847 (Thyssen-Bornemisza Collection) and *Gloucester Harbor*, 1847 (cat. 10) the contours of the beach and Ten Pound Island form a stageset for figures who unload fish or transact business. In *Lanesville, the Mill*, 1849 (cat. 4) they announce the presence of industry: an old horse and

wagon driven along the road at the right of the sawmill lead us into view of the railroad where, as the *Telegraph* pointed out, "the locomotive, pouring out from its smoke pipe, a dense black cloud, is just coming in sight."[25]

The marketplace of Gloucester also defined a view of the town painted in 1852 for the merchant Sidney Mason, a Gloucester native living in New York. One of Lane's largest works, *Gloucester Harbor* (cat. 7) scans the shore from the wide angle of the Outer Harbor—an expanse that is charted and contained by the traffic of boats. At the center foreground the taut line of a trawl holds a Chebacco boat in place, part of the catalogue of Gloucester vessels disposed across the harbor, as space is identified by function. A flood of sunlight bleaches the houses above the shore as the deep blues of clouds and the plane of water, verticals of mast and line, and the scallop pattern of the clouds perform an aesthetic function. But Lane's eye was still in the service of accounting, and the patterns form a backdrop to the shipping. *Gloucester Harbor* was one of at least three works commissioned by Mason in the early 1850s that together represented the commercial corners of his world: Lane also painted a New York view and *St. Johns, Puerto Rico*, 1850 (The Mariners' Museum), which shows men logging mahogany in the harbor of San Juan, where Mason had lived from about 1820 to 1835, served as U.S. consul, and made his fortune.[26]

cat. 4. *Lanesville, The Mill*, 1849, oil on canvas, 18 x 26 in. [private collection]

cat. 7. *Gloucester Harbor,* 1852, oil on canvas, 27$\frac{1}{4}$ x 47$\frac{1}{2}$ in. [Cape Ann Historical Association]

cat. 10. *Gloucester Harbor*, 1847, oil on canvas, 23 x 35½ in. [Cape Ann Historical Association]

SUMMER RETREAT.—As the warm weather approaches, city people wish to be informed of all arrangements being made at the watering places for their accommodation during summer months. They will be welcome here; and to those who have already visited Gloucester and vicinity, nothing need be said of its superiority over other places in New England as a summer retreat. Its cool breezes, romantic scenery, beautiful harbor, hard, white sand beaches, and bracing air, are temptations that cannot well be resisted. If besides these attractions, strangers can be assured of good hotel accommodations, no more can be required. Three hotels will be opened here this summer, the Pavilion, Gloucester House, and Union House; of these we propose at present to speak only of the Pavilion, reserving a description of the other houses for another number.

fig. 6. From *Boston Evening Transcript*, advertisement for The Pavilion, 1849 [Cape Ann Historical Association]

Gloucester Harbor also recorded an aspect of the Gloucester economy that is perhaps less conspicuous to modern eyes. Along the shore at the far left stands the two-story Pavilion, one of the first of the hotels that began to dot the Cape Ann shoreline in the late 1840s and 1850s (fig. 6). With the coming of direct rail service, tourists had followed. "Even now strangers are beginning to visit us," reported the *Telegraph* in 1846, "the facilities for getting here being so abundant."[27] By the end of the decade, newspapers and travel guides were promoting Cape Ann as a summer resort:

Projecting farther into the broad Atlantic than any promontory of New England, [the Cape] breasts the purest waves and courts the freshest breezes, while, unlike other portions of our coast, its soil is luxuriant and well wooded, and its scenery blends, in charming unity, the wild, the rugged, the romantic and the pastoral. No where else upon our seaboard has nature been so prodigal of her charms.[28]

The first visitors stayed at boarding houses, but with the opening of the Pavilion in June 1849 a new standard of comfort was established. Designed by a Boston architect for Sidney and his brother John Mason, the hotel featured elegant sitting rooms, gas lamps and all the amenities demanded by "those who require luxury."[29] Boating and swimming were at the front

door. New shops opened nearby. By September, the hotel's fashionable status was secure and its unusual double piazza a local landmark[30]—though it would offend the New York art critic Clarence Cook. When visiting Lane in 1854, Cook deplored the "ugly, yellow" hotel sunning "itself on the rocks where I used to sit hour by hour watching the lapsing waves upon the beach below."[31] The critic's grumbling aside, Lane made pencil sketches of the Pavilion on its curving sweep of beach and included it in several paintings of the early-to mid-1850s.

As Lane sketched, the hotel was transforming the beach into a site for spectacle. Alfred Brooks called the Pavilion "Gloucester's first conspicuous monument of the profitable and ever-increasing business of housing and feeding the summer people."[32] It represented a business that quickly became a lucrative part of the town's development—and made a commodity of both the scenic landscape of Cape Ann and the act of observing it. "To those who . . . are not fond of entire seclusion, and like the excitement of company," the March 1849 *Pictorial National Library* advised, "this hotel is an excellent stopping place and starting point" for a tour of the attractions found along the eighteen-mile coast of the Cape.[33]

Lane took many of these "points of interest" as his subjects. He drew and painted several views of the Bass Rocks and Little

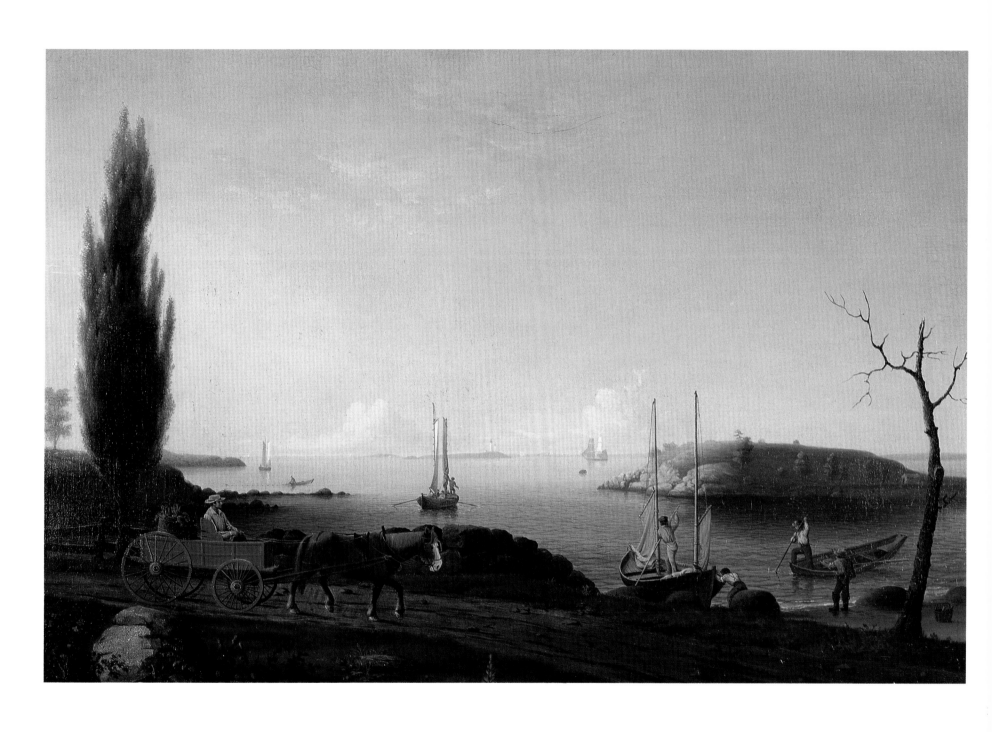

cat. 5. *Good Harbor Beach, Cape Ann*, 1847, oil on canvas, 20³/₁₆ x 30¹/₈ in.
[Museum of Art, Rhode Island School of Design, Jesse H. Metcalf Fund]

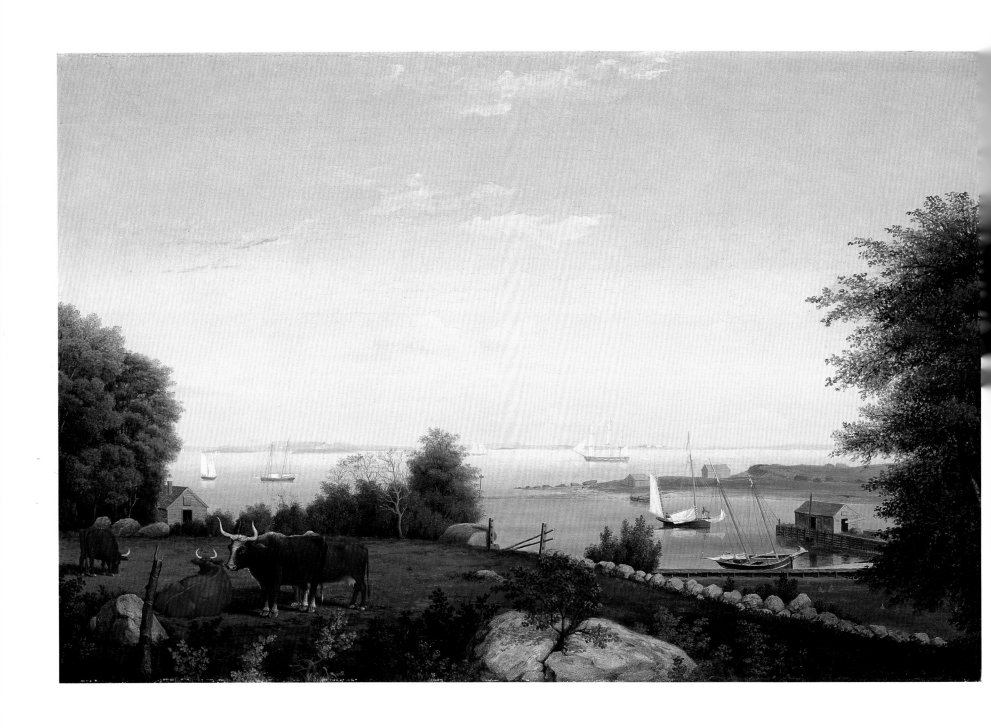

cat. 9. *Gloucester from Brookbank,* late 1840s, oil on canvas, 20 x 30 in.
[Museum of Fine Arts, Boston, M. and M. Karolik Collection]

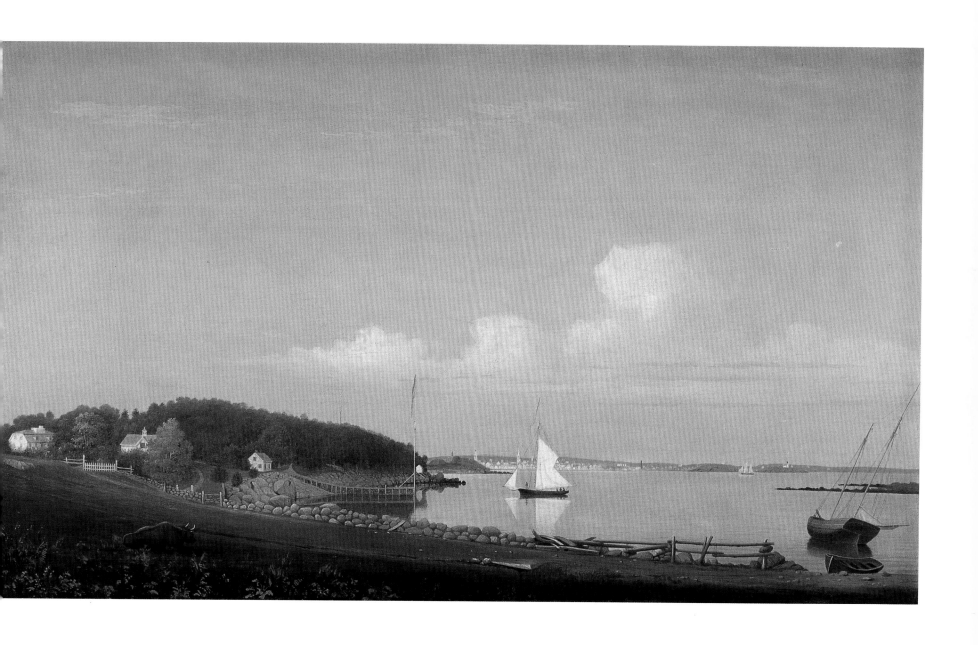

cat. 11. *View of Gloucester from "Brookbank," the Sawyer Homestead*, 1850s, oil on canvas, 18 x 30³/₁₆ in. [The Carnegie Museum of Art, Pittsburgh, acquired through the generosity of the Sarah Mellon Scaife Family]

Good Harbor Beach, a stretch of coast east of town singled out by guidebooks for its rocky shore and sunset views of Salt and Milk islands. The area had already attracted the attention of developers. Beginning in 1846, the pasture rights to the land were bought up by George H. Rogers, a Gloucester merchant who had made his money in the Surinam trade and

foresaw the advantages this beautiful tract offered as a future seashore resort, and at once began the improvement of the property by laying out avenues and roadways, cutting up the pasture into suitable building lots and otherwise greatly enhancing the values of the premises, expending vast sums of money in the work.[34]

Rogers' holdings in the area eventually included a hotel and more than 250 acres before he sold out in the 1860s.

Sunrise through Mist, Pigeon Cove, 1852 (cat. 42) represents an area farther north along the Cape at Rockport. Known to sailors for its stone breakwater and safe harbor, by the late 1840s Pigeon Cove was claimed by travel writers for its "prospect" and pleasant boarding houses.[35] Within a generation, the tourist's view would become a major commodity: "the scene of fishermen at the wharves, and of stone-sloops loading with granite to take to Boston and other cities, is entertaining to those who have not often looked upon it."[36] During the early 1850s local investors banking on the extension of the railroad to Rockport began to buy tracts of land along the shore and a decade later divided nearly 150 acres into building lots for summer homes.[37]

Lane also painted the coast between Gloucester and Magnolia, a section of Cape Ann that by 1860 was "widely known as one of the leading fashionable Summer resorts."[38] As if anticipating the market, *Fresh Water Cove from Dolliver's Neck, Gloucester*, early 1850s (cat. 8) surveys the coast as property: from the fenced pasture of the foreground, the white diagonals of sailboats lead the eye across the cove to the houses along Western Avenue. The largest, "Brookbank," was the summer residence of one of Lane's important patrons, Samuel E. Sawyer.

These views had obvious appeal for investors[39]—and for the artist who, by selecting them, participated, however indirectly, in their appreciation. Lane may, in fact, have profited directly from the real estate market. The value of the granite house and studio that he built on Duncan's Point shortly after his return to Gloucester (whose roofline was said to be modeled on the House of the Seven Gables of Nathaniel Hawthorne's tale)

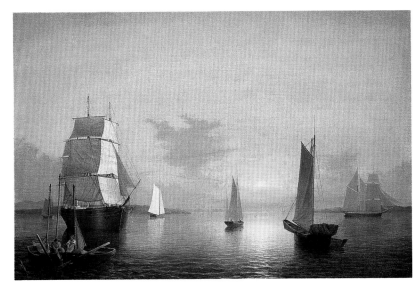

fig. 7. Lane, *View of Gloucester Harbor*, late 1850s, oil on canvas 24 1/8 x 36 1/4 [Mr. and Mrs. Glen Rosio].

more than doubled during the thirteen years following its completion.[40] It was not the first time he had shared his Gloucester patrons' financial concerns. In 1840, when still living in Boston, Lane had supplied Gloucester's Whig merchants with a banner for an election parade protesting the Democratic administration's proposed change in the calculation of fishing bounties. From Gloucester Harbor the famous sea serpent was shown rearing its head from the water as the caption announced: "The Deep has Felt the Attack Upon her Interests and Sends Her Champion to the Rescue."[41]

fig. 8. Lane, *Dolliver's Neck and the Western Shore from Field Beach*, 1857, oil on canvas, 18 1/2 x 32 3/4 [Cape Ann Historical Association]

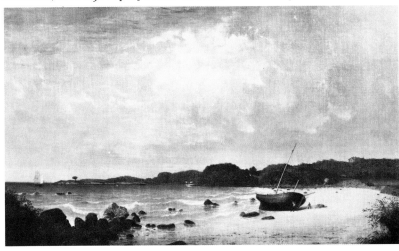

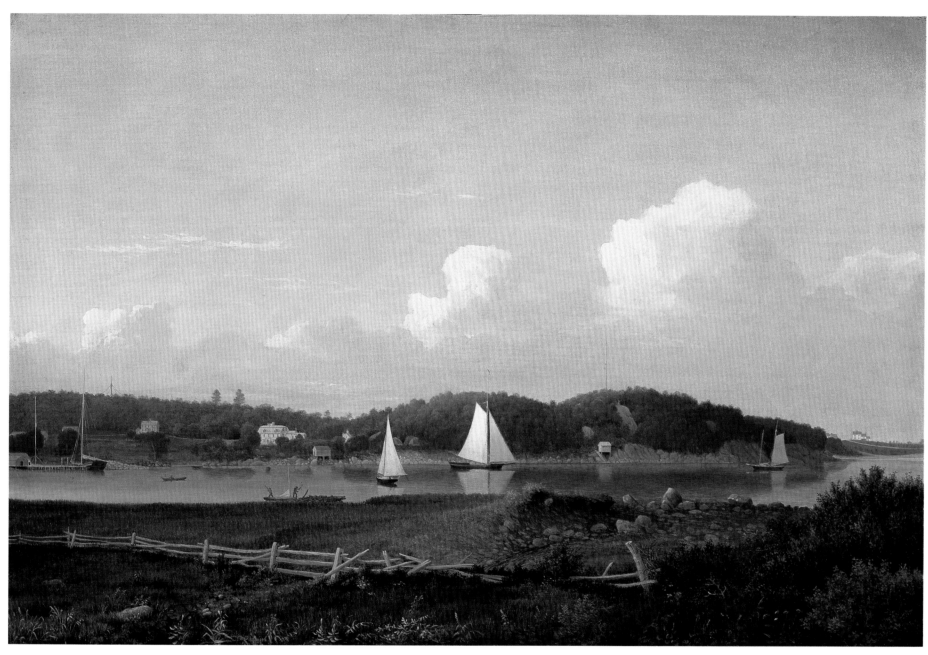

cat. 8. *Fresh Water Cove from Dolliver's Neck, Gloucester*, early 1850s, oil on canvas, 24 x 36 in. [Museum of Fine Arts, Boston, M. and M. Karolik Collection]

Lane's Gloucester subjects of the late 1840s and early 1850s were records of these interests. Yet by the mid-1850s, when his luminist style emerged, his subjects also began to change. The resorts of summer tourists and developers give way to different areas or views of the coast. When Lane returned to Dolliver's Neck in 1857, he sought a new vantage point and vision: *Dol-liver's Neck and the Western Shore from Field Beach* (fig. 8) records the stretch of coast between Stage Fort and Mussel Point; the summer houses along Fresh Water Cove are less conspicuous, anecdote is subdued, and the details of the

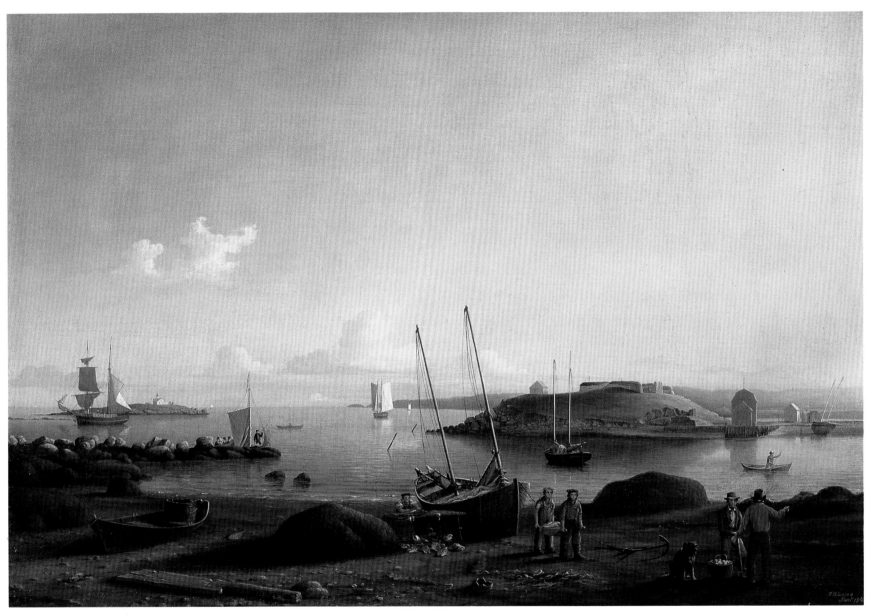

cat. 6. *Gloucester Harbor*, 1848, oil on canvas on panel, 27 x 41 in. [Virginia Museum of Fine Arts, the Williams Fund]

landscape—the fissures in the rocky shore, the wooded hillside—are more selectively observed and rendered. The detail and dark weight of the rocks at the lower left seem at once to condense and foil the larger arc of sand. The distance of the solitary pine from the scumbled trees in middleground, clearly indicated in the pencil sketch Lane made of the site, is uncer-

tain. The eye focuses on pieces of nature that combine less as a map of the site than as formal patterns and contrasts, of dark against light, diagonals against horizon line, green against purple tones.

The new direction of Lane's art is suggested by his discussion of the painting in a letter to his patron and friend Joseph Stevens, Jr.:

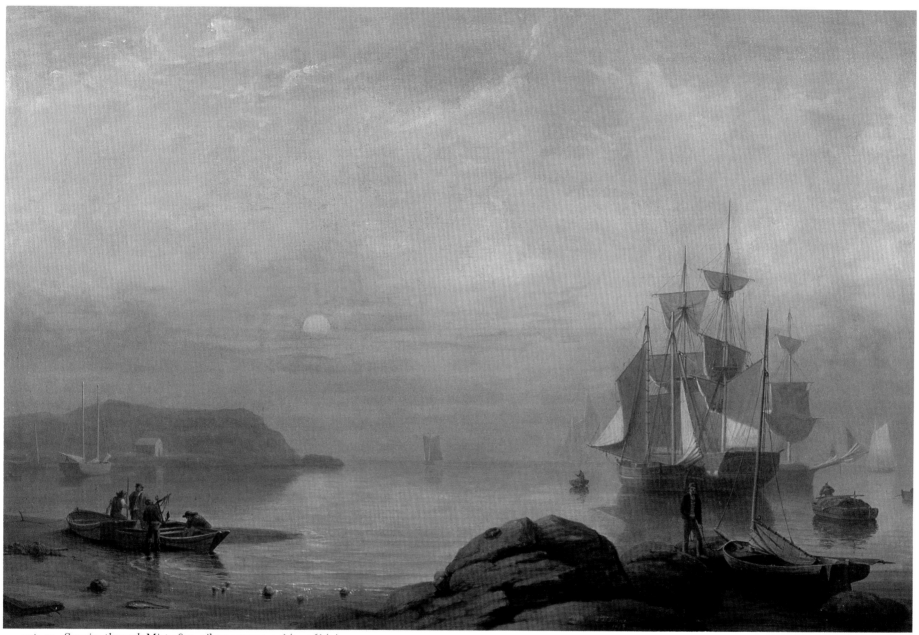

cat. 42. *Sunrise through Mist*, 1852, oil on canvas, 24¼ x 36¼ in.
[The Shelburne Museum, Shelburne, Vermont]

Since writing you last I have painted but one picture worth talking about . . .
The effect is a mid day light, with a cloudy sky, a patch of sunlight thrown
acrost the beach and the breaking waves. An old vessel lies stranded on the
beach with two or three figures, there are a few vessels in the distance and the
Field rocks likewise show at the left of the picture. I think you will be pleased
with this picture, for it is a very picturesque scene especially the beach, as
there are many rocks which come in to destroy the monotony of a plain sand

beach, and I have so arranged the light and shade that the effect I think is
very good indeed.[42]

This description is rare for Lane, and his meaning is not made
clear. "Very picturesque" may refer to the artist's expressly pic-
torial concerns, as he shifted his attention beyond the describ-
ing of topography to the aesthetic effects of variety and rough-
ness (the rocks which relieve "the monotony of a plain sand

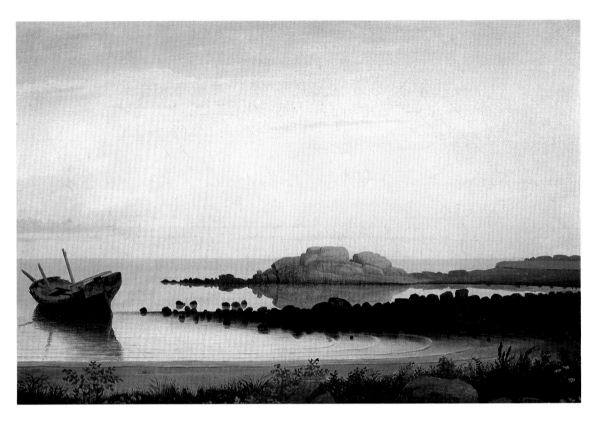

cat. 23. *Brace's Rock*, 1864, oil on canvas,
10 x 15 in. [Mr. and Mrs. Harold Bell]

beach") and the arrangement of "the light and shade." It may also suggest a new level of meaning. The distance essential to perceiving these pictorial possibilities was tied to an emotional detachment from the site. In the neutral territory of his studio, Lane constructed the painting, balancing observation and design, topographical fact and invented color and effects of light. The formal patterns of *Dolliver's Neck and the Western Shore from Field Beach* are not static—for example, the intense contrast of dark and light undoes the measured distance between the Field Rocks and the beach. The tenuous balance of contrasts that define the image suggests the succession of moods and moments that made up Lane's knowledge of the scene, the fluid process that is the province of memory. This may account for the "old vessel . . . stranded on the beach": not included in the preliminary drawing of the site, the boat may serve as a kind of marine ruin, with its associations of time and imaginative return.

We should not make too much of Lane's remark. By the mid-nineteenth century the picturesque was so popularized a term that it had lost precise meaning, especially in American aes-

thetic thought and travel writing. But at its most significant, as in J. M. W. Turner's *Picturesque Views in England and Wales* (1825–1838), which Lane may well have known, the picturesque referred to topographical scenes that sought at once to describe present appearance and to evoke past history. Having set nature above art as the standard of landscape painting, the picturesque taste combined precise observation of details with an attention to private meaning and formal effect. Thus, J. D. Hunt's observation that the aesthetic had its most "pervasive moment" at a time when scepticism about the readable syntax of painting had left "unresolved any fresh means of linking mental and emotional explanations to visual experience"[43] may have particular relevance for Lane. In paintings like *Dolliver's Neck and the Western Shore from Field Beach,* Lane shed art historical or graphic convention and narrative content for both a more abstract formalism and implicit awareness of time.

Old or wrecked vessels occupy many of Lane's luminist paintings of Cape Ann. In the several views of Brace's Rock painted in 1863–1864 (cats. 21, 22, and 23), an abandoned boat, in various stages of decay, shifts position in the shallow water. Lane

cat. 21. *Brace's Rock*, 1864, oil on canvas, 10 x 15 in. [private collection]

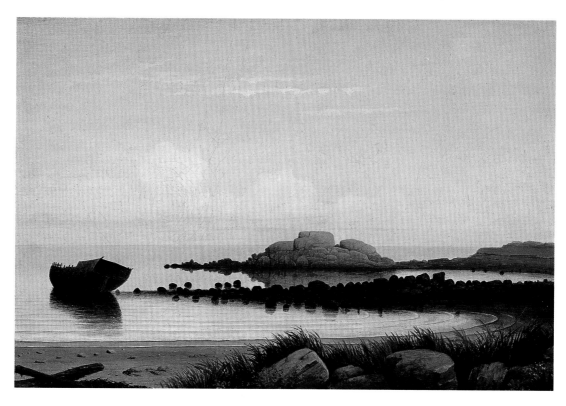

cat. 22. *Brace's Rock, Brace's Cove*, 1864, oil on canvas, 10 x 15 in. [Daniel J. Terra Collection, Terra Museum of American Art, Chicago]

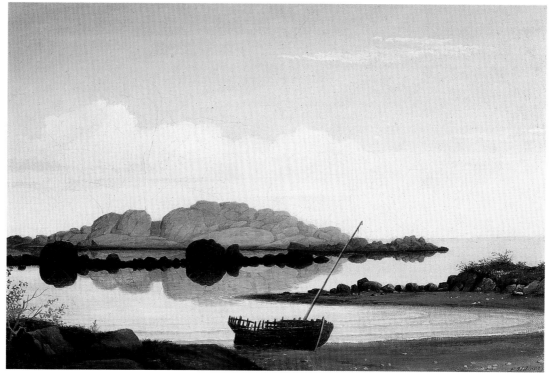

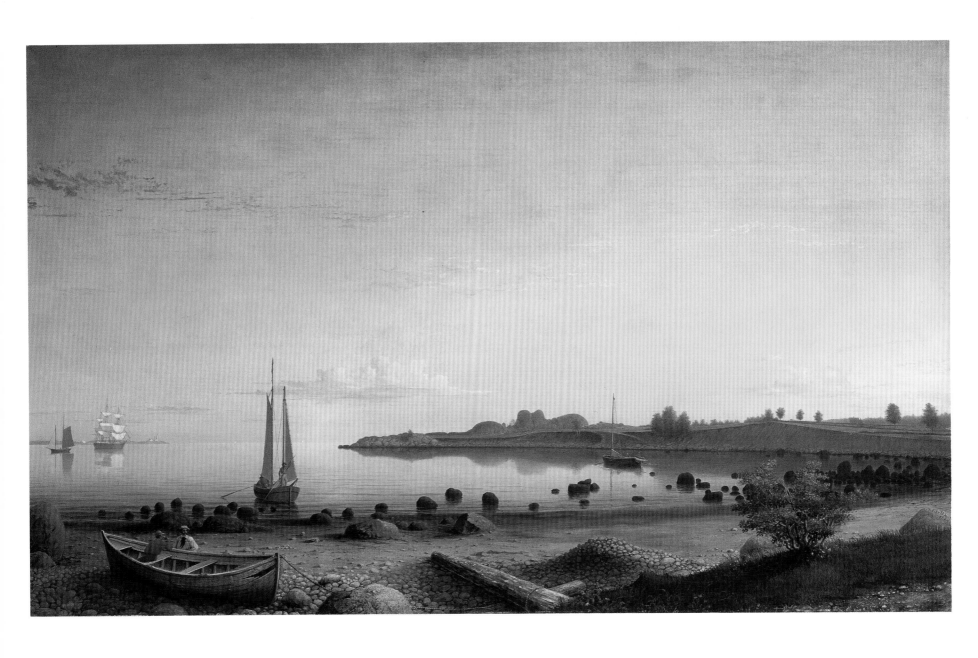

cat. 16. *Stage Fort across Gloucester Harbor*, 1862, oil on canvas, 38 x 60 in.
[Metropolitan Museum of Art, Rogers and Fletcher Funds, Erving and Joyce
Wolf Fund, Raymond J. Horowitz Gift, Bequest of Richard De Wolfe Brixey,
by exchange, and John Osgood and Elizabeth Amis Cameron Blanchard Me-
morial Fund, 1978]

painted the several versions as commissions from Gloucester patrons, and in each version the attenuated shapes of the rocky outcropping and its reflection remain almost constant. But the images are subtly different: the cloud forms and the intensity of colors in the late afternoon sky, suggesting specific meteorological moments, change; the small boat, gradually stripped down to a wrecked hull, changes direction and angle to form different patterns with the lines of rocks and horizon. Each small image is partial, as Lane consciously constructed each in relation to the others. Their serial form—no less than the ruined boat— suggests the presence of time in the landscape and arouses an awareness of the local history and meaning of the site. During the 1860s, Brace's Cove was an increasingly rare part of the Cape Ann coastline: relatively inaccessible, it was off the tourist map and not for sale. Local memory and sentiment were built into the rocky shore.[44]

The conscious evocation of time in the Gloucester landscape may also inform the several views of Stage Fort and the Stage Rocks that Lane painted from about 1855 to 1862. In two views of 1857 (fig. 2), the artist presents, through shifting vantage points, the site where "Massachusetts began her history."[45] Three years earlier the Boston historian J. Wingate Thornton had published *The Landing at Cape Anne* [sic], documenting the effort from 1623 to 1625 to establish a plantation and fishing base on the spot.[46] Part of Thornton's account was based on the research of John J. Babson, a Gloucester banker and civic leader who supplied an appendix describing the topography of the shore. It was probably Babson who introduced Lane to Thornton in late 1857 or early 1858, a meeting that resulted in a history painting of the landing intended as a frontispiece to a second edition of the book. Lane wrote to Thornton on 11 January 1858:

Yours of the 6th came duly to hand and I will answer that I shall be happy to do anything in my power to give you a representation of the scene of the first landing at Cape Ann. The greatest part of the shore, I expect, has undergone but little change, as it is mostly granite rock, the beaches no doubt have incroached [sic] upon the land, since that time, and in fact, within my own remembrance I know much to be the case, to the extent of quite a number of feet, but still the main features of the locality must be nearly the same.

With the stile or model of the vessels, of that time, I am entirely ignorant, and if you, in your researches have ever come acrost [sic] any drawings or engravings of vessels of that period, and would procure me a sight of them, so that I could introduce them into the picture, it would help me out very much—I will consult with Mr. Babson, and when the weather becomes

favourable I will get him to go to the ground and with his help, I think we can give a sketch which will not be far from the truth at any rate, I will do my very best[47].

Lane completed a version of the painting by July and sent it to Boston. The picture, now lost, was probably more conventionally narrative than Lane's luminist canvases, but, even here, the artist's letter suggests that he saw the boats as temporal markers within a landscape that was a container of history and the processes of nature.

fig. 9. Lane, *Gloucester Inner Harbor*, c. 1850, oil on canvas, 24 x 36 [The Mariners' Museum, Newport News, Virginia]

Lane's historical imagination is also evident in what is perhaps his most frequent Cape Ann subject, the view of the Old Fort and Ten Pound Island from the shore of Gloucester Inner Harbor. He painted the scene throughout his career but especially from the late 1840s to early 1850s. Works dating from these years, such as *Gloucester Inner Harbor*, c. 1850 (fig. 9), carefully record the development of Fort Point, much of it owned by George H. Rogers. In a work of about a decade later, *The Old Fort and Ten Pound Island, Gloucester* (fig. 10) this construction has disappeared, as has most evidence of commercial activity. The painting is a luminist work whose classic order and deliberate pattern of boats and reflections and clouds John Wilmerding described as "controlled selectivity in the service of the pictorial statement."[48]

Lane was no less selective in his depiction of the harbor land-

fig. 10. Lane, *The Old Fort and Ten Pound Island, Gloucester*, 1850s, oil on canvas, 22 x 36 [Cape Ann Historical Association, deposited by Addison Gilbert Hospital, Gloucester]

fig. 11. Lane, *View of Old Fort and Harbor, 1837*, c. 1860, lithograph, 4 x 6³/4 [Babson, *History of Gloucester*]

scape. As the *Telegraph* of 30 June 1860 described, the painting is an historical recreation of the site. The dark foreground rocks, "Cunner's Rocks," had long been covered by Parkhurst's Wharf. The point is shown without the construction of the 1850s, "unobstructed by any building, and undisturbed by any roadway." On top of the hill the decaying ramparts of the fort appear "with a distinctness and a completeness which brings former times at once to the memory. The brick house, even then in ruins, yet presented a more defined outline and added greatly to the picturesque effect." Lane's nostalgic vision also extended to the craft in the harbor. The newspaper observed "one of the red-tipped fishing boats that used to frequent our harbor in the days before the breakwater was built at Rockport. A little way off lies at anchor an old fashioned banker 'washing out,' which presents a good contrast to the model clippers of the fishing fleet of today."[49]

The alterations to the site in *The Old Fort and Ten Pound Island, Gloucester* were probably connected with an illustration Lane was preparing for Babson's *History of the Town of Gloucester, Cape Ann*, published in 1860. The same features of the Old Fort are found in the lithograph representing the site in 1837 (fig. 11).

More generally, Lane's historical vision may reflect the antiquarian sentiments he shared with local patrons who, like the artist, had family ties to the early history of Gloucester. Both

Babson and Stevens devoted much of their attention to historical research,[50] and the *Telegraph* praised *The Old Fort and Ten Pound Island, Gloucester* for "preserving so accurately the features of a view . . . which can never again exist in reality" and proposed a "subscription to purchase it for the Public Library Room, or some other suitable place." A strong localism and attachment to tradition had characterized Gloucester since the eighteenth century, but in the mid-1850s these feelings became acute, as many natives sensed their old world slipping away under the very forces of development and population growth from which they had profited. Babson's *History* noted the influx of Irish and Portugese immigrants—"before 1840, there were few persons of foreign birth or parentage residing in Gloucester"— and cautioned readers of their high birthrates: "Some of these infants are born to an inheritance of vice and ignorance" as "the historian must not fail to warn those who are beholding this with indifference."[51] By 1860, a later chronicler complained, "old customs and pleasant associations [were] rapidly becoming dim in the dissolving view of time."[52]

In his luminist paintings of Cape Ann, Lane seemed to turn away from the commercial shore world he had described earlier, into a world of memory and time. He represented, often in successive images, parts of the Cape Ann coastline unaffected by commercial development or laden with history, and thus may have recovered for his Gloucester patrons the associations of a

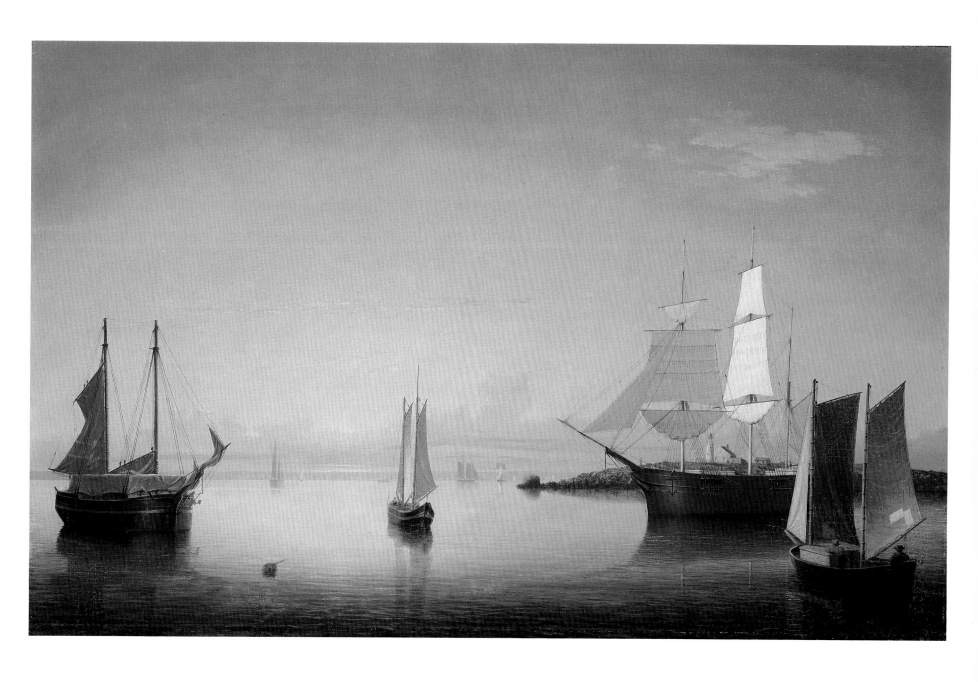

cat. 13. *Gloucester Harbor at Sunset*, late 1850s, oil on canvas, 24¹/₂ x 38¹/₂ in.
[private collection]

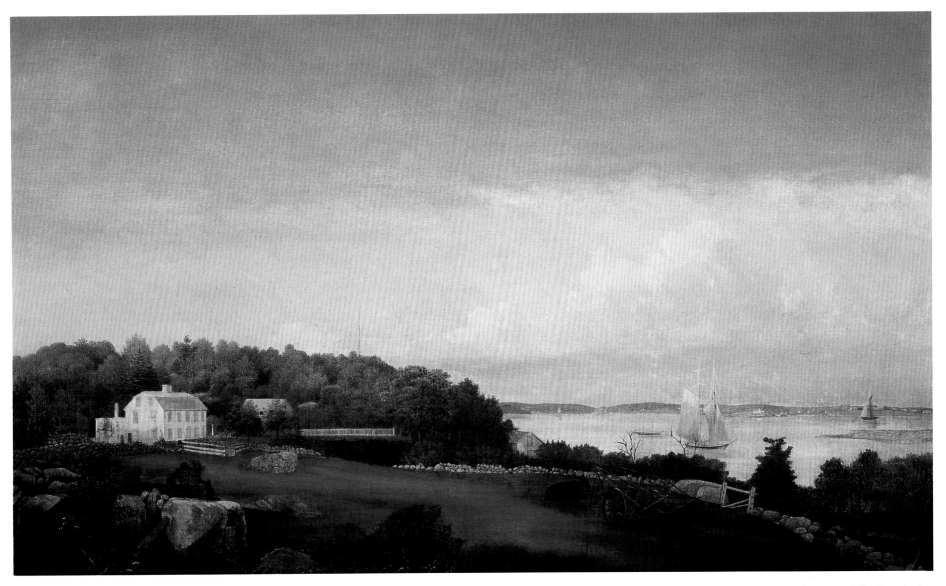

cat. 14. *Sawyer Homestead,* 1860, oil on canvas, 23¹/₂ x 40 in. [The Board of Trustees of the Sawyer Free Library]

more secure and stable past. This strategy was a familiar and in-fluential one during the 1840s and 1850s: Yoder has described it as the "variegated fabric of Romantic and Conservative ideas."[53] By 1840 the poet H. W. Longfellow had begun to pen historical ballads about picturesque sites in New England, and in 1851 Nathaniel Hawthorne defined the project of *The House of the Seven Gables* as "an attempt to connect a by-gone time with the very Present that is flitting away from us." Living in what he took to be a "weightless" present, Hawthorne had found in New England history "an occasionably usable past."[54] This strat-egy, as we have seen, was also to be found in the ways of Fitz Hugh Lane's influential contemporary Emerson, in his retreat from the "transparent eyeball" to the stoic observation of the processes of nature.

1. F. DeWolfe Miller, *Christopher Pearse Cranch and His Caricatures of New England Transcendentalism* (Cambridge, Massachusetts, 1951).

2. Ralph Waldo Emerson, *Nature* in *Essays and Lectures*, ed. Joel Porte (New York, 1983), 10.

3. See Irving Howe, *The American Newness. Culture and Politics in the Age of Emerson* (Cambridge, Massachusetts, 1986), 3–26.

4. Ralph Waldo Emerson, "Historic Notes of Life and Letters in New England," quoted in F. O. Matthiiessen, *American Renaissance, Art and Expression in the Age of Emerson and Whitman* (London and New York, 1941), 6. For Lane and Emersonian Transcendentalism, see Barbara Novak, *American Painting of the Nineteenth Century: Realism, Idealism, and the American Experience* (New York, 1969), 110–112; also John Wilmerding, "The Luminist Movement: Some Reflections," in *American Light: The Luminist Movement, 1850–1875* [exh. cat., National Gallery of Art] (Washington, 1980), 97–99; Earl A. Powell, "Luminism and the American Sublime," in *American Light*, 68–94; Roger B. Stein, *Seascape and the American Imagination* (New York, 1975), 55–62.

5. Lisa Fellows Andrus, *Measure and Design in American Painting 1760–1860* (New York, 1977), 244–260.

6. On Ruskin's "graphic power" and complex understanding of perception, imagination, and truth to nature, see Elizabeth K. Helsinger, *Ruskin and the Art of the Beholder* (Cambridge, Massachusetts, 1982); for Lane and Ruskin, see Wilmerding, "The Luminist Movement", 108–113.

7. "Paintings," in *Authors and Artists of Cape Ann* (album of miscellaneous newspaper clippings), Cape Ann Historical Association, Gloucester; *Boston Evening Transcript*, 28 October 1850.

8. Barbara Novak, "Nature's Art," in *The Thyssen-Bornemisza Collection. Nineteenth-century American painting* (London, 1986), 30.

9. Novak, "Nature's Art," 30. The possible sources for Lane's direct knowledge of Emerson's ideas include the artist's association in Boston in the 1840s with former members of Brook Farm; his friendship with the Rev. William Mountford, a Unitarian minister who, after his move from Gloucester to Boston in the 1840s, became something of a Transcendental hanger-on; and Emerson's lectures at the Gloucester Lyceum, for which see Marshall W. S. Swan, "Emerson and Cape Ann," *Essex Institute Historical Collections* 121 (October 1985), 257–268. Emerson corresponded with the head of the Lyceum, Dr. Herman Davidson, a close friend of the artist.

10. Michael T. Gilmore, *American Romanticism and the Marketplace* (Chicago, 1985), 19.

11. Gilmore, *American Romanticism*, 4.

12. "Spiritual Laws" (1841), reprinted in Porte, ed., *Essays and Lectures*, 317; "The Transcendentalist" (1842), reprinted in Porte, ed., *Essays and Lectures*, 193, 198.

13. "Wealth" (1860), reprinted in Porte, ed., *Essays and Lectures*, 1000.

14. *Nature*, 13. My discussion is strongly indebted to Gilmore.

15. "The Method of Nature" (1841), reprinted in Porte, ed., *Essays and Lectures*, 126.

16. *Nature*, 42.

17. *Nature*, 22, 48, 44.

18. Gilmore, *American Romanticism*, 30.

19. R. A. Yoder, "Transcendental Conservatism and *The House of the Seven Gables*," *The Georgia Review* 27 (spring 1974), 34, and "The Equilibrist Perspective: Toward a Theory of American Romanticism," *Studies in Romanticism* 12 (1973), 705–740.

20. "Experience" (1844), reprinted in Porte, ed., *Essays and Lectures*, 491–492.

21. Yoder, "The Equilibrist," 708; "The Method of Nature," 119.

22. For Gloucester's commercial development, see John J. Babson, *History of the Town of Gloucester, Cape Ann, Including the Town of Rockport* (Gloucester, Massachusetts, 1860); *The Fisheries of Gloucester from the First Catch by the English in 1623, to the Centennial Year, 1876* (Gloucester, Massachusetts, 1876); James R. Pringle, *History of the Town and City of Gloucester, Cape Ann, Massachusetts* (Gloucester, Massachusetts, 1892); Joseph E. Garland, *Down to the Sea: The Fishing Schooners of Gloucester* (Boston, 1983); Paul Johnston Forsythe, *The New England Fisheries* [exh. cat., Peabody Museum of Salem] (Salem, Massachusetts, 1984), vii–xi; "Our Town," *The Gloucester Telegraph* (6 June 1846).

23. *Gloucester Telegraph* (21 September 1859).

24. Babson, *History of the Town of Gloucester*, 569.

25. "Paintings by Fitz H. Lane," *Gloucester Telegraph* (4 August 1849).

26. John Wilmerding, *Fitz Hugh Lane, 1804–1865, American Marine Painter* (Gloucester, Massachusetts, 1967), 17.

27. *Gloucester Telegraph* (6 June 1846).

28. F. A. Durivage, "Cape Ann Sketches," *The Pictorial National Library* 2 (March 1849), 143.

29. Durivage, "Cape Ann Sketches," 143.

30. James F. O'Gorman, "The Pavilion that Sidney Built," *North Shore* (10 January 1976), 3–5.

31. Quoted in William H. Gerdts, "The Sea Is His Home: Clarence Cook Visits Fitz Hugh Lane," *The American Art Journal* 17 (summer 1985), 47.

32. Alfred Mansfield Brooks, *Gloucester Recollected*, ed. Joseph E. Garland (Gloucester, Massachusetts, 1974), 162.

33. Durivage, "Cape Ann Sketches," 143–144.

34. John S. Webber, Jr., *In and around Cape Ann: A hand-book of Gloucester, Mass., and its immediate vicinity* (Gloucester, Massachusetts, 1885), 29–30; for Rogers, see Brooks, *Gloucester Recollected*, 62–74.

35. Durivage, "Cape Ann Sketches," 145.

36. Webber, *In and around Cape Ann*, 56.

37. Marshall W. S. Swan, *Town on Sandy Bay* (Canaan, New Hampshire, 1980), 138–164; Babson, *History of the Town of Gloucester*, 465.

38. Webber, *In and around Cape Ann*, 32–35.

39. For example, Rogers owned at least four of Lane's paintings: see "Sale of Lane's paintings" (12 May 1871), *Authors and Artists of Cape Ann*.

40. Alfred Mansfield Brooks, "The Fitz Hugh Lane House in Gloucester," *Essex Institute Historical Collections* 78 (1942), 281–283. Deeds and liens to the property and house dating from 1849–1859 are in the Essex South District Registry of Deeds, Salem, Massachusetts.

41. Pringle, *History of the Town and City of Gloucester*, 109–110.

42. Fragment of letter in Cape Ann Historical Association.

43. John Dixon Hunt, "Picturesque Mirrors and the Ruins of the Past," *Art History* 4 (September 1981), 256–257. It is significant that both the primacy of sight and concern with a new relationship between the verbal and visual found in Ruskin's *Modern Painters* were substantially derived from his education in the picturesque: see Hunt, "*Ut pictura poesis*, the picturesque, and John Ruskin," *Modern Language Notes* 93 (1978), 794–818.

44. Joseph E. Garland, *Eastern Point* (Peterborough, New Hampshire, 1971), 57–94.

45. Babson, *History of the Town of Gloucester*, 34.

46. John Wingate Thornton, *The Landing of Cape Anne; or, The charter of the first permanent colony of the Massachusetts company* (Boston, 1854). See John Wilmerding, *Fitz Hugh Lane* (New York, 1971), 72–74.

47. Lane to Thornton (11 January 1858), in John Wingate Thornton Papers, New England Historic & Genealogical Society, Boston. The Thornton Papers also contain an undated letter to Thornton from N. D. Cotter, Picture Frame Manufactury & Art Repository, 272 Washington Street [Boston], informing him that "Mr Lane has left with me a Painting of the first landing at Cape Ann, which he would like you to look at."

48. Wilmerding, *Fitz Hugh Lane*, 42.

49. "A Fine Painting," *Gloucester Telegraph* (30 June 1860).

50. For Stevens, see F. A. Sharf, "Fitz Hugh Lane: Visits to the Maine Coast, 1848–1855," *Essex Institute Historical Collections* 98 (April 1962), 111–113.

51. Babson, *History of the Town of Gloucester*, 563–564.

52. Pringle, *History of the Town and City of Gloucester*, 112.

53. Yoder, "Transcendental Conservatism," 33.

54. See Helen Archibald Clarke, *Longfellow's County* (New York, 1909); Nathaniel Hawthorne, *The House of the Seven Gables* (New York, 1982), 2; Howe, *The American Newness*, 4.

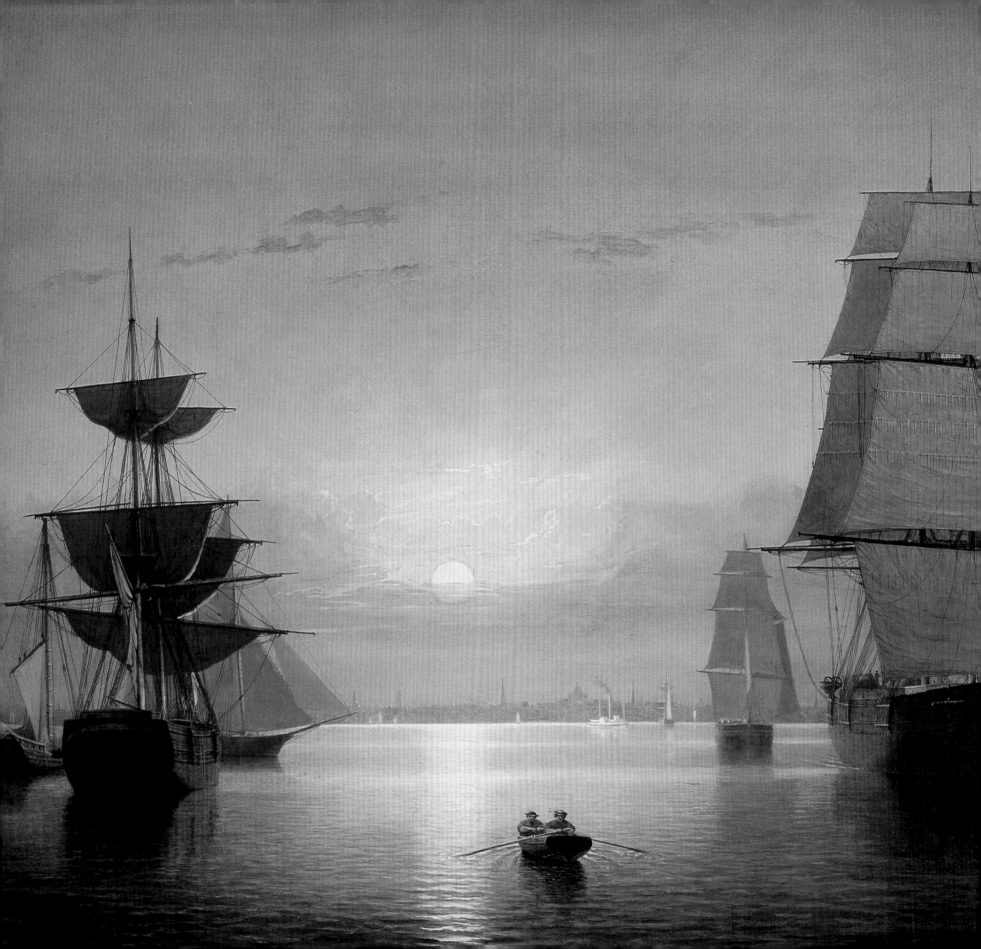

The Boston Harbor Pictures

EARL A. POWELL, III

FITZ HUGH LANE'S MOVE IN 1850 TO A NEWLY CONSTRUCTED stone house in his native Gloucester, Massachusetts, signified both a personal and artistic consolidation for him. His new economic and professional security allowed his art of the following decade to reflect a sense of confidence and maturity, culminating in works of major significance in which the aesthetics of luminism were refined to their highest level.

Several of these masterpieces, devoted to sunset views of Boston Harbor and nearby Gloucester, are remarkable for their elevated formal aesthetics and sheer beauty. With these paintings luminism achieved a place in the American naturalist tradition that was characterized by an intimate and measured experience of nature, in contrast to the romantic nationalism of the Hudson River School.

In the 1840s, particularly after he visited Maine, Lane had applied his sensitivity to conditions of light and his union of luminous hues with brilliant colors to new subject matter. His paintings of the 1850s articulate a stylistic and conceptual sophistication that crisply delineates the elements of luminism and explores the full potential of silence and light. These paintings are poetic in a transcendental sense, as well as contemplative; they are not influenced by the literary romanticism that inspired Thomas Cole and an earlier generation of American landscape painters. The imperatives of classic luminism are distilled, revealing a sense for ordered, mathematically conceived composition encapsulated in an atmosphere of tinted, crystalline light. The penumbral colors of the luminist palette were made more visually emphatic by the cadmium hues introduced in the 1840s, and Lane exercised precise and masterful control in the structured symphonies of light that irradiated his paintings of this period.

The work Lane produced during the 1850s reveals an accomplished master who had assimilated the influences of his predecessor Robert Salmon. Lane had also studied European engravings and incorporated their styles into his own pictorial methodology. He melded the tightly controlled style of Canaletto with the Dutch marine tradition as represented in the work of Jan van Goyen (1596–1656) and Willem van de Velde (1611–1693). But the influence of Salmon and the European masters was mitigated by the development of a personal style and vision.

The pictures depict Boston Harbor in the historic decade before the Civil War, when the maritime supremacy of Massachusetts was at its height. Indeed, as Samuel Eliot Morison has noted, "Throughout the clipper-ship era, nearly all the traditional lines of maritime commerce continued to expand and new ones were created . . . the commercial prosperity of Boston, in 1857, reached its high-water mark for the ante-bellum period."[1] The Boston paintings thus consolidate the aesthetics of luminism with the high moment that celebrates the ascendency of the New England maritime tradition, the final chapter of the age of sail, in an exquisite and provocative confluence of history and style. These evocative images, so eloquent in their prophetic silence, depict a moment in time as if frozen, and evoke a mood of transcendental silence that is an important reflection of the attitude of the American imagination at mid-century.

The Boston paintings do not necessarily represent a singular chapter in Lane's work; as is discussed elsewhere in this book,

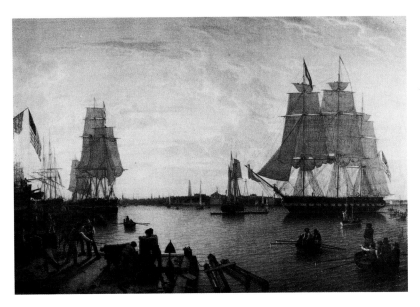

fig. 1. Robert Salmon, *Boston Harbor from Constitution Wharf*, c. 1842, oil on canvas, 26¼ x 41 in. [United States Naval Academy Museum, Annapolis, Maryland]

the experience of Maine and its remarkable, evanescent light was central to Lane's mature stylistic evolution. The two paintings that best represent Lane's consolidation of the aesthetics of luminism both depict *Boston Harbor at Sunset*, 1850–1855 (cats. 24 and 25). The two paintings are complementary examples of luminism at its poetic and formal height and underscore Lane's emergence as a master of color and light. The paintings of Boston Harbor are far more than mere views, although they have roots in Lane's early experience as a lithographer. They are also indebted specifically to the work of Robert Salmon, as John Wilmerding has remarked.[2] Lane obviously knew and closely studied Salmon's painting *Boston Harbor from Constitution Wharf* (fig. 1), c. 1842, also published as a lithograph.

Salmon's view, however, is taken from the wharf and is filled with anecdotal vignettes that show the preparation of a saluting cannon to signal sunset, and color and light are much more incidental to the subject than in Lane's Boston pictures. Lane emptied the foreground of distractions and placed the ships in geometrically conceived relationships that reinforce a static, reverential quiet. Color, light, and silence are the subject of Lane's pictures. His indebtedness to Salmon was also formally

acknowledged in the *Yacht "Northern Light" in Boston Harbor*, 1845 (cat. 26), on the reverse of which Lane noted, "From a sketch by Robert Salmon."[3] The bustle and activity of this yachting painting, however, are also remote from Lane's cool and structured later compositions. Lane's Boston pictures are more poetically conceived and spatially complex than Salmon's straightforward views.

Neither painting of Boston Harbor is dated, but the delicacy and refinement of the surfaces and their tranquility share much with Lane's work in the middle part of the decade and relate closely to the other important works as, for instance *Salem Harbor*, 1853 (cat. 27). In this harbor scene several sailing vessels are disposed along converging orthogonal lines that form a geometric matrix. The sails hang limp, reflected in a glasslike calm in which all action is frozen. The same stylistic manifestations are apparent in Lane's very beautiful *Entrance of Somes Sound from Southwest Harbor*, 1852 (cat. 57) one of his greatest formal essays on quiet and light.

An interesting comparison can also be made between a painting entitled *Ships in Ice off Ten Pound Island*, 1850s (cat. 3) and his classically luminist scenes of Boston Harbor. The ships in this Gloucester scene are quite literally trapped in planes of harbor ice that reflect the clear white light from the winter sky. The juxtaposition of the frozen winter scene, reminiscent of Dutch paintings, with the spring or summer harbor pictures emphasizes Lane's interest in literally freezing time. The almost-undisturbed, mirrorlike surfaces of Boston Harbor in the Karolik and Ganz paintings, which articulate a canon of luminism's formal doctrine of color, light, and silence, confirm this recurring theme in his art.

Lane had begun to paint sunsets in Maine during the previous decade and his Boston Harbor pictures reveal his continuing interest in this theme. Each of Lane's paintings in this group open out to the west with Bulfinch's state capitol in the center of the composition. The sunset in American mid-century painting was a theme interpreted often by the major landscape artists beginning with Thomas Cole and including Lane's contemporaries Martin Johnson Heade, John Frederick Kensett, Sanford Robinson Gifford, and culminating in perhaps the most spectacularly incandescent work of the period, Frederic Church's *Twilight in the Wilderness*, 1860 (fig. 2). This interest in the sunset transcends an empirical concern for pyrotechnical

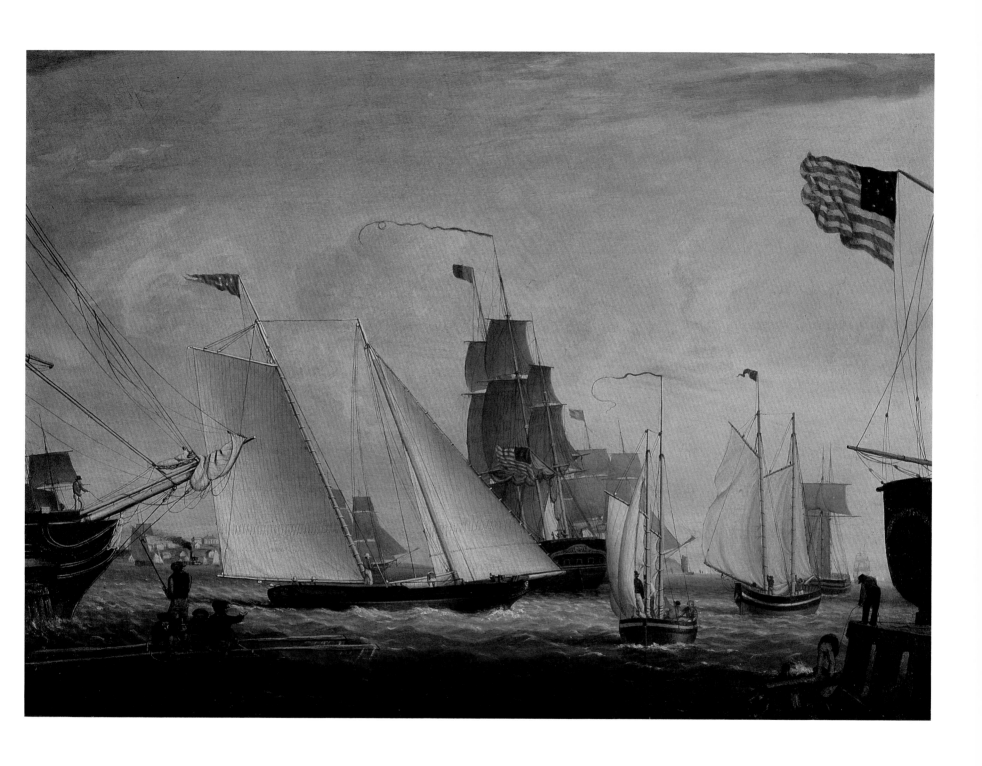

cat. 26. *Yacht "Northern Light" in Boston Harbor*, 1845, oil on canvas,
18³/4 x 26¹/2 in. [The Shelburne Museum, Shelburne, Vermont]

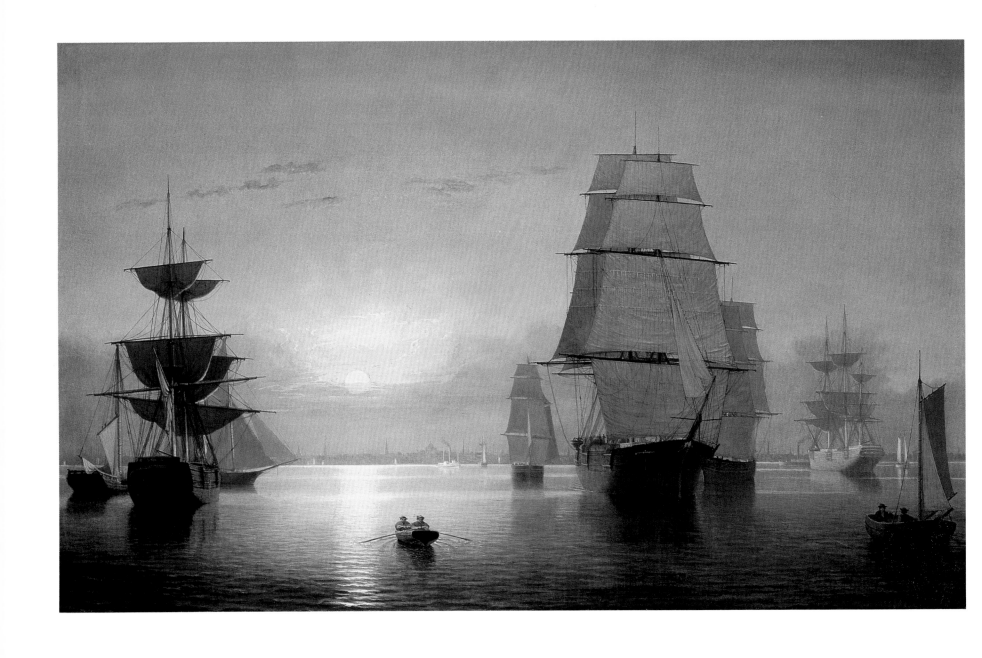

cat. 25. *Boston Harbor at Sunset*, 1850–1855, oil on canvas, 24 x 39¹/₄ in.
[Collection of Jo Ann and Julian Ganz, Jr.]

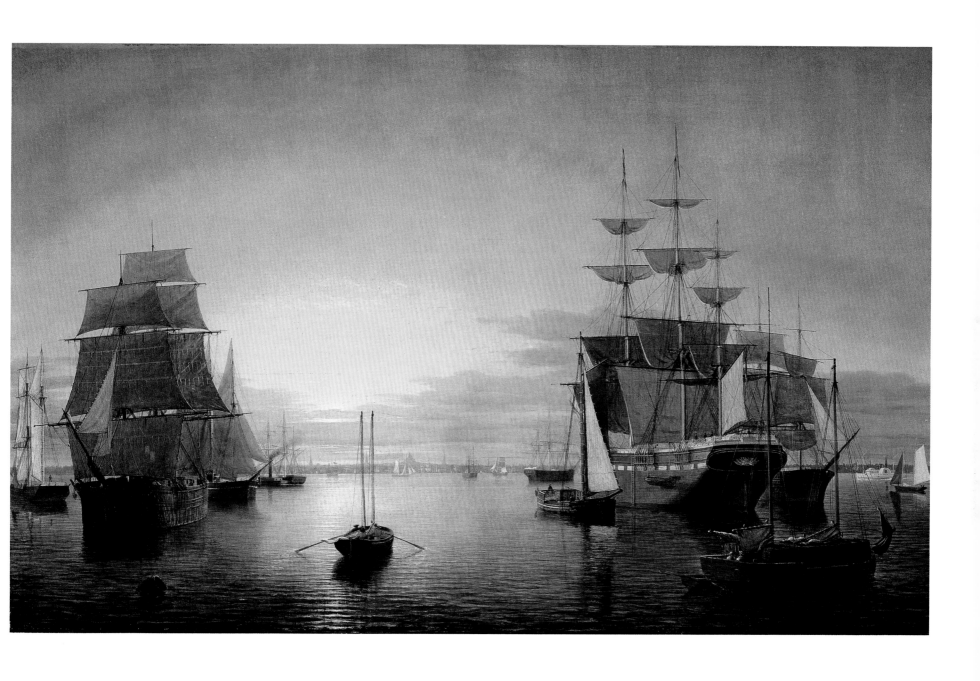

cat. 24. *Boston Harbor at Sunset,* 1850–1855, oil on canvas, 26¼ x 42 in.
[Museum of Fine Arts, Boston, M. and M. Karolik Collection by exchange]

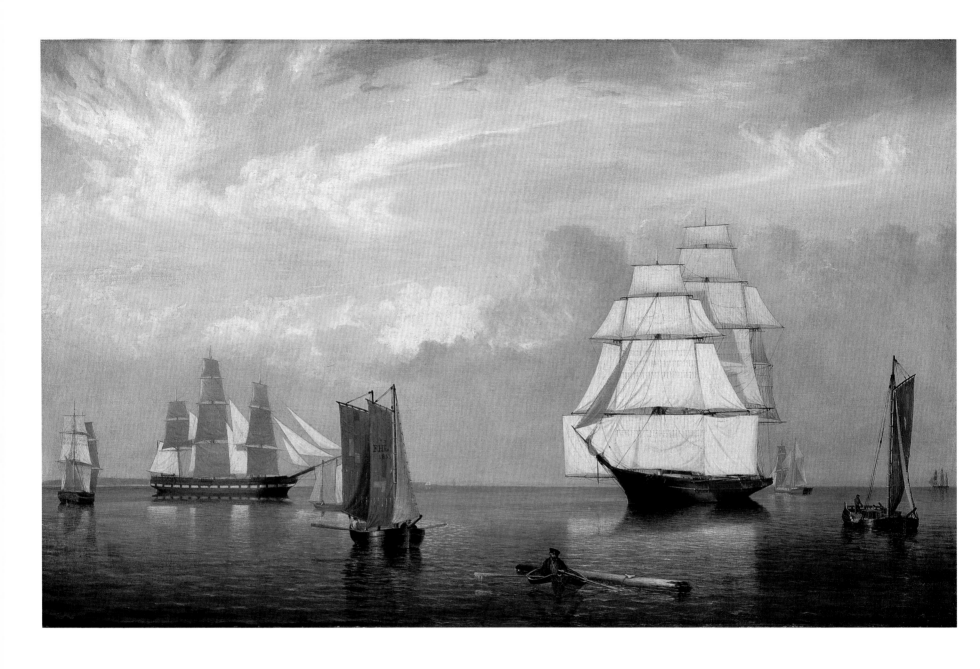

cat. 27. *Salem Harbor*, 1853, oil on canvas, 26 x 42 in. [Museum of Fine Arts, Boston, M. and M. Karolik Collection]

fig. 2. Frederic Edwin Church, *Twilight in the Wilderness*, 1860, oil on canvas, 40 x 64 in. [Cleveland Museum of Art, Mr. & Mrs. William H. Marlatt Fund]

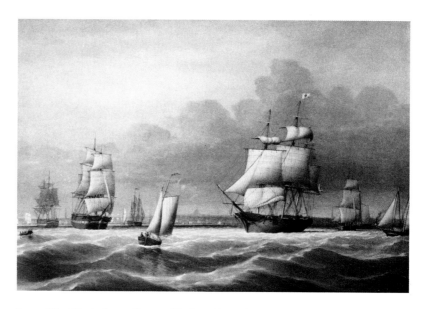

fig. 3. Fitz Hugh Lane, *Boston Harbor*, 1852, oil on canvas, 23¼ x 34¾ in. [The State Department]

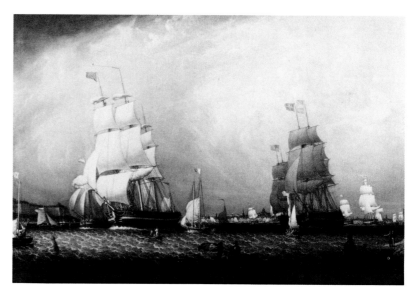

fig. 4. Robert Salmon, *Boston Harbor from Castle Island*, 1839, oil on canvas 40 x 60 in. [Virginia Museum of Fine Arts, Richmond]

effects of light in nature and elevates these pictures to a profound level of interpretation consistent with the nineteenth-century understanding that fused God with nature. These paintings are poems of light, but together they represent a commentary on the tentative and ephemeral condition of a changing civilization.

Lane's paintings are not static formulas, but employ varieties of expression, which have sources in the European traditions that he subsumed in his art. His 1852 painting of *Boston Harbor* (fig. 3) is clearly indebted to Van de Velde and the Dutch marine tradition. The dark storm clouds in the distance and the alternating dark and light chiaroscuro effects in the turbulent water, with ships under full sail, effect a high drama similar to that in Robert Salmon's paintings. Salmon also painted a work that Lane may have known, entitled *Boston Harbor from Castle Island*, 1839 (fig. 4). The light in the 1852 picture comes from the far left, creating elongated bands of shadow across the picture plane, a pictorial device often used effectively in Robert Salmon's pictures. Of all Lane's Boston pictures this is the least luminist in its formal attributes. It can be compared to the 1853 painting *Boston Harbor at Sunset* (cat. 28). In this scene Lane interrupted the direct view of the sunset by placing the ship on the right, with the result that a shadow is cast toward the front

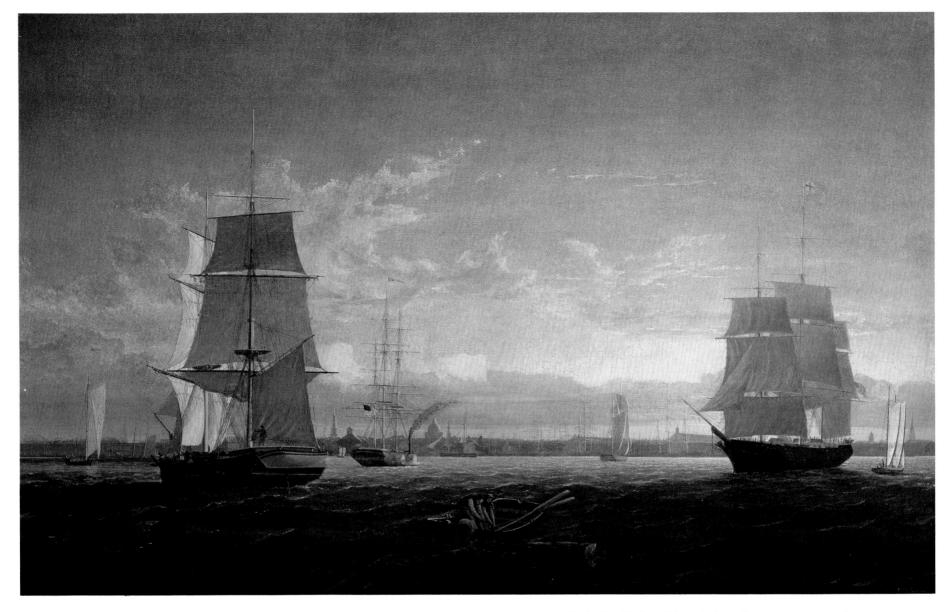

cat. 28. *Boston Harbor at Sunset*, 1853, oil on canvas, 24 x 39 in.
[private collection]

of the picture plane. In contrast to the 1852 picture, the subject of the painting is light itself: the pink and orange tinted reflections on the underside of the cloud formations. The surface of the water, broken by a strong breeze, somewhat mitigates the saturated, reflected colors of the sunset, however. The contrast

between the 1853 *Boston Harbor at Sunset* picture and the 1852 painting is provocative, and points out how diverse Lane's approach to a subject could be.

Two other studies of Boston Harbor, one dating from 1854 (cat. 29), the other from 1856 (fig. 5), make an interesting com-

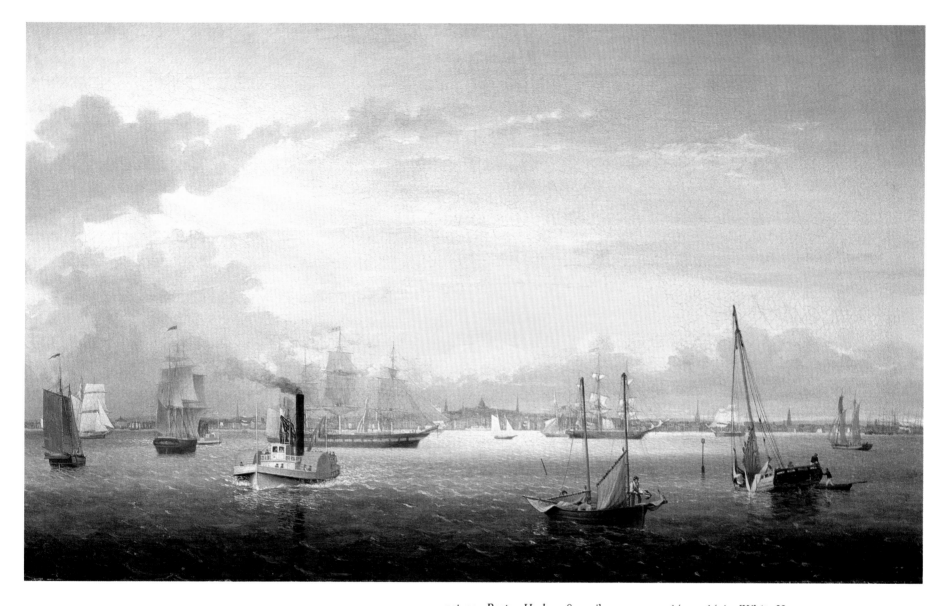

cat. 29. *Boston Harbor*, 1854, oil on canvas, 23 1/4 x 39 1/4 in. [White House Collection]

parison. In each the focus is on a small steamship moving toward the front central part of the composition. The organization of the vessels in the 1854 picture seems to refer back to Lane's earlier, Salmon-inspired views of Gloucester. The scale of the vessels is not emphasized, and they are primarily horizontally disposed, while the 1856 painting has more in common with the darker tonalities of the earlier painting.

The emphatic introduction of the steamship into the calm waters of a harbor filled with sailing vessels creates a paradox. American landscape artists of the nineteenth century, begin-

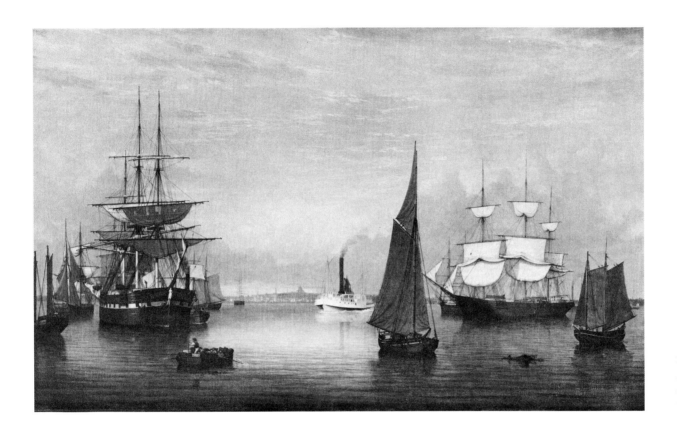

fig. 5. Fitz Hugh Lane, *Boston Harbor*, 1859, oil on canvas, 40 x 60 in. [Amon Carter Museum, Fort Worth, Texas]

ning with Thomas Cole, expressed an escalating frustration at the rapid advance of urbanization to the detriment of the pastoral ideal represented in the American landscape. Cole, Thoreau, Nathaniel Hawthorne, and a host of artists and writers saw the encroachment of civilization as tantamount to a loss of American virtue and morality, as nature gave way before a rapidly expanding western frontier. The railroad, whose piercing whistle jarred the contemplative atmosphere of nature, symbolized this new industrialized age. In the context of Lane's painting the presence of the steamship has much the same effect of a railroad engine shrieking in the landscape.[4]

The steamships in the two paintings of Boston Harbor are metaphors for the same attitude. Surrounded by sailing vessels, either becalmed or awaiting the tide, this new symbol of the industrial revolution, white against the darker hulls of the sailing ships, moves outward toward the viewer. The two paintings herald a transitional moment in America's history—the coming of the age of steam. In the two paintings of *Boston Harbor at Sunset* from 1850–1855 (cats. 24 and 25), though, the steamship is rel-

egated to an insignificant spot in the background.

These pictures hold a central position in the group of Boston Harbor paintings. They are remarkable explorations of the measured, contemplative, and poetically colored qualities that characterize luminism. The two works can be imagined as companion paintings with their complementary palettes: pink and orange in the one, and blue and yellow in the other. Likewise, the sun sets in the same position on the horizon and in each the ships are disposed in similar precisely geometrical configurations. Unlike Lane's earlier horizontally banded compositions, these two paintings have a spatial organization that moves along perspective orthogonals formed by the position of the ships, which move toward the center of the composition. The bottom of the picture is left open to extend toward and encompass the viewer's space. Nevertheless the paintings differ in size; cat. 25 is slightly smaller, and however similar they are in mood and spirit, it is unlikely that they were meant to hang together.

These pictures represent the sense of assured mastery that

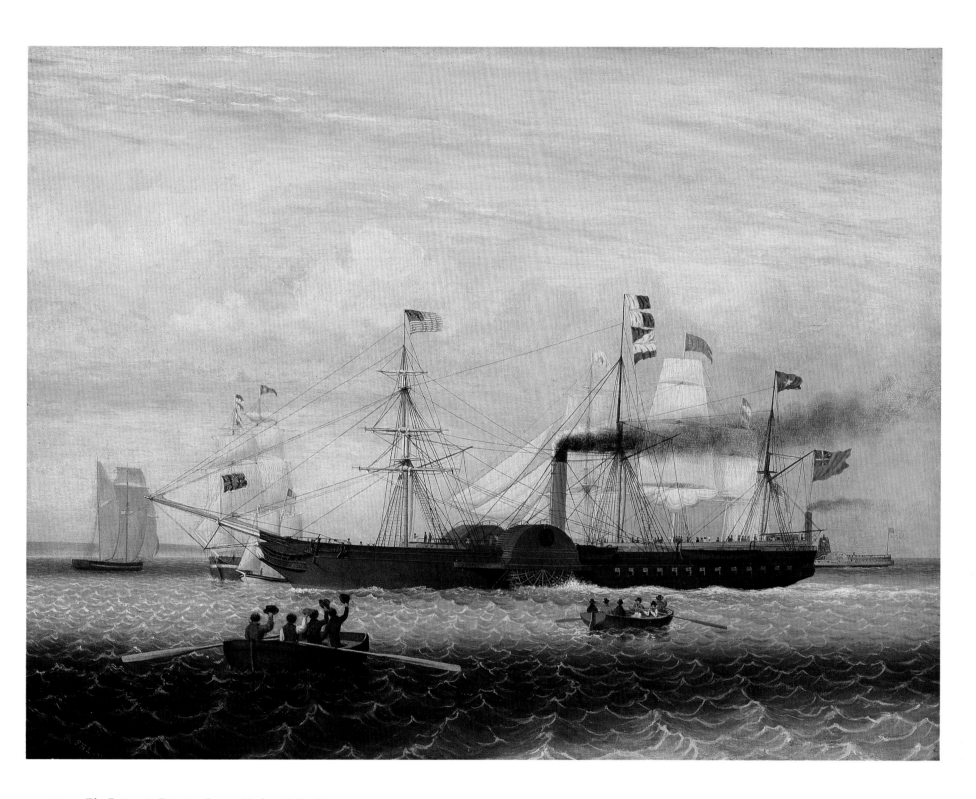

cat. 30. *The Britannia Entering Boston Harbor,* 1848, oil on canvas,
14³/₄ x 19³/₄ in. [Mr. and Mrs. Roger A. Saunders]

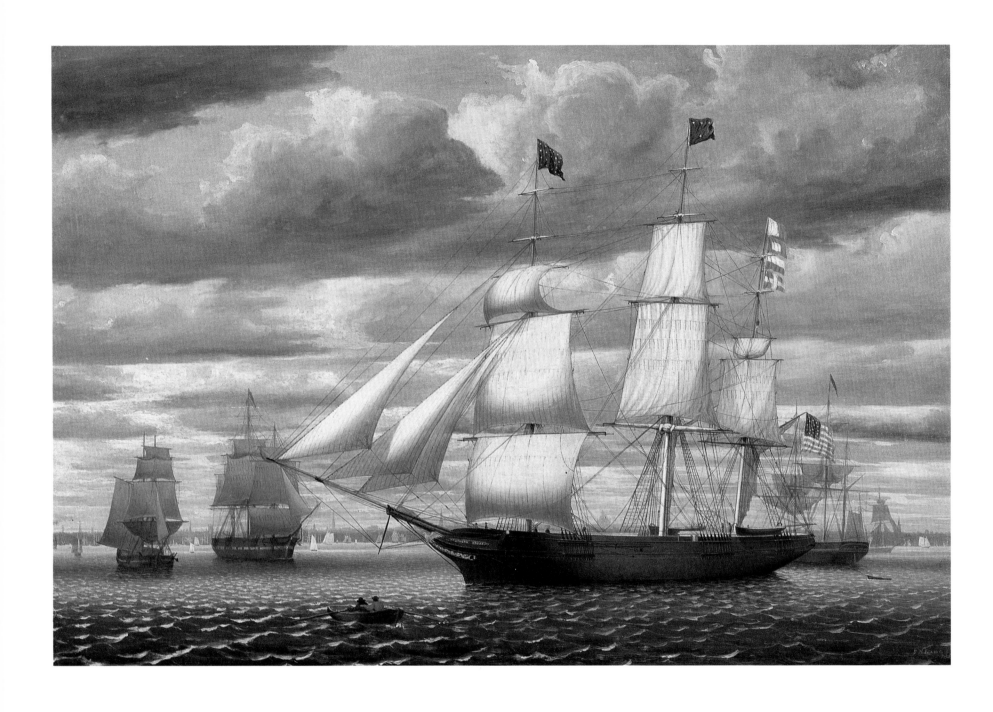

cat. 31. *Clipper Ship "Southern Cross" Leaving Boston Harbor*, 1851, oil on canvas, 25¼ x 38 in. [Peabody Museum of Salem]

Lane achieved in the decade of the 1850s, and he rarely surpassed the exquisite sense of touch and articulation of light and color. The light in both pictures halates almost imperceptibly in extended gradations from the setting sun, creating a penumbral effect as it is dispersed toward the darker, upper atmosphere. The harbor appears transfixed. It is a fascinating, pivotal moment as the ships wait for the tide to change and the wind to fill their sails and move them on to distant points. Lane has depicted a moment when the mind and spirit are at one with nature and the universe. The moment is emphasized through the utter stillness and quiet in these sensitively rendered poems of light. The metaphor of silence, so often applied to luminist paintings, is certainly central in the two works, which are so different in their style and symbolism from the more literary visual rhetoric of an earlier generation of artists. In their quiet and timelessness, they are clearly representative of the mood of mid-nineteenth century American painting. They summarize the conclusion of an era characterized by Jacksonian optimism and expansion, and look forward tentatively to a new decade in which the nation would be shattered by the Civil War. This fact endows these paintings with a unique poignancy, and compels the viewer even today to speculate on the fascinating dichotomy represented in the luminist pictures of Fitz Hugh Lane.

1. Samuel Eliot Morison, *The Maritime History of Massachusetts 1783–1860* (Boston, 1961), 366.
2. John Wilmerding, *Fitz Hugh Lane* (New York, 1971), 34–35.
3. Wilmerding, *Lane*, 34.
4. See Leo Marx, *The Machine in the Garden* (New York, 1964) for a complete discussion of this subject.

Imagery and Types of Vessels

ERIK A. R. RONNBERG, JR.

THE YEARS 1840 TO 1860 CAN BE DESCRIBED AS A PERIOD OF contrast in American shipbuilding and shipping activity. Rapid advances in naval architecture took place side-by-side with conservative, often static, shipbuilding and boatbuilding traditions. This contrast was in turn reflected by shipping activity along the New England coast, where clipper ships and steamships plied sea lanes between Boston and distant ports while processions of trading schooners, fishing schooners, and a multitude of small craft hugged the coastline. The swiftest and most refined examples of marine technology glided past traditional watercraft types that looked and worked very much the same throughout the nineteenth century. Progressive and conservative ship designs have always existed together, but the Industrial Revolution accelerated divergences of design and construction methods to an unprecedented degree. In the two decades preceding the American Civil War, this phenomenon was to become manifest in the ports and shipyards of New England.

With photography in its infancy, the camera record of New England shipping from 1840 to 1860 could only be fragmentary, leaving the making of a broader pictorial record to painters and printmakers. Among them were artists in many foreign ports who depicted individual vessels with great accuracy, but rarely with knowledge or inclination to place them in a New England setting. The representation of a New England vessel in its milieu required knowledge of the vessel, particularly its hull form and rigging; knowledge of the setting, such as a seaport or coastal environs; and knowledge of crew activities and how the vessel was worked. A few competent local painters, such as William Bradford, augmented by a handful of immigrant colleagues, like J. E. Buttersworth, possessed this knowledge and produced some admirable ship portraits. It was left to a native of Gloucester, Massachusetts, a landsman whose physical handicaps limited severely his seagoing experiences, to depict the vessels he saw with accuracy while placing them in port scenes and seascapes of great artistic achievement. If the aesthetic qualities of Fitz Hugh Lane's work overshadow the technical accuracy of the ships he depicted, then it is time to assess an overlooked aspect of his painting and to gain a better understanding of what is probably the most strenuous and time-consuming part of a marine artist's work.

The great progress in shipbuilding and ship design that established American primacy in western shipbuilding from 1830 to 1857 was due to two basic needs: greater carrying capacity and greater speed. As the rapidly developing nations rimming the North Atlantic Basin intensified their seaborne commerce, they needed larger ships to carry material in greater volume and faster ships to maintain regular communication among major seaports. The construction of this fleet was left initially to a small number of master shipwrights whose competence and imagination allowed them to gauge the form, proportions, and dimensions of materials to build hulls of untried size and form. Experience soon proved, and improved, their rudimentary calculations and guesswork, and in turn became the datum for even more ambitious designs.[1]

The technical knowledge needed by the American shipyards was initially provided by shipwrights and constructors employed by the United States Navy, which, in the experience of the War of 1812, had embarked on an ambitious fleet construc-

tion program, planning and building warships that surprised and alarmed even the largest European navies. It is likely that if naval constructors such as Samuel Humphreys, John Lenthall, and Samuel M. Pook had not engaged in design work for private yards, progress in American merchant shipbuilding would have been very different, certainly slower. A number of their apprentices left naval service to found some of the leading private yards of the antebellum period.[2] Isaac Webb, perhaps the most distinguished of these, in turn trained three apprentices—William H. Webb (his son), John W. Griffiths, and Donald McKay—who were to become the most influential ship designers of their day.

The growth of the United States Navy in this period and its influence on yards owned by former naval shipwrights marked the birth of naval architecture as a legitimate science in America. Intuitive and traditional design methods were supplemented, but not altogether displaced, by increasingly sophisticated methods of calculating hull displacement, stability, loading capacity, and other qualities that permitted a ship's performance to be predicted prior to construction. Drafting techniques were refined, allowing accurate hull plans to be drawn without relying on half-models to judge hull form; however, American shipwrights still lagged behind their European counterparts in the development of this practice.[3]

The introduction of steam propulsion and vessels with specialized mechanical features (particularly for use in harbors) forced on American shipwrights the sister science of marine engineering. In the transatlantic trade, their efforts were superseded by English steamships, but in the coastwise passenger trade and in major ports, a variety of steam-powered craft found useful niches for themselves.[4] Even sailing ships could not escape the marine engineer's services, for as hulls grew in size, their wooden frames and planking became increasingly subject to stresses requiring metal strapping and careful distribution of timber mass. Larger ships required mechanical aids to enable smaller crews to perform heavier tasks, giving rise to many "patent" rigs and sail-handling devices. Anchors, windlasses, pumps, and steering mechanisms were under constant improvement.[5]

The dissemination of naval architecture and marine engineering in antebellum America relied solely on the master-apprentice system until the 1840s. In 1839, Lauchlan McKay, a brother of Donald McKay, published *The Practical Shipbuilder*, the first American textbook to describe shipbuilding methods from the initial design processes to launching and rigging.[6] In 1849, a much more scientific work was published, *Treatise on Naval Architecture* by John W. Griffiths, whose goal went far beyond answering the needs of the day. Well-read in the works of English designers, Griffiths did not hesitate to criticize their theories and reply with theories of his own. He frequently attacked maritime laws and tonnage regulations, which he felt were stifling the development of better ships, and derided the naval establishment's reluctance to adopt more progressive warship designs and improved machinery.[7] A prolific writer and lecturer, Griffiths was probably the most influential American figure in his field, and the only one in his country to publish regularly and criticize publicly the latest trends in shipbuilding.

The 1850s saw the appearance of a handful of American publications on marine drafting and mold loft work. Perhaps the most interesting is *The Shipwright's Handbook and Draughtsman's Guide* by Leonard H. Boole, which showed for the first time in an American source the progressive construction of a vessel's lines plan to modern standards of completeness and accuracy. Some very interesting commentaries aside, this book, like McKay's, was meant chiefly as a remedial guide for shipwrights with no formal training in their field.[8] Progress in shipbuilding, for Americans at least, was thus one of individual endeavor with rare opportunities for formal instruction. Such a situation was bound to leave the country in a precarious way, as indeed happened following the collapse of American foreign shipping during the years 1857 to 1865. During this period, European shipyards took the initiative with the building of more efficient steamships and the replacement of wooden hulls with iron and steel. For decades, American yards lacked the technology and economic support to reply. Only in the late nineteenth century was their production capacity restored. This event was closely tied to the founding of the earliest American schools of naval architecture.

For every clipper, fast packet, and steamer built in New England, there were probably built dozens of hulls whose form and behavior showed no progress at all in ship design since 1800 or earlier. It can be argued that in some types of marine commerce, improvements could not be justified for sound economic reasons; however, in many instances the shipwrights used archaic design methods and held conservative attitudes

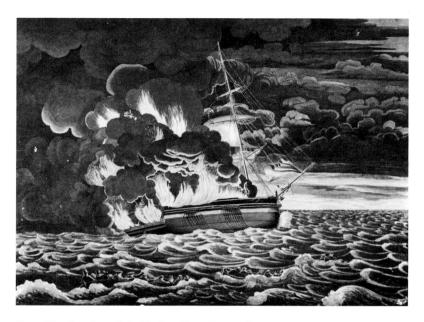

fig. 1. *The Burning of the Packet Ship "Boston,"* 1830, watercolor, 19¼ x 27 in., after a sketch by E. D. Knight [Cape Ann Historical Association]

fig. 2. Lane, *Study of Sailing Vessels,* 1851, pencil, 6½ x 9 in. The rigs, left to right: fore-and-aft schooner, hermaphrodite brig, sloop, and schooner; the last called a pinky, for its double-ended hull form with a "pinked" stern [Cape Ann Historical Association]

that prevented them from making significant changes. The shipwright uneducated in his trade in the 1830s was the result of a hand-me-down tradition wherein ownership and operation of a yard passed from father to son or from master to apprentice, together with a collection of framing molds, basic rules of proportions, and crude tables of timbering dimensions. Much of this knowledge was not even on paper, but passed along verbally; its sources often dated back to the colonial period. This system worked so long as changes were gradual and work methods were consistent. In a period when ships were not highly specialized, a standard hull form for a given tonnage could suit many customers with but a few modifications to suit individual tastes.[9]

During the 1830s empirical design methods were replaced by use of the builder's half-model, which was made by carving one side of a vessel's hull to a convenient scale. The finished hull was disassembled and its parts were traced and measured to obtain a table of dimensions for making the frames. Said to have been introduced by Isaac Webb (there are conflicting claims of origin), the half-model gave the shipwright the opportunity to visualize hull form as none of the old methods could allow.

Such a tool enabled better judgment of form, opportunities to modify the design, and, most important, an inexpensive way to create altogether new hull shapes.[10] In the hands of a Webb or McKay, the opportunities were unlimited; in less ambitious hands, new mediocrities were fashioned whose marginal improvements did not seriously help or hinder their sailing qualities.

Between the extremes of progressive and static designers was a large group of shipwrights who responded to the needs for larger, faster, or more specialized craft, and who produced successions of handsome, able ships and boats whose looks and performance set the standards for their classes. Such vessels included fishing and pilot schooners, schooner- and sloop-rigged packets, and many smaller ships, barks, and brigs built to ply the lesser trade routes. Specialized craft filled out the broad spectrum of vessel types that dotted the New England coastline and sailed onto Fitz Hugh Lane's canvases. Lane's sensitivity to the full breadth of this spectrum is perhaps the most remarkable aspect of his choice of nautical subjects, for his attention to the details in a humble lumber drogher is as keen as for that in a clipper ship or steamer. As these vessels are enumerated and de-

scribed in greater detail, we must consider them not just from the qualitative aspects of their accuracy and realistic placement, but also from the quantitative question of relative numbers of different vessel types. It is probably not possible to establish numerical answers of any weight, but an impression might be gained that Lane did not especially favor certain types of vessels for subjects; that the groups of watercraft in his canvases, while artfully arranged, are in fact unselected assortments of ships and boats actually observed.

Lane's drafting technique and sensitive eye for detail and proportion were undisputedly as good as those of the best specialists in ship portraiture of the day, and in some respects, even superior. Freehand drawing apparently came naturally to Lane, for he was able to proceed from a faint outline sketch to intricate detail in pencil with bold strokes and very few mistakes or erasures. Most of his drawing and painting techniques appear to be freehand, with little if any use of drafting tools like straightedges, curves, and compasses. This conclusion is often difficult to accept without minute scrutiny of the works in question, yet it is exactly this skill that creates an illusion of precision and delicacy, which the ruthless uniformity of mechanical drafting techniques would destroy.

If Lane's drafting abilities were innate, they were rigorously disciplined by his work in lithography, a medium that requires freehand drawing skill and does not tolerate carelessness. Not only did it offer Lane discipline, but it undoubtedly honed his awareness of values and his ability to juxtapose light, delicate tones against darker areas to create contrasts of desired power or subtlety. Lane's progress in this respect is evident in a comparison of his earliest known watercolor, *The Burning of the Packet Ship "Boston,"* 1830, with his pencil drawing, *Study of Sailing Vessels* (figs. 1,2). Both views reveal a sure knowledge of the subject matter and ability to render it accurately, but the watercolor has none of the subtleties of tone that the drawing possesses. The latter indeed seems to have a lithographic quality in the delicacy and balance of its light and dark areas. When this drawing is compared to Lane's lithograph, *View of Gloucester Harbor,* 1836 (see p. 10), the artist's debt to his work on stone is obvious.

No erasures are detectable in *Study of Sailing Vessels;* given the difficulty of making clean erasures on so small a drawing, one may conclude that Lane was in the habit of rendering his

fig. 3. Lane, *Brig "Cadet" in Gloucester Harbor*, late 1840s, oil on canvas, 15¼ x 23½ in. [Cape Ann Historical Association]

subjects correctly the first time, with very few or no mistakes. The assuredness, and probable rapidity, of his drawing technique is dramatically evident in one of his simplest sketches, *Square Topsail* (see p. 7), c. 1850. The subject could be either the whole topmast of a large topsail schooner or a vignette of a large square-rigger's topsail. Topsails in this state, "hanging in the gear," appear in many of Lane's paintings. The yard is lowered and hanging by its lifts and the sail has been clewed up (gathered up by the lower corners to the center of the yard on the aft side); the buntlines have been mostly hauled up, pulling portions of the sail up to the yard at its mid-point; reef tackles and flemish horses (foot ropes) are rigged at the yard arms. Lane must have made this sketch very quickly, yet its correctness of detail and the impression it gives of heavy canvas hanging slack are ample proof of the artist's knowledge, keen observation, and ability to capture what he saw in a few bold strokes.

Lane's ship portraits are relatively few in number, and his preference to paint in oils gives these canvases a very different quality from the watercolors preferred by most European painters. A good example from the 1840s is *Brig "Cadet" in Gloucester Harbor* (fig. 3), which offers a broadside view of a small merchant brig outward bound on a probable voyage to Surinam. She is hove-to with her fore sails aback, waiting to pick up a pilot from what is likely a pilot schooner approaching her. In the background, bits of Gloucester harbor scenery have a decidedly

fig. 4. Ange-Joseph Antoine Roux, *Corporal Trim of Gloucester, F. H. Davis, Master*, 1825, ink and watercolor, 17¼ x 23½ in. [Cape Ann Historical Association]

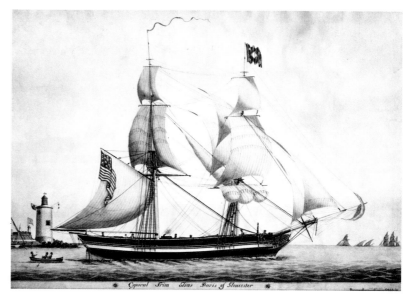

fig. 5. Antonio Lenga, *Corporal Trim, Elias Davis of Gloucester*, 1816, ink and watercolor, 18½ x 26½ in. [Cape Ann Historical Association]

fig. 6. François Joseph Frédéric Roux, *Unidentified Brig*, c. 1847, watercolor and pencil, 16¼ x 22¾ in. See note 11 [Peabody Museum of Salem]

different look from the busy European ports; otherwise, the treatment of subject is very similar to what we find in the European ship portraits.

Two European paintings of a very similar Gloucester-owned merchant brig are available for comparison (figs. 4,5). Both are watercolors representing the brig *Corporal Trim*, one painted by Antoine Roux (the younger) at Marseilles, 1823; the other, by Antonio Lenga at Malaga, Spain, 1816. The watercolor by Roux is very typical of the artist in terms of composition and treatment of detail: the vessel is in profile view under most plain sail with a polacca and a chebec in the background against the Marseilles skyline. The work by Lenga is closer to Lane's treatment with the brig hove-to, awaiting a pilot, with the entrance to Malaga in the background. Antonio Lenga has escaped mention in American works on marine artists, though works by Malaga painters with the last name of Lengo or Lengi—and other first names—have been discovered. His style bears a marked resemblance to that of Roux, although it is somewhat cruder.

Roux and Lenga undoubtedly followed similar sequences in making a ship portrait. First, the vessel and all background detail were drawn in pencil on a sheet of watercolor paper with great care, using drafting tools to rule in the sheer and planking, the spars, outlines of the sails, and the rigging. The sky and cloud formations were then applied in thin washes, followed by the sea and shoreline in heavier washes. The light ecru tones of the sails were painted in, together with shading, to show sail

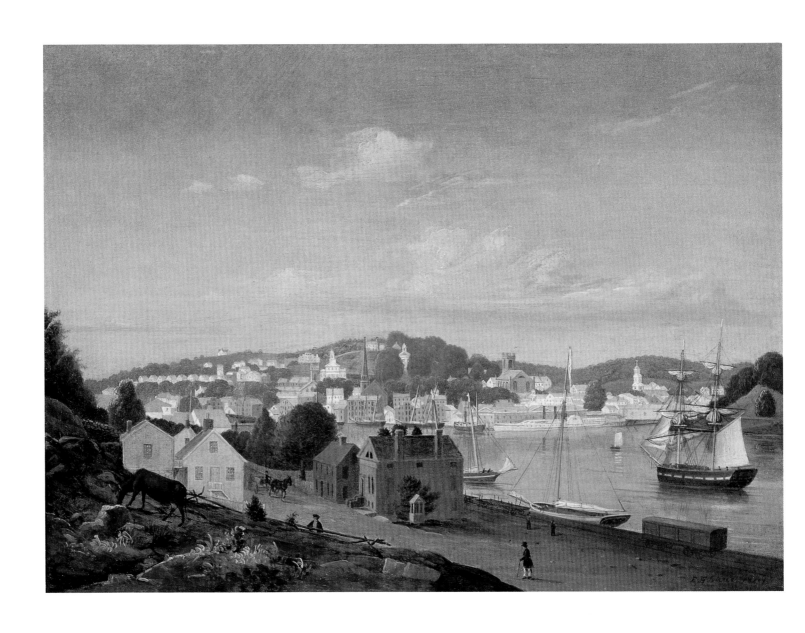

cat. 43. *View of Norwich, Connecticut*, 1847, oil on canvas, 12 x 16 1/2 in.
[Mr. and Mrs. Thomas M. Evans]

contours and some shadow detail; colors and shading of the spars and flags were probably added after that. The overall colors of the hull and visible deck details were the last masses of color applied. Having done all this, the rigging and hull details could be ruled in.[11]

Close examination of Roux's and Lenga's treatment of rigging, sail and spar outlines, and hull planking indicates extensive use of straightedges and drafting curves as ruling guides. Some of the spars and any rigging under great tension (shrouds and backstays) are straight lines; all others are curved, reflecting the filling of the sails, the sag of the rigging from its own weight, and the gentle sweeps of the rails and plank seams as they follow the sheer. The artists may have employed a set of shipwright's ship curves, each curve with a slightly different shape. Alternatives were flexible battens, which were bent to the desired shape and held in place by weights, or a flexible batten was mounted at its ends to a rigid wooden stave and its shape was altered by a series of thumb screws. These drafting aids were in widespread use in European shipyards, hence were readily available to any marine artist who chose not to make his own. The Roux family, being sellers of hydrographic charts and marine drafting instruments, were in a particularly advantageous situation for obtaining these tools.

Having selected a curve or shaped a batten to the desired form, the artist could rule in the rigging and plank seams with a ruling pen and ink or thinned watercolor. Hull seams and decorative carvings were frequently highlighted with white ink, and very small lines and details were added freehand, using a very fine brush or quill pen. All of this work is necessarily exacting and the net result, in terms of time spent in its execution, is actually more the product of mechanical drawing than freehand sketching and painting.

The greatest obstacles to achieving realistic results are heavy-handedness or excessive neatness in the ruled line work. Here, Roux was much more skillful than Lenga by allowing the bowlines to break up the smooth outlines of the square sails, using lighter tones for the rigging, and giving greater variation to the tones, shading, and highlights of the hull planking. The watercolor by Lenga exhibits a very noticeable defect due to excessive dependence on curves: an unnatural S-curve in the sweep of the bright main wale of the hull, and far too much sheer amidships, while the bow seems to sag. Lenga may have in-

tended to create an illusion of the vessel heeling, but it is a failed experiment and detracts from the otherwise convincing appearance of the profile. However contrived some aspects of these paintings were, they have great charm, and some could indeed be very accurate representations. Lane was undoubtedly familiar with many pictures like these and probably studied some in detail in the years before he painted *Cadet*.

Lane probably painted the *Cadet* canvas in the time-honored way with oils: the masses of color for sky, sea, sails, and hull were blocked in, followed by glazes that added detail, illumination, and shadow. His handling of the sail contours and shadows is more sophisticated than the port painters' methods. Subtle shading reveals sail contours compounded by wrinkles in the luffing main sails, while the main yard and main topsail cast clearly outlined shadows on the spanker. Sunlight is here treated as true point-source illumination, rather than as diffused lighting, which casts undefined shadows in the Roux and Lenga watercolors.

Cadet's rigging is also more convincing in overall appearance, as each line varies in weight and value, lending a shimmering effect to the whole, not unlike that of many old photographs of sailing ships. Like his contemporaries, Lane allowed lines to hang in subtle catenary curves while shrouds and backstays kept their characteristic look of tautness. Unlike Roux and Lenga, he did not draw them mechanically. To sight down any of the rigging lines at a glancing angle to the canvas (so their lengths are compressed visually), it is evident that Lane painted them freehand, with a very fine brush. Whether Lane used any aids beyond a maul stick for steadying and guiding his brush hand is now impossible to determine. It seems highly probable that his training with the lithographic crayon did much to enable him to execute fine line work with such impressive neatness.

The unconventional aspects of Lane's ship portraits were undoubtedly due to boredom with the routine broadside views and repetitive treatment of sails and rigging demanded by owners and shipmasters. His paintings of ships are marked by a skilful use of perspective and an understanding of its effect on these objects of complex form. This is hardly surprising for an artist of the luminist movement, for the play of light on a hull and the reflections and shadows that reveal its contours are most interesting when viewed from unusual angles. Lane

fig. 7. Lane, Detail from *Gloucester from the Outer Harbor*, 1852, pencil and watercolor, 9¹/₂ x 31¹/₂ in. [Cape Ann Historical Association]

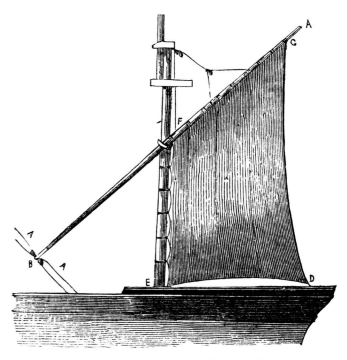

fig. 8. *l'Artimon*, 1860, engraving, 2¹/₄ x 2¹/₄ in. [Babson, *History of the Town of Gloucester, Cape Ann*, 1860, after Jal, *Glossaire Nautique*, 1848]

showed no hesitation to place ships in very difficult poses, and in most cases he was able to convey the geometry of the hulls and the perspective of the rigging very convincingly. His knowledge of hull form is evident in many of his pencil drawings, and on one he actually sketched a hull in end view with a number of sections which, when compared with sections in a naval architect's lines plan, suggests that he made a serious study of hull form (fig. 7). This sketch, in fact, resembles the thumbnail sketches many naval architects make during the planning stage of a new design, or simply for amusement. Another drawing shows a small sloop with vertical lines sketched lightly on the hull, revealing its contours. This treatment would leave little to guesswork when making a painting of the sloop from it. In many of Lane's drawings, hulls are sketched without any contour lines, but effective shading technique makes their forms readily discernible.

Lane's mannerisms of delineation and treatment of detail strongly suggest a familiarity with both American and European literature on nautical science and the practices of seamanship and rigging. His insistence on originality of composition leaves scant evidence that he copied directly from these works, and then only when dealing with completely unfamiliar subjects. His drawings of two Indonesian sailing craft, a bugis from Borneo and the Celebes, and a pirate proa from the Sulu Archipel-

ago, indicate that he had access to some of the literature on the exploration of the western Pacific containing views of native watercraft. Lane was certainly exposed to one of the great marine dictionaries of the nineteenth century when he was called upon to illustrate the precursor to the gaff rig of schooners for Babson's history of Gloucester.[12] His engraving follows closely that in Jal's *Glossaire Nautique* (figs. 8,9), with the author's keyed caption below it in the original French.[13] These fragments hint tantalizingly at a wealth of information Lane had either ferreted out on his own, or which had been placed at his disposal for commissioned work.

Given the near-photographic treatment of many of his ships, it is logical to wonder if Lane resorted to photographs as drawing guides or as sources of information. Among his sketches at the Cape Ann Historical Association is a photograph of the coastal passenger steamer *Harvest Moon* at wharfside in Portland (fig. 10). A grid has been carefully drawn in pencil over the image to enable accurate enlargement when drawing the steamer to the desired size on the canvas. While this method of transferring from photographs became extremely common later

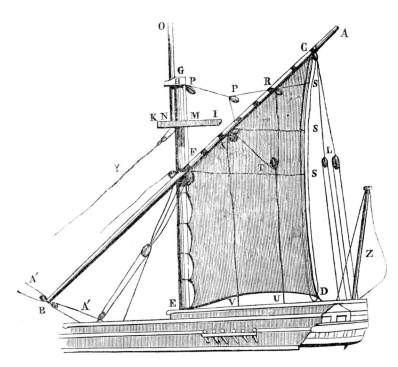

fig. 9. *l'Artimon*, 1848, engraving, 3³/₄ x 3³/₈ in. [Jal, *Glossaire Nautique*, 1848, Peabody Museum of Salem]

fig. 10. *Steamer "Harvest Moon," Lying at Wharf in Portland*, 1863, photograph and pencil, 9³/₄ x 10¹/₂ in. [Cape Ann Historical Association]

in the century, 1863 is a very early date to find the technique used with this subject matter. Very few, if any, well-regarded ship portraits or marine paintings from this period can be traced to photographs, and of Lane's contemporaries who did use them, William Bradford is perhaps best known; however, his use of photography came slightly later and with very different uses in mind. None of the daguerrotypes of clipper ships by Southworth and Hawes found their ways into contemporaneous paintings of merit, and no use of photographs by J. E. Buttersworth has been established for this period. The *Harvest Moon* photograph may thus be suspected to be a very early, possibly pioneering, example of this practice. Cost may be one reason, as the decorative value of the print is destroyed, so Lane must have had the incentive of a commission for marking it up this way. But once the novelty had passed, how long would Lane have used photographs in this mechanical way before he was again possessed by the urge to resume his more imaginative freehand drawing of ships? If an artist of his ability would balk at the chore of grinding out conventional ship portraits, it is difficult to believe that he would have been any happier to allow

photographs to supplant one of his most creative activities: drawing a ship as he personally envisioned it.

Despite his physical disabilities, Lane was probably as active as any other marine artist of his day, scouting the coastline and combing the waterfront for likely motifs for a picture, or for subjects that might become elements of one. His years at Boston afforded an opportunity to view the latest progress in ship design and his association with William S. Pendleton's lithography firm undoubtedly made his work sufficiently widespread to catch the attention of shipbuilders, naval architects, and vessel owners or their agents. This must have been the case when he made a lithograph of the steam propeller *Massachusetts* for her owner, Robert Bennett Forbes, and it was surely Forbes who suggested that Lane make a lithograph of the demi-bark *Antelope* for publication in *The U.S. Nautical Magazine* some ten years later (fig. 11). This journal, the brainchild of John W. Griffiths, was the first periodical on shipbuilding and naval architecture to appear in North America and the first publication apart from Griffiths' earlier book to offer serious criticism of the cur-

fig. 11. Lane, *Steam Demi Bark Antelope*, 615 tons, 1855, lithograph, 11⅜ x 14½ in. [*U.S. Nautical Magazine and Naval Journal*, October 1855]

rent state of shipbuilding. It served admirably as a pulpit for Griffiths' exhortations to improve American ships, and as a showcase for the designs of promising young shipwrights. It also published articles by experienced shipmasters whose ordeals at sea had led them to try their own innovations.

Foremost among inventive sea dogs was Robert Bennett Forbes, whose credentials as a sailor and shipmaster, and family connections in the China trade, guaranteed an attentive audience for his frequent writings and announcements of better ideas for ship design. Since 1830, he had had sailing ships built under his supervision or to his specifications, and in 1845 had begun to build steamers and a variety of vessel types with iron hulls.[14] Although constantly inventing and improving ships' gear, he remained mindful of the practical limits to any improvements, and so built a number of ships with novel features, but whose basic soundness of design and construction would assure outstanding performance. The "demi-bark" *Antelope* was such a design, being small but well furnished for her highly specialized role: trade between American merchants in China and the newly opened ports of Japan. Under Forbes' watchful eye, she was designed by Samuel Hall and Samuel H. Pook and built

at Hall's shipyard at East Boston in 1855. Her steam plant and uncoupling propeller were designed as auxiliaries to her three-mast barkentine rig, a rig then so new that terminology for it had not been settled. Steam engines were still wasteful of fuel in this period and Forbes correctly planned their use as auxiliary power to speed the vessel along in light airs or away from pirates. *Antelope* was equipped with an impressive array of steam-driven pumps that could pump the bilges, take out sand ballast, flood the powder magazines, fight fires, and even throw jets of scalding water on any pirates who might attempt to board her! To defend herself further, *Antelope* carried three large caliber deck guns on swivel mounts, which permitted the guns to be trained in any direction. This was the same sort of armament adopted by large naval cruisers which proved so effective in high-seas actions fought by many of the world's navies in the coming decades. *Antelope* thus combined the qualities of a fast auxiliary packet and a small warship, which allowed her to ply her trade unmolested in a then little-known and often hostile part of the world.[15]

Antelope was not Lane's first depiction of Forbes' innovative steamers, as earlier mentioned. In 1845, he made two lithographs of the auxiliary steam bark *Massachusetts* whose novelties included Forbes' double topsail rig and a swiveling propeller hoisting arrangement.[16] This ship was also designed and built by Samuel Hall. By 1854, when *The U.S. Nautical Magazine* began publication, the association among Forbes, Griffiths, and prominent Boston shipwrights had perhaps become the greatest influence on the progress of ship design in America. For an artist like Lane, the publication of his lithograph in this journal was indeed an important endorsement. In a newspaper article eulogizing Lane, appreciation of his talents by shipowners was evident, but in his association with Forbes and perhaps indirectly with Griffiths, we have evidence that his work was acclaimed by the severest critics one could possibly find in this field.

The *Antelope* lithograph illustrates a problem that faced all ambitious publishers in mid-nineteenth-century America: the difficulty of obtaining good pictorial material on short notice, particularly for periodicals. Griffiths commissioned a few other lithographs to illustrate his magazine, but the small format led to two unsatisfactory alternatives: printing a small image on heavy stock with one fold, or printing a larger image on thin vel-

fig. 12. Lane, *Cunard Steamship Entering Boston Harbor*, c. 1840, pencil 4⅛ x 5⅝ in. [Cape Ann Historical Association]

fig. 13. Lane, *Steam Propeller "Tow Boat,"* 1850s, pencil, 8¼ x 11 in. [Cape Ann Historical Association]

lum or onionskin with two or more folds. Few examples of either have survived in good condition, and all have suffered from creasing and acid migration from the surrounding text paper. For a journal of naval architecture, the reproduction of ships' plans was essential for many articles, and the available means were highly unsatisfactory. Copperplate engraving, then in widespread use in Europe, was poorly utilized in American publishing due to a severe shortage of skilled engravers. For the precise line work needed in a ship's plan, the medium was ideal and in fact was used to illustrate the great European tracts on naval architecture of the eighteenth and nineteenth centuries. Lacking this resource, Griffiths relied mainly on much cruder wood block prints for illustrations. The deficiencies of this medium are readily apparent when the lines plan of *Antelope* is compared with Lane's lithograph of her.

By 1840, the steamship was no longer a novelty to Bostonians who were by then accustomed to the daily sight of coastal passengers, naval steam frigates, and a variety of towboats, ferries, and other harbor auxiliaries. The arrival of the Cunard steamer *Britannia* in that year, followed by her three sister ships, was more important by far as a commercial link with Great Britain. Her operation made Boston the most important American port

for receiving mail and expedited cargoes from Europe.[17] In view of such intense public interest, it is not surprising that Lane's painting of *Britannia* in stormy seas is one of his most flamboyant works; indeed, what is surprising is the absence of a Lane lithograph of this ship, an obvious candidate for such popular treatment. One of Lane's surviving drawings depicts *Britannia* (or a sister vessel) being escorted by a towboat, which suggests other possible paintings by Lane that have since disappeared (fig. 12).

Lane's attention to commoner steamship types was no less meticulous. His harbor views of Boston and New York abound with towboats, ferries, and coastal steamers, all of them as carefully rendered as the sailing vessels. Among his drawings is a view of a large propeller towboat of about 150 feet in length, probably belonging to New York or Boston. This vessel was powered by an early compound steam engine, or perhaps an oscillating engine, which is why no engine parts project above deck or cabin level as in the case of "walking beam" engines. Steam was generated by two boilers mounted side-by-side, hence the placement of the funnels athwartships. The prominent masts, which are rigged to set riding sails to steady her motion in heavy seas, indicate that she was designed for off-

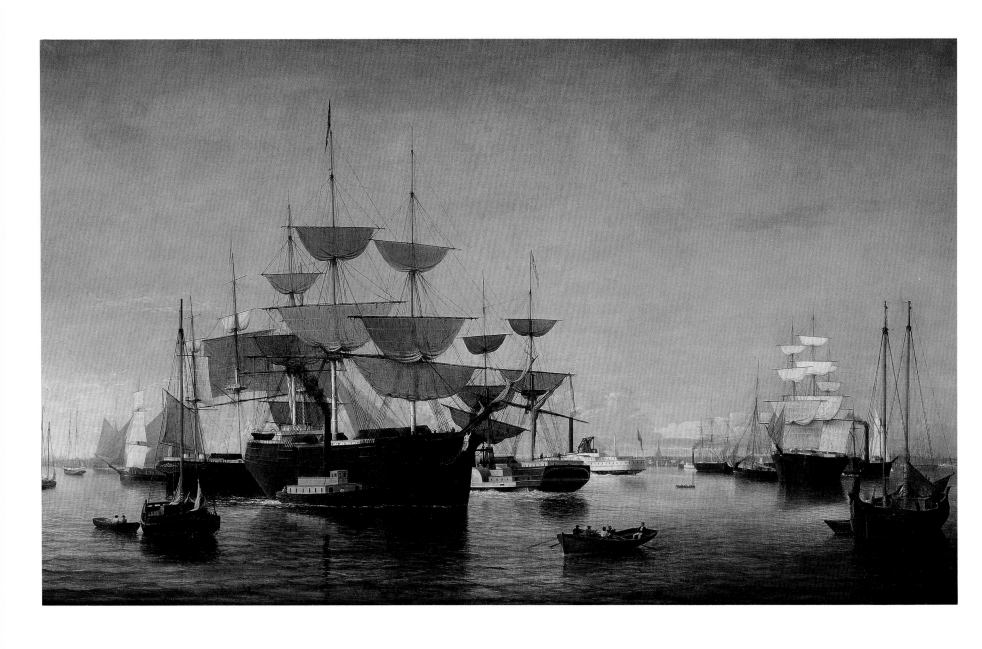

cat. 38. *New York Harbor*, 1860, oil on canvas, 36 x 60 in. [Museum of Fine Arts, Boston, M. and M. Karolik Collection]

shore towing and for deep-water salvage. Even in so early a state of development, the large coastwise towboats had acquired their essential characteristics; subsequent decades would see improvements to hull form and machinery, and more extensive superstructure, but the basic arrangement had been established by the 1850s (fig. 13).

In contrast to Lane's large towboat, the smaller harbor tugs were still in transition from paddlewheelers with cross head or walking beam engines, to screw-driven hulls with less cluttered and awkward topside structures. *New York Harbor*, 1860 (cat. 38) offers a glimpse of this change with a brig (middleground) being "towed" by a paddlewheeler while the large merchant ship (foreground) is in the charge of a "propeller" whose cabin and pilot house more closely resemble those of later tugs. Although it is easy to become distracted by the bustle and apparent confusion in Lane's later canvases of Boston and New York harbors, the steamers warrant close inspection. They show clearly the emergence of the engine-powered vessel as a vital part of water transport, performing tasks in local situations for which it was far better adapted than sailing craft.

If, in Lane's time, steam vessels were promising signs of the future in marine transportation, the clipper ship was then the ultimate symbol of oceanic travel and the object of intense scrutiny by ship designers and overstatement by the press. Lane could not escape this contagion any more than his fellow marine artists, hence the survival of a number of his canvases with clipper ships. None is a portrait in the sense of Buttersworth's or Bradford's, and only one is of a notorious vessel. All are set against port scenes or pelagic backgrounds, which are as carefully composed and painted as the ship itself. In some examples, the setting is visually more interesting than the vessel, whose presence acts as a dark counterpoint to a brilliant pattern of water reflections or to a delicately balanced grouping of smaller vessels. In *Southern Cross Leaving Boston Harbor* (cat. 31), the meticulous detail of the subject's rigging and sails is barely able to hold the viewer's attention against a busy skyline, strong cloud formations, and a delicate tracery of waves. This is not to say that the clipper ship *Southern Cross* has been badly portrayed, only that the artist probably felt the need to include other strong elements in the canvas to sustain his own interest in the subject.

Southern Cross was regarded as a "medium clipper," a nebu-

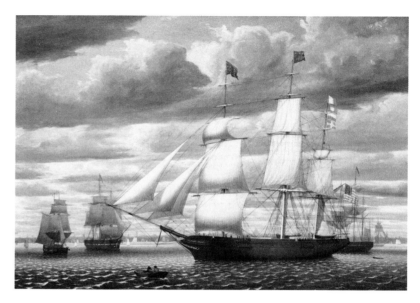

cat. 31. *Clipper Ship "Southern Cross" Leaving Boston Harbor*, 1851, oil on canvas, 25¼ x 38 in. [Peabody Museum of Salem]

lous term for fast sailing ships that had the looks, but less extreme hull forms and rigs, of the "extreme clippers," as the quintessential examples were called. She was built (and presumably designed) by E. and H. O. Briggs at East Boston for Boston owners, and launched in 1851. Plagued by dismastings, fire at sea, and generally adverse weather conditions, most of her passages were disappointing and she was subject to several costly repairs. Her career ended in 1863 when she was captured and burned by the Confederate cruiser *Florida*. When new, *Southern Cross* was described at length in an article in *The Boston Atlas*, and this matches Lane's painting very closely, particularly the figurehead and trailboard carvings, with which Lane seems to have taken special care.[18] The picture also shows the ship flying Elford's marine telegraphic flags at the mizzen truck, an early American signal system in widespread use before 1860. *Southern Cross*' signal reads, from top to bottom, "3-4-2-5," which corresponds with the vessel's actual listing in the code book for Boston vessels. The pennant colors, red and white, differ from the blue and white originally prescribed by Elford in the 1820s, although the system was extensively modified for regional use in subsequent years. Whether Lane copied the pennant colors from life or guessed their colors from the signal book, which does not specify colors, is unclear.[19]

In canvases where a vessel's name is shown clearly, it is very often safe to assume that the buyer of the picture also owned or commanded the ship. Despite statements that he painted numerous ship portraits for their owners, the vast majority of Lane's known paintings portrayed unnamed vessels, which are likely to keep their anonymity despite our best research efforts. This difficulty notwithstanding, a few unidentified vessels offer such strong clues to their identity that we can be very certain which ship was on the artist's mind, even if an exact likeness was not intended. A case in point is a canvas known for many years as *Gloucester Harbor at Sunrise*, 1850s (cat. 12), a harbor scene with a group of ships clustered at the right middleground and a much more prominent clipper ship at the left. The background scenery belies the title, for it cannot be reconciled to that harbor's geography at any conceivable vantage point, nor can the sun rise over the mouth of the outer harbor, which faces south southeast. For similar reasons, Boston Harbor can also be ruled out as the setting. Lane was too familiar with both ports to allow anything less than an instantly recognizable rendering of their skylines. Since the artist was spending many of his summers in Maine in the 1850s, a seaport north of Gloucester seems the most likely source for this setting.

The ship itself has the appearance of an extreme clipper, but it has features that immediately set it apart from the clippers of Donald McKay. Most prominent is the beakhead with headboard and headrails, cheek knees and trailboards, and a very small figurehead in the likeness of a woman. KcKay's clippers by contrast were largely devoid of elaborate headrails and moldings, leaving the carved scrollwork and figurehead to stand by themselves. Lane's clipper has a form of beakhead decoration that was very popular for packet ships of the previous decade, but not popular at all among the sleekest flyers of the early 1850s; moreover, the adaptation of these carvings to a much sharper bow and raked cutwater would have widely varying results on the diverse handful of extreme clippers that had them. The one vessel that so closely resembles Lane's clipper ship is *Nightingale*, built at Portsmouth, New Hampshire by Samuel Hanscom in 1851. Launched in June, she remained in Portsmouth through July, when she was towed to Boston to await the untangling of her builder's financial embarrassment and her sale to a prominent Boston shipping firm.[20] Her stay in Portsmouth could have coincided with Lane's travels to Maine

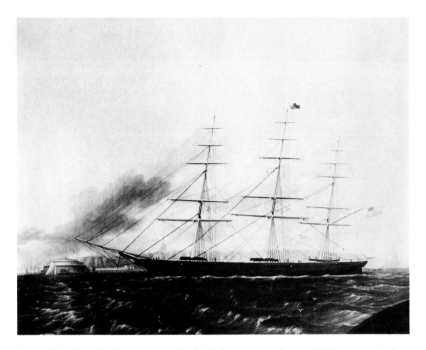

fig. 14. Unidentified artist (possibly J. E. Buttersworth or a Chinese copyist), *Clipper Ship "Nightingale" in New York Harbor,* c. 1851, oil on canvas [Peabody Museum of Salem]

in that year, and because this city was a convenient stop for artists and "rusticators" making their migrations to cooler climes, it is difficult to imagine that Lane would have shunned the opportunity to view a ship that had gained so much notoriety and admiration (fig. 14).

If *Nightingale* is indeed the main subject of this canvas, the setting conforms but vaguely to the geography of the mouth of the Piscataqua River, to the east of Portsmouth Harbor proper. If we can imagine an anchorage off Fort Point, Newcastle, then the low land mass in the left background would be Gerrish Island, with Wood Island to the right of center. Whaleback Lighthouse, an important sea mark just south of Wood Island, would be obscured by the vessels in the right middleground. Given the hazy depiction of important landmarks, it is difficult to state flatly that Lane had a specific Portsmouth setting in mind. His itinerary probably denied him adequate time to master the geography of the area, thus compelling a vague treatment of the setting. For now we can say that this painting possibly shows the extreme clipper ship *Nightingale* bending sail at the mouth of the Piscataqua River in the early summer of 1851.

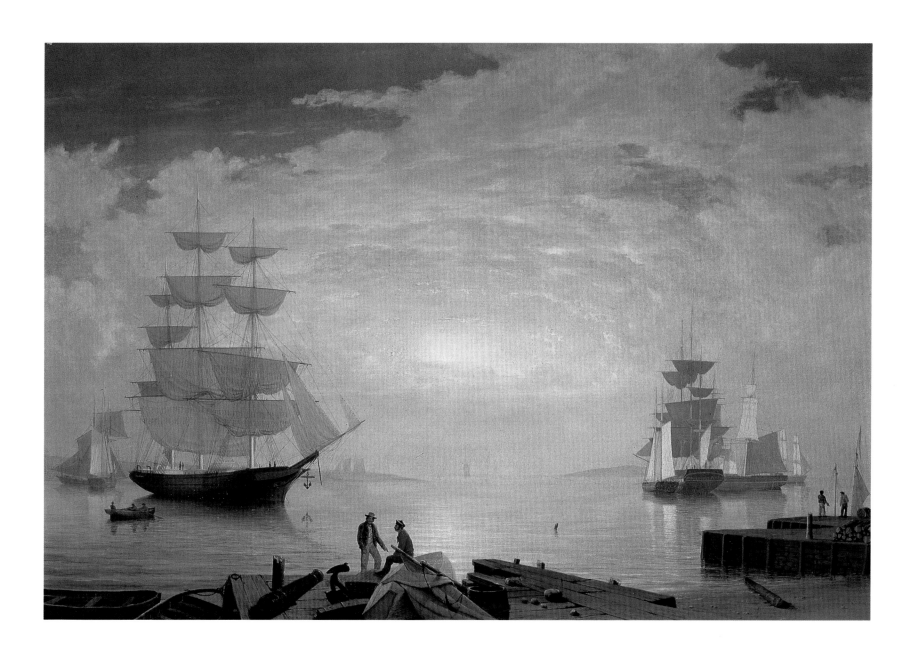

cat. 12. *Gloucester Harbor at Sunrise*, c. 1851, oil on canvas, 24 x 36 in. [Cape Ann Historical Association]

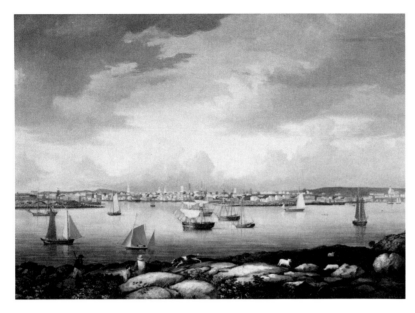

cat. 2. *Gloucester Harbor from Rocky Neck*, 1844, oil on canvas, 29½ x 41½ in. [Cape Ann Historical Association]

fig. 15. Detail from left foreground of cat. 2.

Lane's paintings of yachts and important regattas are less numerous than his portrayed of pleasure craft. Even his harbor scenes, with their purposeful portrayal of commerce and fishing, show an occasional "party boat" taking summer guests out for a day of fishing and sightseeing. Perhaps when Lane encountered occasional pleasure craft in an overwhelmingly commercial milieu, he added them, as a matter of record, to the scene; similarly, when working craft stumbled upon the scene of a yacht race, or just looked on as part of the spectator fleet, he treated them as much as a part of the scene as the racing vessels. One of Lane's earliest and most charming depictions of pleasure craft is found in *Gloucester from Rocky Neck*, 1844 (cat. 2). The yawl-rigged boat closest to the foreground (fig. 15), with its party of sightseers on board, was likely built for this activity, the cockpit arrangement being best suited for a comfortable and relaxed day's excursion. The leg-of-mutton mizzen sail steadied her motion and allowed the helmsman some relief from steering to give more attention to his guests.

In the 1840s and 1850s, small pleasure craft for personal use probably were converted workboats or built along workboat lines. Lane's sketch of Joseph L. Stevens, Jr.'s father's boat (fig. 16) shows a hull typical of boats used in the shore fisheries; likewise, his sketch of *General Gates,* the boat he used for

his Maine cruises, shows another workboat of traditional appearance.

Yachting, in the sense of racing and cruising by gentlemen with professional crews, was beginning to flourish in America in the 1840s and 1850s, and Lane was to portray some of the most important vessels and events. His earliest depiction of a yacht may be his painting of the schooner *Northern Light*, 1845, made from a drawing by Robert Salmon. *Northern Light* was designed by Louis Winde in 1839, probably along the lines of the Boston pilot schooners whose performance was the standard by which other vessels were judged. Winde, a young Danish immigrant with formal training in naval architecture, is credited as being the first professional (by modern standards) ship designer in America, and his yacht designs were seminal in the development of the type in New England.[21] Lane's painting therefore commemorates an important development in the progress of American shipbuilding; moreover, he infused Salmon's composition with elements of his own, setting this greyhound among

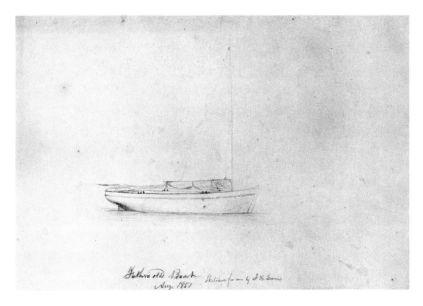

fig. 16. Lane, *Father's [Steven's] Old Boat*, 1851, pencil, 10¼ x 15¾ in. Belonged to the father of Lane's close friend, Joseph L. Stevens, Jr. [Cape Ann Historical Association]

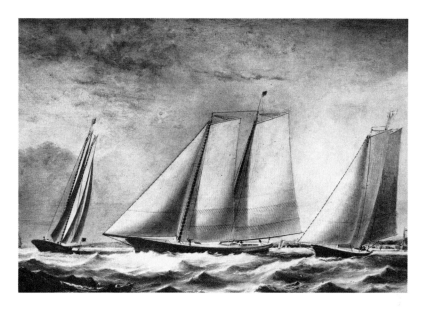

fig. 17. Lane, *Three Views of Yacht "America,"* 1851, oil on canvas [Peabody Museum, Salem]

small fishing vessels so characteristic of his Gloucester and Maine paintings (cat. 26, see p. 49).

The sensational accomplishments of the schooner yacht *America* inspired at least two paintings, one derived from English sources at the time of her race; the source of the other is open to speculation. Following her launch early in May 1851, *America* remained in New York for less than two months before sailing to Europe. If Lane had been in New York at this time, it would have been his only opportunity to see the finished schooner firsthand. Were this the case, then his painting with three views of the vessel could have been the result. There are notable differences in rigging details between this canvas and other sources, suggesting that he may have seen the yacht from some distance and was forced to guess at some rigging leads. It is also possible that he never saw *America* and simply used *Northern Light's* rigging as a model, as the leads are exactly the same in both paintings. What makes *Three Views* so interesting is Lane's careful treatment of her sails, which show the artist's understanding of the tightly woven canvas and careful sewing that gave them such an advantage over the loosely woven flax sails used by English yachtsmen. L. Francis Herreshoff, a renowned yacht designer and one-time owner of this painting, was emphatic on the accuracy of Lane's depiction of the vessel:

Three views of the *America* as she appeared in her races in England are shown . . . This painting by the accurate artist, Fitzhugh (sic) Lane, is very interesting. In the view from astern you can see that her sails are almost perfect airfoils, just twisted aloft correctly for the higher wind velocities there. . . .[22]

While Herreshoff thought this to be a view of *America* racing in English waters, a dory in the left foreground almost certainly identifies the scene as American, and thus a record of *America's* trial racing activity before her departure for Europe. The view of the dory is in itself important, as its hull and gear are close to that used by banks dories in the last half of the nineteenth century, though dories at this time were confined to the shore fisheries (fig. 17).

The New York Yacht Club regatta of 1856 brought Lane to New Bedford to paint and sketch some of his liveliest yachting scenes. The sloop- and schooner yachts, then as now, had a look of pristine sameness that no doubt encouraged him to punctuate this procession of black hulls and white sails with steamers and a ragtag assortment of small spectator boats. One of his surviving sketches, *Sloop Yacht with Detail of Topmast Rigging* (fig. 18), is likely to have been made at this time. It and the paintings show that the sloops and schooners favored by New York yachtsmen in the 1850s were only beginning to acquire characteristics of their own, and still showed their origins based on

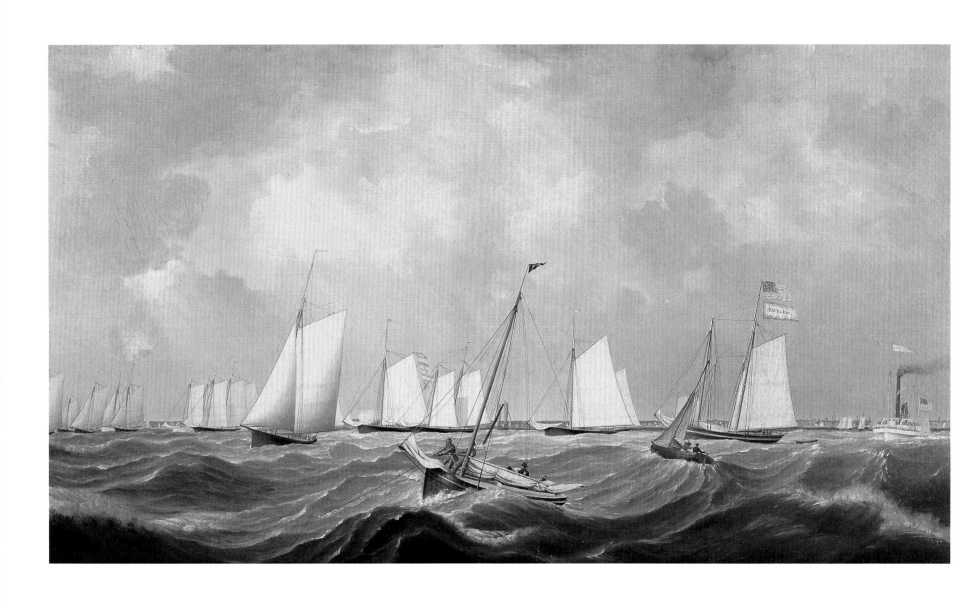

cat. 33. *New York Yacht Club Regatta*, mid 1850s, oil on canvas, 28 x 50¼ in.
[private collection]

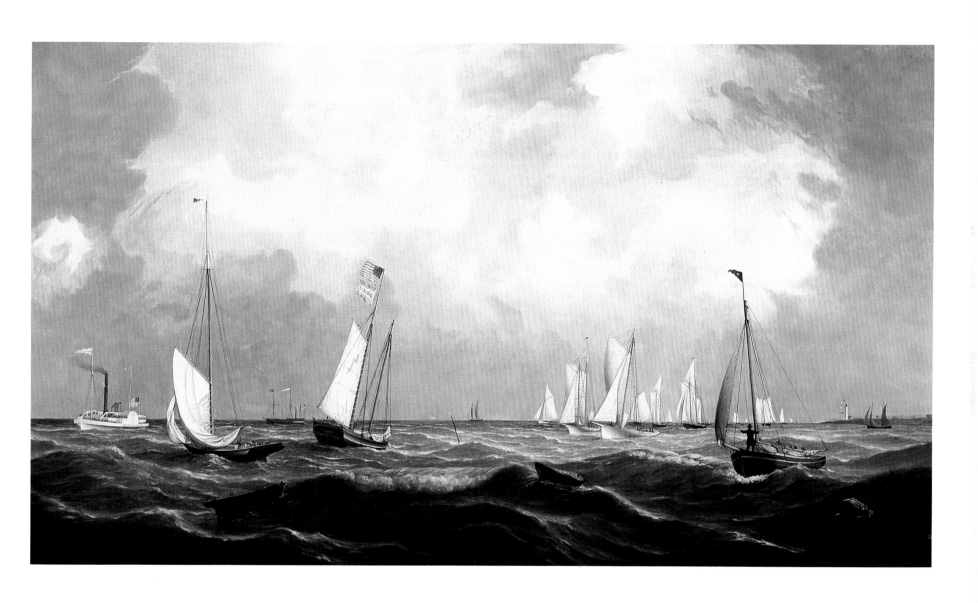

cat. 34. *New York Yacht Club Regatta*, mid 1850s, oil on canvas,
28 1/8 x 50 1/4 in. [Estate of Alletta Morris McBean]

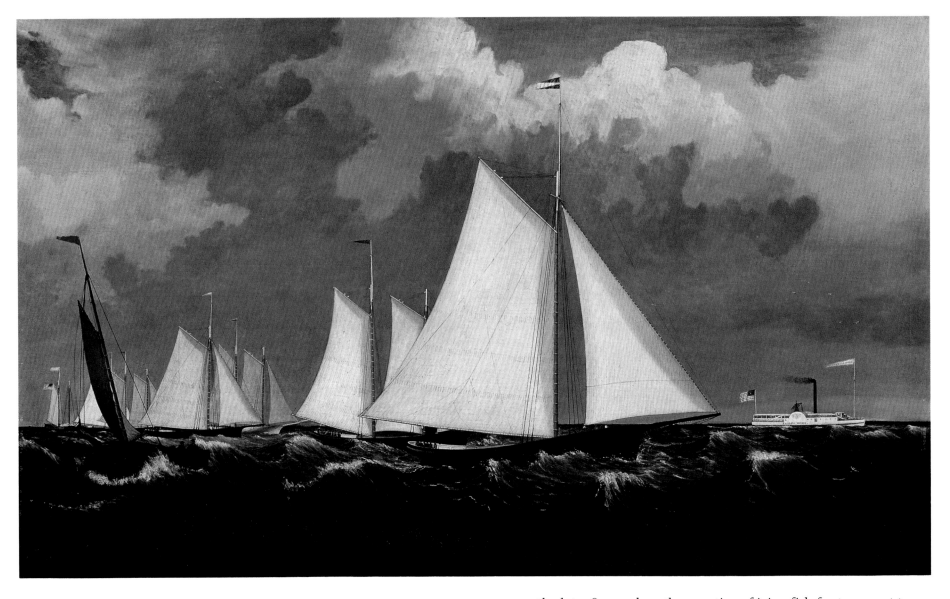

cat. 36. *New York Yacht Club Regatta*, 1857, oil on canvas, 30 x 50 in. [Dr. and Mrs. Thomas Lane Stokes]

New York work boat types, which were much shallower and wider than their counterparts in Boston. These vessels were usually fitted with centerboards, and with their large sail plans they could be tricky to handle in a strong breeze. With the advent of the deep, narrow cutter from England, a long-winded controversy over these rival hull forms (and everything in between) raged for the rest of the century.[23]

The design of fishing schooners remained conservative until the late 1840s, when the practice of icing fish for transport to market in a fresh state was introduced. Prior to the creation of this fresh-fish market, the catches were salted on deck by the crew and brought to port pickled in casks. Less commonly, a live catch was brought home in a live well (a specially partitioned section of the hold that allowed sea water to flow freely through it) of a schooner called a smack. Increased demand for fresh fish was beyond the capacities of the well smacks, so ice was used to preserve the catch in specially fitted partitions, or pens, in the schooner's hold. A faster schooner was needed to get the fish to market before the ice could melt, and two types were developed

fig. 18. Lane, *Sloop with Detail of Topmast Rigging*, c. 1857, pencil, 10¾ x 14¼ in. [Cape Ann Historical Association]

in response: the "sharpshooter" and the "clipper" schooners. Both looked very similar when afloat, but the clipper's hull form was somewhat more capacious relative to its depth, and this type eventually replaced the sharpshooter. The need to get iced fish to market as quickly as possible soon led to serious competition, as schooners vied with each other to reach port first to secure the highest bids. The fish market then as now was an auction, and fish prices floated on the fluctuations of supply and demand. So important had this market become that vessels built for this service had to be fast sailers, even at the expense of the crews' safety.[24]

For all their speed and dashing looks, few sharpshooter and clipper schooners have been found in Lane's paintings, and none is more than part of a busy port scene. The handsomest example lies in the right middleground of *Gloucester Harbor,* 1852 (cat. 7, see p. 26) just off Fort Point, under jumbo (fore staysail) and main sail. A second appears in the same painting in the far right background, lowering her fore sail. While both schooners are small elements of a large canvas, they are painted with great care, revealing much detail, particularly the former vessel. Here we find precise rigging leads, accurate hull form, sails hanging realistically in the still air, and the yawl boat hanging from the wooden stern davits in the way we see in later photo-

fig. 19. Detail of sharpshooter fishing schooner in cat. 7.

graphs. Very noticeable too are the strongly raked masts, a feature confirmed by sail plans of vessels of this type and period (fig. 19).

A smaller example of a sharpshooter appears in the right middleground of *Ships in Ice off Ten Pound Island,* 1850s (cat. 3, see p. 23). The high quarter deck and its bulwarks suggest that this is an earlier example of the type. Unlike the previous examples, her beakhead is only a gammon knee, lacking trailboards and head rails, but probably fitted with a small billethead or eagle's head. Unlike many clipper ships whose unadorned bows proclaimed their pedigree, a plain stem on a fishing schooner only bespoke its owner's limited means. The first class schooners of the Gloucester fishing schooners became renowned for their fine workmanship, handsome finish, and artistic carvings. Lane's paintings indicate that by the early 1850s that custom was already well established.

cat. 45. *Ships off Massachusetts Coast*, late 1850s, oil on canvas, 15 x 23 in.
[private collection, Virginia]

GLOUCESTER HARBOR IN THE LAST TWO DECADES OF LANE'S life was a classic colonial seaport in the process of shedding its traditional economy and waterfront infrastructure for a more specialized role as the leading fishing port of the American industrial revolution. The old port of Gloucester combined its fishing activities with coastal trade, the Surinam trade, some West Indies trading, and a host of other mercantile endeavors on a small if far-flung scale. Until the 1840s, Gloucester's shipping activities, like Boston's, reflected the need for self-sufficiency in the absence of a strong regional economy. However, as canals and railroads improved inland transportation, bringing growth and prosperity to the largest seaports, the smaller ports saw their trade dwindle and their merchant fleets disappear against rising competition. Specialization was the key to survival, and through the combined fortunes of geography and an established fishing and fish processing industry, Gloucester made this transition quickly and profitably.[25] In the 1840s, the vessels in Lane's views of this port were a mixture of trading and fishing craft, mostly Gloucester-owned and managed. By 1860, his canvases showed the harbor occupied by many more and larger fishing vessels with little change in the number of other types of ships. To compare Lane's views of the harbor from his lithographs of 1836, 1846, and 1855, his large canvases of 1844 and 1852, and his smaller harbor views of the 1850s and 1860s, is to witness the gradual change in vessel types, their hull forms and rigs, and their relative numbers as harbor commerce changed its emphasis.

The larger merchant vessels were square rigged, either three-masters (ships and barks) or two-masters (brigs and brigantines). Lane painted splendid examples of all types. In *Three Master on the Gloucester Railway* (cat. 39), a full-rigged ship dominates the skyline while in smaller harbor views the type often appears in the background. Between 1789 and 1857, at least twenty-eight ships were registered at Gloucester with an average tonnage per vessel of 269. The rig was most numerous between 1805 and 1835, and only three were registered after 1850. The barks, while having a slightly simpler rig, averaged 324 tons and were more common in the 1840s and 1850s (eighteen were registered from 1809 to 1870). The largest examples were registered in the 1860s under Boston ownership; the nature and extent of their trading activity in Gloucester is unclear at this time. Barks figure prominently in many of Lane's Gloucester views, with good examples

in *Ships in Ice off Ten Pound Island* (cat. 3) and *Gloucester Harbor at Sunset*, late 1850s (cat. 13).[26]

Most of the ships and barks owned by Gloucester merchants tended to be rather small, in the vicinity of 300 registered tons, due to the shallowness of the inner harbor where the best wharves lay. A deeply laden inbound vessel could not approach the wharves without partial discharging of its cargo to lighten its draft. This was done at "Deep Hole," an area of deep water just inside the mouth of Inner Harbor, where the vessel anchored while lighters took off the cargo. All three of Lane's lithographs of the harbor show large ships moored at this location.

The large square-rigged vessels in Lane's Gloucester views were probably all engaged in the Surinam trade, which this port dominated from 1821 to the early 1860s. Gloucester vessels laden with salt fish for Surinam would return with cargoes of sugar, molasses, and cocoa; this trade seems to have grown out of the port's regular commerce in the West Indies, and grew significantly in the 1840s and 1850s. During this period, the numbers of vessels do not seem to have risen in proportion to the volume of trade; instead, there was a transition from the use of brigs to ships and barks of greater tonnage.[27] In the 1860s, Gloucester lost much of its West Indies trade and the Surinam trade was largely taken over by Boston interests. Thereafter, large ships and barks with salt cargoes from Liverpool, Cadiz, and Trapani began to make regular visits, since schooners formerly in the West Indies trade were no longer returning with salt cargoes from that region.[28]

While the Surinam trade may not have employed all the brigs and brigantines owned by Gloucester merchants, they were undoubtedly the rigs of choice for this commerce in the 1840s. The brig and the true brigantine bore a close resemblance to each other, but by Lane's time, the latter had disappeared, leaving brigs as the only two-masted vessels with square sails on both masts. The rig is common in Lane's large lithographs and paintings of the harbor, most examples looking quite handsome in naval fashion, with elaborate beakhead carvings, painted false gunports, and a generally smart appearance. The most handsome and most detailed view is the ship portrait of *Cadet*, but the brigs in the harbor scenes are usually shown in perspective from subtle and unusual angles. Lane's deft handling of perspective gives a very clear impression of the full-ended, burdensome hulls and the complexities of their powerful rigs,

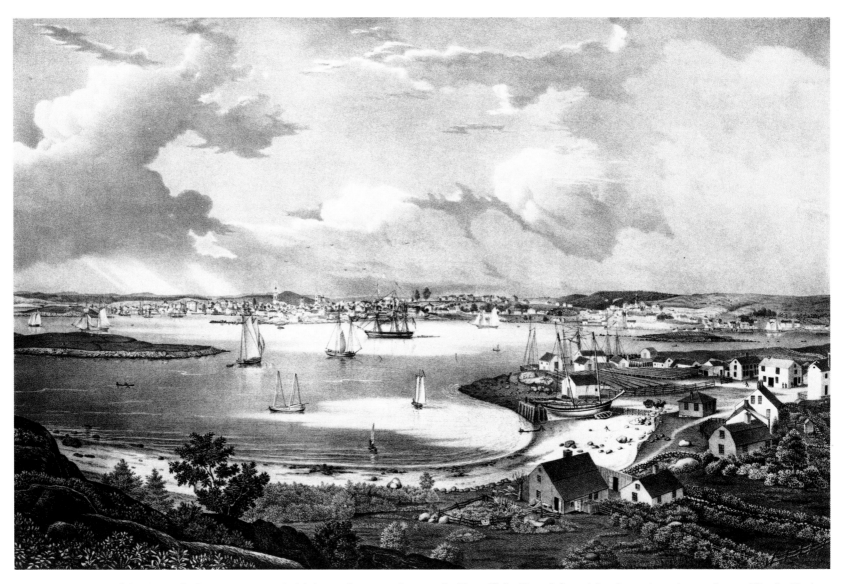

fig. 20. Lane, *View of the Town of Gloucester, Mass.*, 1836, lithograph, 13 x 19¾ in. In the foreground is Smith's Cove with the inner harbor lying beyond. The point in the left middleground is Rocky Neck; the island in the right background is Five Pound Island. In the background at extreme left is Fort Point; in middle left, Duncan Point. The square-rigged ship at center is anchored in the Deep Hole. From left to right, the various rigs are: beyond Rocky Neck, schooner, topsail schooner; in Smith's Cove, three schooners under sail with a New England boat at anchor; on hard ground alongside a wharf, a pinky; in the inner harbor at right, schooners [Cape Ann Historical Association]

which are not fully appreciated from a profile view.

In contrast to the handsomely finished square riggers of the deep-water trades, the sailing vessels of the coastal trade were usually much plainer in hull form and rig, presenting a readily discernible contrast when the two are seen in the same picture.

The common rigs for "coasters" were the hermaphrodite brig, the topsail schooner, the fore-and-aft schooner, and the sloop. While square sails are a conspicuous part of the first two rigs, all are predominately, or exclusively, fore-and-aft rigged, that is, carrying mostly staysails and jibs, gaff-rigged sails, and gaff top-

sails. Prevailing westerly winds along the Atlantic coast have long favored the fore-and-aft rig for its ability to point higher into the wind than the square rig, and for its more economical use of sailcloth, spars, cordage, and manpower. When sailing off the wind, the square sails of the hermaphrodite brig and the topsail schooner added significantly to their sail areas, and thus to speed; moreover, these sails pivot along their vertical center axes and are thus "balanced." In heavy offshore swells and light winds, ships were subjected to constant rolling, causing their gaff sails to swing violently from side to side, straining the slatting canvas and rigging and causing it to wear prematurely. Square sails set high aloft would not swing and slat while their higher vantage points enabled them to catch breezes unaffected by ocean turbulence, thus helping to give the vessel a steadier motion. The price of this savings on wear and tear was the cost of extra sails, spars, and rigging, and the manpower to tend them. For a coasting vessel making long passages along the Atlantic seaboard, and perhaps to the West Indies as well, the addition of square sails was justified; for coastal traders working from port to port, never out of sight of land, it was not.[29]

In Lane's time, the topsail schooner rig was fading from the scene, while the hermaphrodite brig was gaining favor, growing in size, and changing in hull form to conform to more progressive ideas for its use. Few American topsail schooners survived long enough to be photographed, while photographs of the later hermaphrodite brigs looked very different from their antebellum precursors. Topsail schooners are nevertheless quite common in Lane's harbor and coastal views. Two of his best paintings for studying this rig are *Becalmed off Halfway Rock*, 1860 (cat. 41) and *Lumber Schooners at Evening on Penobscot Bay*, 1860 (cat. 61). These compare very closely in detail and proportions of rig to a contemporaneous photograph of an unidentified topsail schooner under sail (fig. 22). The long gaffs with low angles of peak and the very large fore staysail are characteristic of schooner sail plans dating from the first half of the nineteenth century. Although Lane's picture is dated 1860, the vessel he portrays has the hull profile of a schooner from the 1840s.

The origins of the hermaphrodite brig are obscure, apparently dating to the late eighteenth century, and tangentially connected with the development of the brigs and brigantines, which have a common etymology and history. Its name denotes the combination of a square-rigged fore mast and a fore-and-aft-

fig. 21. Detail from *View of Gloucester, Mass.*, 1855, lithograph. Schooners are hauled out at Burnham's marine railway on Duncan's Point. At the extreme right, a small passenger ferry approaches Burnham's Wharf. The building at the extreme left, with triple gables, is a rare depiction by Lane of his own house [Cape Ann Historical Association]

cat. 2, *Gloucester Harbor from Rocky Neck*, 1844, detail. Vessel types, from left to right: brig, schooner (behind brig), hermaphrodite brig, and sloop

fig. 22. *Unidentified topsail Schooner Entering Havana Harbor, Cuba*, c. 1860, Stereograph image [Peabody Museum of Salem]

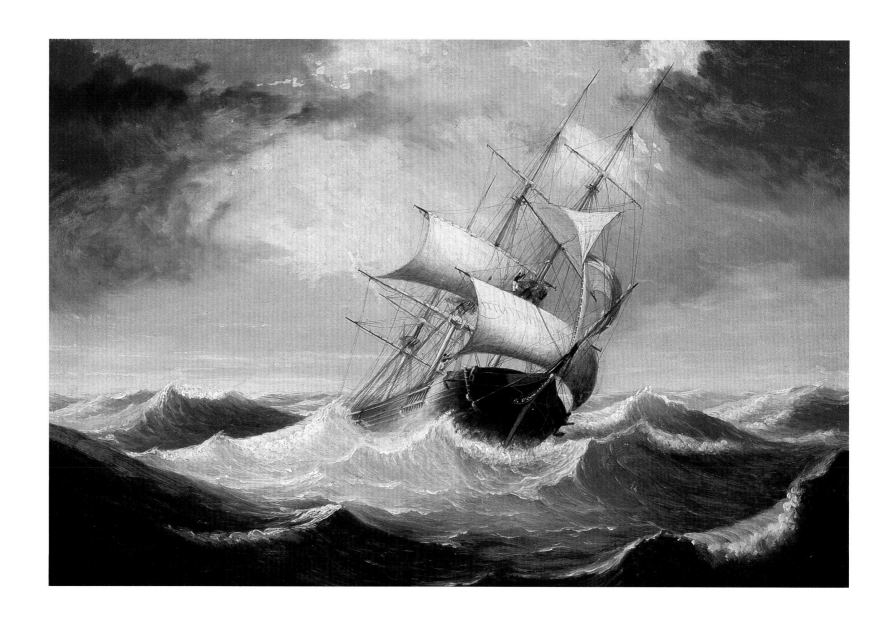

cat. 15. *Three-Master on a Rough Sea*, 1850s, oil on canvas, 15¹/₂ x 23¹/₂ in. [Cape Ann Historical Association]

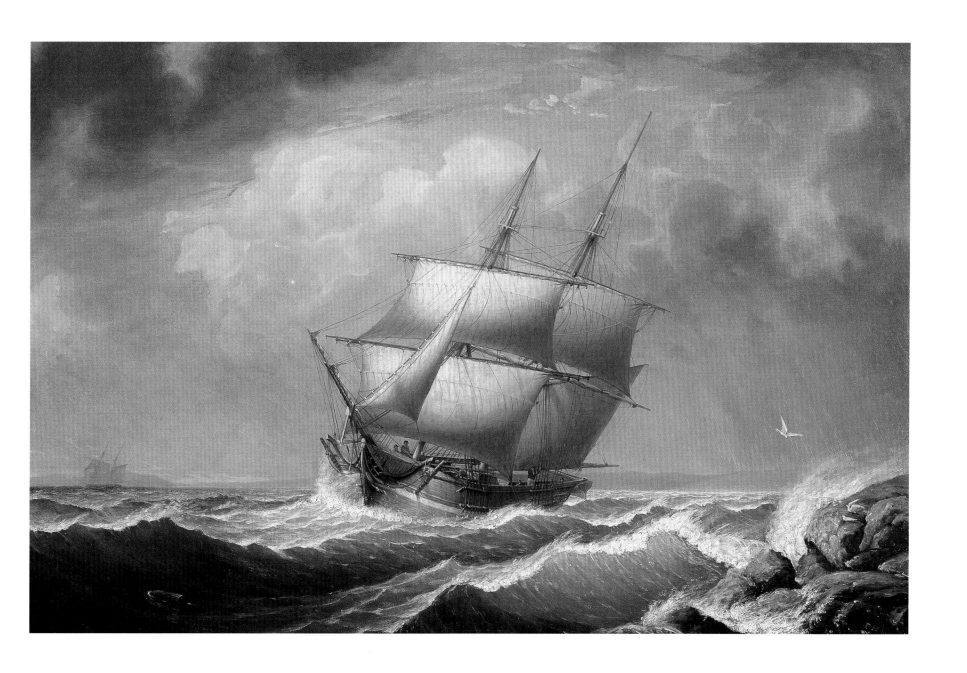

cat. 40. *Merchant Brig under Reefed Topsails*, 1863, oil on canvas, 24 x 36³/₈ in.
[Collection Mrs. Charles Shoemaker]

rigged main mast, combining equally the qualities of the brig and schooner. Lane's painting, *Gloucester from Rocky Neck,* 1844 (cat. 2) offers a good example in the center middleground, between the brig and the sloop. Several more can be found in subsequent paintings of the harbor and in many of his Maine scenes. The view of Castine shows the rig under sail, while the dominant vessel in the sketch *Study of Vessels* (fig. 2) is a hermaphrodite brig at anchor, drying sail. In contrast to Lane's jaunty brigs of the Surinam trade, these craft have boxy, burdensome hulls, drab color schemes, and no carvings or ornamentation. They are quite often shown deeply laden, usually with large deckloads of lumber, which only emphasizes their ungainly looks. In terms of hull form and size, they are closer to schooners than to brigs. As the economics of the coastal trade forced vessel owners to cut their expenses, the hermaphrodite brigs were cut down to schooners and the rig was abandoned for this trade. This did not mean the end of the hermaphrodite brig, for in the 1850s large examples were being built for foreign commerce, and in the second half of the nineteenth century the type prospered as a handsome deep water trader of 300–500 tons.

The fore-and-aft trading schooner that became the ubiquitous "coasting schooner" of the late nineteenth and early twentieth centuries was easily recognizable in Lane's time, though still evolving in hull form. Due to its maneuverability, this was the rig most favored by merchants sending small cargoes from one small coastal community to another. What had been the task of the earlier colonial ketches was passed along to the schooner in the eighteenth century. If it is correct that the schooner is a descendent of the seventeenth century ketch, this is not surprising.[30] Lane's coasting schooners are hardly distinguishable in hull form from his hermaphrodite brigs: slab-sided with blunt ends and plain looks. To allow them to reach shallow harbors and river ports several miles inland, their hulls tended to be shallow and broad, a characteristic confirmed by surviving builders' half models of this type and retained by later schooners in this trade.

Lane's harbor views show many inbound schooners with large deckloads of lumber from Maine and the maritime provinces of Canada. The woodlands of Gloucester and most other coastal towns of southern New England had long since been denuded of trees suitable for construction of any kind, compelling the importation of pine, spruce, cedar, and the northern hardwoods in very large quantities. Upon discharging their cargoes, coasters might return to home port with a variety of food, domestic items, and industrial wares, such as returns from the sale of their lumber cargoes might allow. No doubt much molasses and sugar from Surinam was resold to schooners returning to Maine ports.

Hay was another conspicuous cargo carried by coasting schooners, and Lane shows one example in *Gloucester Harbor at Sunset,* late 1850s (cat. 13) in the left foreground. Hay was much lighter than lumber, and despite the enormous deckload, the vessel is riding high in the water. Tarpaulins are stretched over it to prevent soaking; while under way, a lookout was posted to give the helmsman steering directions. Vessels used in this commerce tended to be older, outdated designs, but still had tight seams so seepage could not ruin the hay stowed in the hold. With the abundance of fields and salt marshes around Cape Ann, Gloucester was very likely self-sufficient in this commodity, so the vessel in Lane's painting is probably in transit to Boston with its cargo.

Merchant sloops are occasionally, if not frequently, shown in Lane's port scenes of Gloucester, but their heyday in the 1820s and 1830s had passed. The best examples are to be found in *Gloucester from Rocky Neck,* 1844 (cat. 2) (center middleground) and in the pencil drawing *Study of Vessels.* Both have high quarter decks, while the latter has square glazed ports across the transom, suggesting that they are packet sloops fitted to accommodate passengers and special freight for direct passages to other New England ports. As seaport towns prospered and grew, the need for faster direct communication grew, and larger packet vessels were needed. The sloop rig became very unwieldy for larger hulls and was largely abandoned for the schooner rig. Only in the highly specialized business of freighting stone from Cape Ann quarries did the rig survive; the large single mast was ideally suited as a derrick post for working the heavy loading boom. A few of the older stone sloops survived to have their pictures taken; they did not differ appreciably from their packet counterparts in Lane's views (fig. 23).[31]

Although the numbers of fishing schooners increased markedly in the 1830s and 1840s, this was a static period for their design as well as older fishing methods. Fishing on Georges Bank began early in the 1830s, giving rise to a class of large, heavily

fig. 23. *Stone Sloops at Pigeon Cove, Massachusetts*, c. 1890, stereograph [The Mariners' Museum, Newport News, Virginia]

fig. 24. Martha Hale Harvey, *Pinky and Mackerel Seiner, Gloucester Harbor*, c. 1900, glass plate photograph, 5 x 7 in. [Annisquam Historical Society]

built schooners called "bankers," which brought their catch to market salted, and which had a reputation for slow sailing and poor handling to windward. Without the market incentive—and ice—to bring fish to market speedily, slow burdensome schooners were favored because their owners got more carrying capacity for their investment than with sharper hulls.[32] Lane's painting *Gloucester from Rocky Neck*, 1844 (cat. 2) shows two bankers in the right middleground, while *Gloucester Harbor*, 1848 (cat. 10) shows five or six excellent examples of the type. Well-built of durable materials and handsomely finished, their appearance is otherwise unremarkable.

Smaller, but much more distinctive, was the pinky, a double-ended schooner-rigged boat whose bulwarks and rails projected aft around the rudder head and ended in a graceful upsweep, which served as a crutch for the main boom when sails were lowered. The type name is derived from the much older term "pink," which described a multitude of European rigs whose hulls had a similar form of stern. The pinky and its smaller antecedent, the Chebacco boat, were lineal descendents of the colonial shallops, large double-ended open boats with two-mast rigs. Pinkies were regarded as one of the most seaworthy vessel types ever used in the fisheries, but the design had practical limits to

size and deck arrangement.[33] As larger schooners were added to the fishing fleet in the 1830s, construction of pinkies declined on Cape Ann until no more were built after 1845, although several of them survived into the twentieth century. Their picturesque appearance must have interested Lane, for they are frequently to be seen in his paintings, drawings, and lithographs, and are not confined to his Gloucester scenes. The sheer line and stern of this type are very challenging to draw correctly, particularly in perspective, yet Lane did not hesitate to depict them from any angle, and very successfully in most cases. Indeed, it is possible that Lane's representations of pinkies are more accurate than photographs of relict examples whose many rebuildings and alterations had destroyed much of the original form and detail. A model of this type built recently by the author, using plans derived from a builder's half model, bore a much stronger resemblance to Lane's representations than to photographs of aged and rebuilt pinkies.

In most views, Lane's pinkies are either at anchor or in the process of entering or leaving port with few hints as to the nature of their fishing gear. In *Becalmed off Halfway Rock*, 1860 (cat. 41) we find one fitted out for gillnetting, mackerel being the likely fare. By the 1840s, setting gillnets for fish swimming near the surface (an old European method) had been adopted

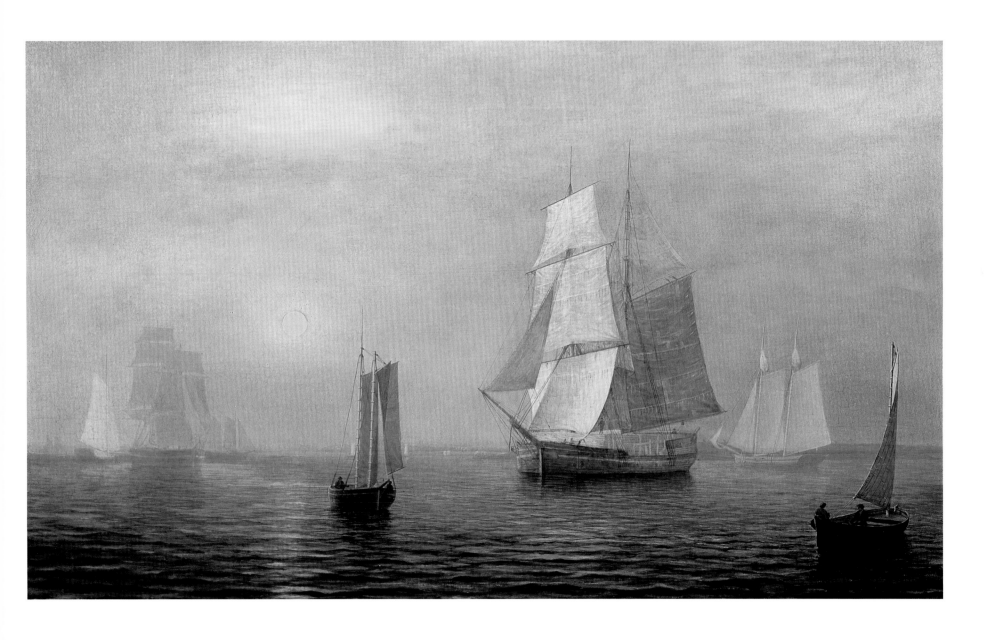

cat. 32. *Shipping in Down East Waters*, c. 1850, oil on canvas, 17³/4 x 30 in.
[William A. Farnsworth Library and Art Museum, Rockland, Maine]

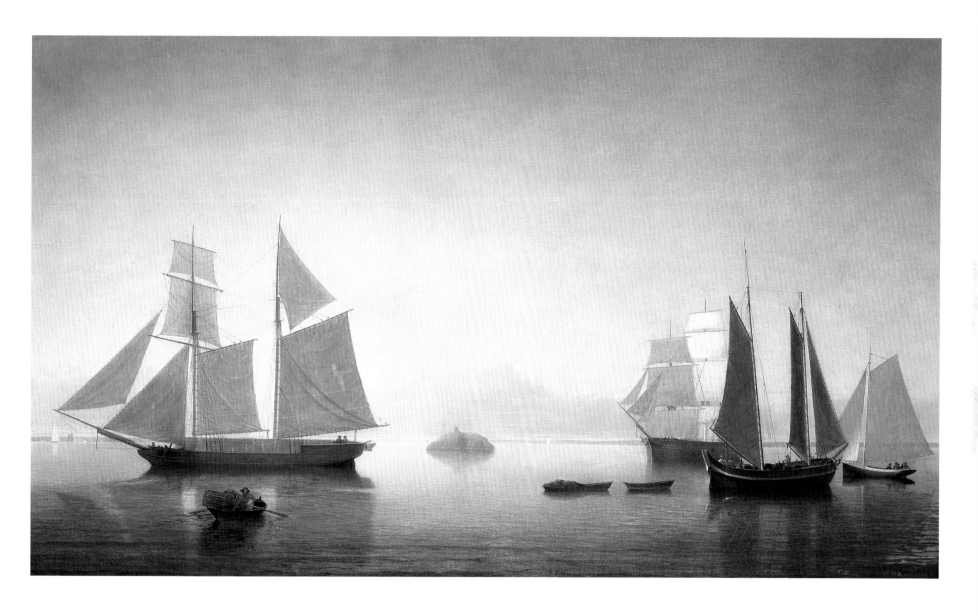

cat. 41. *Becalmed off Halfway Rock*, 1860, oil on canvas, 29 x 48¹/₂ in.
[From the Collection of Mr. and Mrs. Paul Mellon, Upperville, Virginia]

fig. 25. Lane, *Sloop*, 1850s, pencil, 9½ x 11¾ in. [Cape Ann Historical Association]

fig. 26. *Maine Fishing Sloop*, c. 1890, photograph [Maine Maritime Museum]

by poorer New England fishermen whose smaller boats could not compete in the banks fishery. By setting the nets in the way of a suspected school of mackerel, herring, or menhaden, large numbers could be caught without the expense of trawl lines, bait, and large crews. Only the schooner, the net, two boats, and a small crew were required.[34] Lane's painting shows a dory and a larger net boat (possibly a discarded whaleboat) in tow.

Sloop-rigged fishing boats are difficult to identify in Lane's paintings. An occasional merchant sloop is to be seen, while some of the very small sloops could be pleasure craft. A few, such as the one in the middle foreground of *Gloucester Harbor*, 1852 (cat. 7) are really yawl boats—rowing craft whose sails are a secondary form of propulsion. It has long been presumed that the small fishing sloop (or "sloop boat," as Cape Ann fisherman called this rig in its diminutive form) had its origins on Cape Ann and spread to other New England ports.[35] If so, this process was only beginning in Lane's time and very few caught his attention, as in the left middleground of *Fresh Water Cove from Dolliver's Neck, Gloucester,* early 1850s (cat. 8) (the sloop in the center is probably a small freighting vessel). The boat in the

center of *Gloucester from Magnolia* may also be an early sloop boat. One of his sketches from the 1850s is a fine example of the hull form and rig associated with sloop boats built as late as the 1890s (fig. 25). A photograph of a Maine fishing sloop from the turn of the century shows how little the type changed over the next fifty years (fig. 26).

Chebacco boats and pinkies were certainly not the only descendents of the colonial shallops; indeed, the two-mast double-ended open boats with lapstrake hulls evolved into later types that kept a much closer resemblance to their eighteenth-century forebears. By the late nineteenth century they had differentiated into local types such as the Hampton boat, the Casco bay boat, and the Isles of Shoals boat.[36] In Lane's time, there were many small boats that met the basic shallop description, but if their type was defined, the name has been lost. A model of established provenance, representing a two-mast boat from Rockport in the 1850s, is labeled the "sloop" *Susan*, suggesting that the term "sloop" embodies a definition by hull form, not rig.[37] Since the word "sloop" is derived from "shallop," this is apparently a case of an archaic definition surviving locally, long after it had changed in other areas. Given this confusion, and lacking any better local terminology, students of this small craft type have chosen "New England boat" as a general term, reserving specific names for the later regional variants.

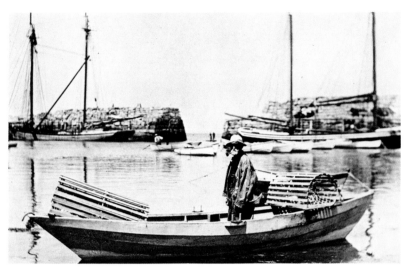

fig. 27. *Lobster Fisherman and Dory, Lane's Cove, Gloucester*, c. 1900 [Peabody Museum of Salem]

Thus named, the New England boat is a common denizen of Lane's harbor views, particularly as an element of the background scenery. In *Good Harbor Beach, Cape Ann*, 1847 (cat. 5) and *Gloucester Harbor*, 1852 (cat. 7) examples of the double-ended type figure prominently, while a later version with a transom stern appears in the right middleground of the latter. Most of these boats are pictured with gaff-headed sail plans; spritsails are uncommon. Larger examples often have short bowsprits, jibs, and stayed masts; the very largest appear to be decked over to some extent, usually in the form of cuddies at the ends. With some modification, New England boats survived in Cape Ann harbors until the first decade of this century. They were principally used in the shore fisheries, lobstering, hand-lining, gillnetting, and trap fishing. A poor man's boat, they largely disappeared from Gloucester Harbor after the Civil War and became fixtures of smaller Cape Ann fishing communities, principally Rockport and Pigeon Cove.

The smallest boats used in the fisheries were the yawl boat and dory. The former was intended as a lifeboat and tender for larger schooners, from whose stern davits they hung. Yawl boats were usually of the best materials and workmanship and thus not cheap, but old boats discarded by the bankers were put to use in the shore fisheries. These craft were often purchased by chandleries and other waterfront businesses as water taxis and errand boats.[38] They were frequently rigged for sailing, as in

Gloucester Harbor, 1848 (cat. 6) using either a gaff or sprit rig. In the foreground of *Gloucester Harbor*, 1847 (cat. 10) a yawl boat is shown overturned while its owner is filling the seams with hot pitch. This type had probably been carried on in form and function for over a century when Lane was drawing them, and its use in the fisheries would last until the 1880s, when the fishing methods of the bankers were superseded altogether by trawling with dories. Schooners in the coasting trade carried them to the end of their working days (the 1940s), while a few relics of that type that have survived in the summer cruise trade in Maine use very similar modern versions of yawl boats.

While we think of the dory as a boat carried in large numbers on the decks of fishing schooners for trawling and hand-lining on the banks, in Lane's time it was used only in the shore fisheries, usually by individuals too independent to go fishing with others and too poor to afford anything but the cheapest boat and gear.[39] Dories frequently dot the shorelines of Lane's harbor views and one occasionally wanders into an offshore scene. Their simple yet distinctive hull form with straight sides and angular ends contrasts strikingly with the rounded forms of the yawl boats and New England boats—something Lane no doubt appreciated and utilized in his compositions. In some paintings there is human activity involving dories, possibly because their work in such proximity to the shore allowed Lane to observe and sketch them in detail. In *Good Harbor Beach, Cape Ann*, 1847 (cat. 5), the dory at the right is pushing off, to be joined by the New England boat also getting under way. The two craft will probably work together setting a gillnet. In the left background, a solitary dory can be seen tending such a net. Another shore detail, in *Sunrise through Mist*, 1852 (cat. 42), shows a dory and yawl boat with their crews hauling them ashore and taking out the fishing gear.

A number of offshore scenes also show dories in action; the fishing dory in the ship portrait *Three Views of Yacht America* has already been mentioned. In *Becalmed off Halfway Rock*, 1860 (cat. 41), a particularly interesting situation appears in the left foreground, where a lobsterman rows his dory with several lobster pots in the stern. This is very useful graphic documentation of this fishery, which is otherwise sparsely described at this time. Forty years later, a photographer could still take pictures of the same types of boats and gear. About the only thing that changed was the style of the hats the fishermen wore (fig. 27).

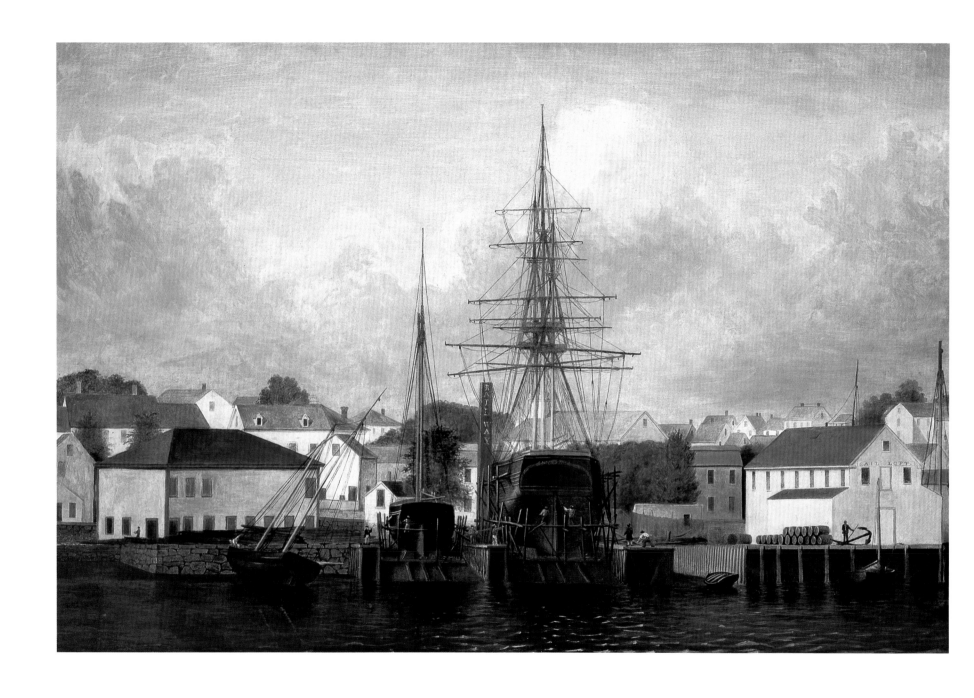

cat. 39. *Three-Master on the Gloucester Railway*, 1857, oil on canvas, 39 1/4 x 59 1/4 in. [Cape Ann Historical Association]

Several of Lane's scenes of Gloucester are of interest for the waterfront activity they show, ranging from the sublime to the mundane. Of the latter, the pitching of the yawl boat's bottom in *Gloucester Harbor*, 1847 (cat. 10) has already been mentioned. Regarding fishing activity, *Gloucester Harbor*, 1848 (cat. 6) offers a foreground view of a New England boat hauled ashore with a splitting table set up alongside it for cleaning and dressing the catch. Two of the crew are carrying away dressed fish while a third continues with the splitting. The pile of fish heads and entrails under the table looks like early testimony to the pollution of Gloucester Harbor, then as now.

Icing over of the harbor caused much of the work usually done at wharves to be moved to unaccustomed places. In the winter of 1855–1856, the inner harbor froze solidly out to an imaginary line between Rocky Neck and Duncan's Point. The following year, the entire harbor froze over, with a line of ice stretching from Eastern Point to Norman's Woe. *Ships in Ice off Ten Pound Island*, 1850s (cat. 3) records what is probably an early stage of the second freeze and was undoubtedly painted from direct observation from Lane's second floor studio at Duncan's Point. The group of people in the center background is busy cutting a channel through the ice to free the outward-bound schooner and bark.

Lane's most imposing waterfront scene is *Three-Master on the Gloucester Railway* (cat. 39), which was originally a shop sign for John Tarr's paint shop located in the railway's machinery building. The sign was much publicized when it was hung in 1857, and each building, particularly houses belonging to owners of the railway and adjacent businesses,[40] was identified as to its owner. Comparison of their locations in the painting with building positions given on city street maps reveals a number of discrepancies, the net result being that buildings belonging to the railway or its owners are given prominence. The railway site itself is quite accurate in the layout of its buildings and the orientation of the finger piers. The perspective views of the vessels are seemingly satisfactory, if not representative of the most graceful hull forms, and the rigging seems very reasonable in proportions. When this painting is compared to a photograph of a similar situation, the similarities of common features are quite startling (fig. 28). Were it not for the fact that the photograph was taken five years after Lane's death in a shipyard two hundred miles to the east, it would be easy to speculate that he had

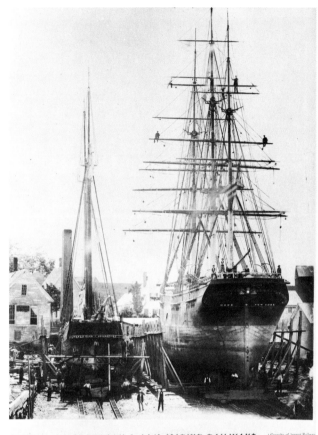

fig. 28. *Wm. McGilvery & Co.'s Marine Railways*, 1870 [Peabody Museum of Salem]

used the photograph for reference. While this coincidence is striking, it lends credence to the view that Lane's draftsmanship was nothing less than masterly and that he had full command of every situation that made critical demands on his handling of form, proportions, and perspective. If discrepancies exist between his compositions and the subjects, they are more likely to be intentional than accidental, reflecting his ideas, and perhaps his customers' wishes. So well had Lane sharpened his eye for delineating the images he saw or wanted to see, and so well had he mastered his drawing technique, that his hands could draw with easy deliberation while his mind and eye could dwell on the problems of light and color, which brought realism and vitality to his pencil lines.

While Lane discovered in Maine's coastline a new world to

fig. 29. *Northport, Maine*, c. 1880. The hard gravel shoreline of this inlet provided good conditions for hauling small craft and beaching larger vessels for repairs. The schooner is a good example of the plainer type used for freighting stone, lumber, hay, and other bulky cargoes [private collection]

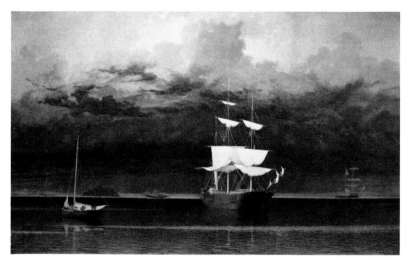

cat. 51. *Approaching Storm, Owl's Head*, 1860, oil on canvas, 24 x 39⁵⁄₈ in. [private collection]

paint, most of the ships and boats he encountered must have been very familiar. Cape Ann was both a terminus and a temporary refuge for the Maine coastal traders as they sought markets to the south and west for lumber, hay, stone, lime, potatoes, and whatever else could be coaxed from a reluctant land, dragged to the sea or riverbank, and loaded onto a freighting vessel. In Lane's time, the sea was the most important route of access to Maine; overland, it was impassable for movers of bulk loads, and even the railroads were unable to remedy this situation for much of the coast line. Not until the advent of asphalt highways and motor trucks in the 1930s were there major changes in the transportation of freight to, through, and from this state.[41] The bulk of Maine's population was then concentrated along its shore line whose peninsulas and islands project like fingers out into the Atlantic. From Searsport to Castine is seven miles by water across Penobscot Bay, but twenty-five miles by the road that goes around it. Compound this geography with winter weather that makes roads impassable, and the necessity of seaborne transport in Maine should be obvious. For an artist visiting this state in summer, the sea lanes were not only essential for travel, but sublime in their beauty born out of a reluctance to be tamed and reshaped in the image of southern New England. Against this background, the simpler rigs and plainer hulls of coasters and fishing boats would have seemed more logical and in keeping with their surroundings.

Among the larger trading vessels portrayed by Lane, hermaphrodite brigs, topsail schooners, and fore-and-aft schooners predominate. An occasional ship or bark appears, as in *Approaching Storm, Owl's Head*, 1860 (cat. 51), which serves to remind us of farther flung ambitions of many Maine shipowners and shipbuilders. In this period, Maine shipbuilding was hitting its stride as the leading producer of deep water tonnage on the American east coast. The largest ships were built for commerce between foreign ports and major American seaports to the south; they seldom, often never, returned to the places where they were built. This exodus did little to build up foreign commerce with Maine, but it kept thousands of inhabitants of coastal and river communities steadily employed in shipyards.[42]

If the rigs of Maine coasters looked familiar, their environment was most striking. Anchored in tidal inlets, sometimes hard aground at low tide, the idyllic surroundings of woodlands and sparsely settled villages present a jarring contrast to the businesslike waterfront of Gloucester Harbor, not to mention Boston. In *Bar Island and Mt. Desert Mountains from Somes Settlement*, 1850 (cat. 50), Lane has captured a sense of this environment, which yields reluctantly and only temporarily to man. The grounded schooner at the right is very typical in its small size, shallow draft, and flat bottom which combine to make the vessel take the ground more easily as the tide ebbs. To load a coaster under these conditions, the vessel was sailed up to the

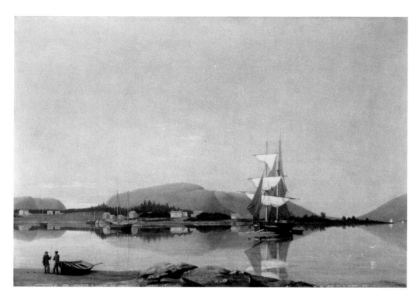

cat. 57. *Entrance of Somes Sound from Southwest Harbor*, 1852, oil on canvas, 23³/₄ x 35³/₄ in. [private collection]

fig. 30. H. A. Mills, *Rockport, Maine*, c. 1880, stereograph [Maine Maritime Museum]

fig. 31. *"General Gates" at anchor off our Encampment at Bar Island in Somes' Sound, Mt Desert Maine*, August 1850, pencil on paper, 9¹/₂ x 11 in. [Cape Ann Historical Association]

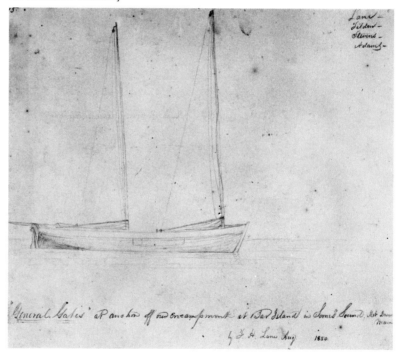

shore or riverbank where the bottom was free of rocks; whatever loading ramps or gangways were needed were put aboard or ashore, and loading (by hand) commenced.[43] Larger vessels might have to be loaded at a mooring, using barges or floats. The hermaphrodite brig in *Entrance of Somes Sound from Southwest Harbor*, 1852 (cat. 57) is being loaded this way. Loading ports have been cut in her bow so lumber can be passed into her hold without having to pass each board over her decks and awkwardly through small deck hatches. However the vessels were loaded, land lay close aboard, often rising precipitously and cloaked with vegetation which threatened constantly to reclaim any man-made structures. A stereograph view of Rockport, lying halfway up the west shore of Penobscot Bay, conveys a sense of this tenuous balance (fig. 30).

In the part of the Maine coastline that Lane visited, fishing was done on a much smaller scale than at Gloucester. Pinkies were still very much in favor, with their ideal size for the herring and mackerel fishing that prevailed in this area. Many of the larger pinkies had been built on Cape Ann and were sold down east, some new, others used. The larger examples differ little from those Lane painted in his Gloucester scenes. Pinkies were built in Maine, though they tended to differ in ways that maritime historians are still studying.[44] The type remained popular in this state until the early 1900s.

Among the smallest Maine boats for fishing and harbor commerce, a transom-sterned version of the New England boat appears in several of Lane's pictures. A drawing of one example is *General Gates* (fig. 31), in which he did most of his cruising; this may also be the boat that appears in his view of Castine. A very similar example (if not the very same boat) is the subject of *Fish-*

fig. 32. Martha Hale Harvey, *Schooner-boat Gray Eagle at Head of Lobster Cove, Annisquam*, c. 1890. This large Casco Bay boat is a derivation of the New England boat, from which the Hampton boats also descended. The type is often regarded as a variation of the Hampton boat [Annisquam Historical Society]

fig. 33. *Ship "Sacramento" on Marine Railway*, c. 1870 [Cape Ann Historical Association]

ing Party, 1850 (cat. 48). Transom-sterned New England boats became quite popular in Maine, and one distinct version came to be known as the Casco Bay boat in the 1880s. Named for the body of water on which Portland is situated, examples of the type survived to the end of the century, one of them ending its days in a small Cape Ann harbor. Surviving plans and photographs seem to indicate that some later Casco Bay boats were sizeable enough to warrant simple schooner rigs with stayed masts (fig. 32). They were usually of lapstrake construction.[45]

The watercraft of Maine probably offered no surprises to Lane, who in turn treated the subject realistically on canvas. His depiction of individual craft seems neither flattering nor condescending, and if they are fewer in number, the striking contrasts they make against wooded coves and sparse settlements serve as effectively as the complex gatherings of mast and sail against the harbor skylines of Gloucester and Boston.

While Boston and New York were the principal centers for the advancement of merchant ship design and the production of innovative sailing and steam vessels, their highest proportions of tonnage consisted by far of older, conservatively designed ships and boats. Lane was obviously aware of this situation and his port scenes of these cities are veritable concourses of the old and the new, the traditional and the experimental in ship technology. Having discussed Lane's pictures of innovative craft, some mention of the others is needed.

The large full-rigged ship was the workhorse of the deep water trade, carrying the heaviest and bulkiest goods in the largest quantities possible. Its hull form was governed by tonnage laws that determined arbitrarily the vessel's cargo capacity for purposes of levying harbor dues by port customs agents. Capacity was expressed in tons and was based on measurement of length, beam, and depth of the hold between specified structural points. The measurements were then applied to a formula, minus certain allowances, which was divided by ninety-five to give a measurement of volume called registered tonnage. By this formula, a vessel was always said to *measure* so many tons, never to *weigh* that amount. Because the points of measurement were arbitrarily chosen and no effort was made to determine actual hull volume or displacement weight, it was not difficult to design hulls whose tonnage measurements looked modest on paper, but whose hold capacity far exceeded that envisioned by the rule makers. Length and beam were measured over upper portions of the hull, so builders were free to make the ends as full and bluff as they wished; in some vessels, the sides of the bottom bulged out until the hull in cross section resembled an iron kettle, hence the nickname "kettle-bottom." The sleek hulls of the clipper ships and the rage for speed in the 1850s had some moderating effect on this trend, but not until 1864, when

cat. 37. *New York Harbor*, mid 1850s, oil on canvas, approx. 23½ x 35½ in. [private collection]

tonnage legislation based on actual measurements of hull volume was passed, did builders have incentive to use more wholesome designs for ships in bulk cargo trades.[46]

A photograph of the Boston-owned merchant ship *Sacramento* shows very well the bottom form of a very burdensome large merchantman; her beam under water is almost three feet more than at her rails (fig. 33). This ship was built in 1865, exactly the time when the new tonnage laws took effect, so her

design was probably conceived in the previous year with the old regulations in mind. Even so, she is moderate by comparison with the "kettle-bottoms" in the cotton trade of a few decades earlier. *Sacramento's* hull is an excellent one to compare with burdensome examples in Lane's paintings and drawings. The large merchant ship in the left foreground of *New York Harbor*, mid-1850s (cat. 37), is decidedly of similar hull form, and Lane's delineation of the bluff ends and tumble-home sides conveys an

fig. 34. *Beached Hull,* 1862, pencil, 14 x 15 in. [Cape Ann Historical Association]

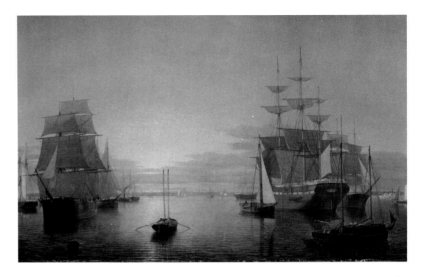

cat. 24. *Boston Harbor at Sunset,* 1850s, oil on canvas, 26 x 42 in. [Museum of Fine Arts, Boston]

accurate image of the topside mass while giving the impression that there is considerable submerged bulk as well.

An even better idea of Lane's comprehension of this kind of hull form can be gained by comparing the photographs of *Sacramento* with his oil, *"Dream" Painting,* or the sketch he made for that canvas (fig. 34). Despite the visual obstruction of the rocks and the twisting of the hull, it is obvious that Lane had a firm grasp of the geometry of this hull type and could delineate it with accuracy. The concept of hull mass is a difficult one for artists to master unless they have spent considerable time studying plans of ships' hulls and sketching the actual vessels when hauled out so their underwater shapes are plainly visible. Too often a painting conveys the impression of a hull floating on the surface of the water with no part of it submerged, in total contradiction to the physics of displacement by floating objects. This is a lesson Lane mastered and put repeatedly to good use. In *Boston Harbor at Sunset,* 1850–1855 (cat. 24), we have a textbook study of floating vessels in perspective, each hull posing a very different problem in terms of form, degree of immersion, and angle of view. The wall-sided brig at left floats as if half her hull volume is submerged, as it would be for a vessel partially loaded or in ballast (carrying no cargo, but having extra ballast in the hold for stability). The large packet ship at right is seen from nearly the same angle as the stern view of *Sacramento;* having discharged all her cargo, she is said to be floating

light. The little New England boat, left of center, is also correctly trimmed for hull bearing only a light load. Of particular interest is the sloop to right of center with her main sail and staysail set; the perspective of this hull warrants comparison with that of a deeply loaded schooner photographed some forty years later. The sloop is a bit more boxy in shape, but the S-shape of the sheer at the rails is very similar and rises gracefully at bow and stern (fig. 35). Both vessels are carrying heavy loads, giving the impression that their hulls are mostly under water and rather resistant to motion unless at the prodding of a good breeze. It is this awareness of hull mass, how a ship floats, and how it moves through the water that so often sets Lane's ships apart from those of his contemporaries. Lane both appreciates these properties yet treats them with such ease that we sense their correctness without thinking, without feeling compelled to analyze them to the point of being distracted from their beauty. This unbelabored treatment is undoubtedly also why his vessels fit so easily into his compositions, for they blend with their uncontrived surroundings, harmonizing rather than competing with other elements for the viewer's attention. By painting ships this way, Lane has given us a visual record whose value transcends that of purely technical information.

Minor watercraft vary considerably in their importance to scenes of Boston and New York. In *Boston Harbor,* 1854 (cat. 29), they dominate the foreground, relegating the ships to distant

cat. 29. *Boston Harbor*, 1854, oil on canvas, 23¼ x 39¼ in. [White House Collection]

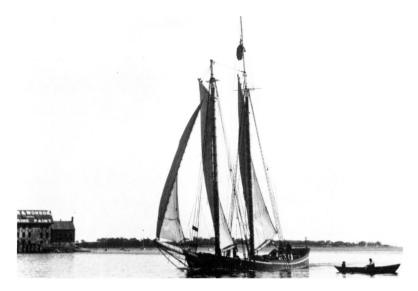

fig. 35. Ernest L. Blatchford, *Coasting Schooner off Rocky Neck, Gloucester*, c. 1900, glass plate photograph, 5 x 7 in. [Cape Ann Historical Association]

objects of secondary importance, not unlike the large views of Gloucester Harbor. At right, a sloop (probably used as a lighter) has made fast to a mooring, possibly awaiting an inbound vessel whose cargo she will discharge. The crew has done a hasty job of lowering the main sail, which is trailing in the water, a demonstration of seamanship that deep-water sailors would have laughed at. The large New England boat to right of center has lowered her sails a bit less sloppily, but again in a display of boat handling viewed disdainfully by sailors who manned the clippers and packets. Other Boston views show similar if less prominent small craft at work, particularly in the foregrounds, and often with purposeful and sometimes amusing human activity.

Lane's New York port scenes offer a number of small craft that provide interesting contrasts to the very large ships and the gigantic scale of activity in that harbor. The 1860 view, which is packed with sailing vessels and steamers of every sort, gives its foreground over to a sloop (at left), a pulling boat (center), and a small coasting schooner (at right). The first may be a small version of the great Hudson River sloops, but a very plain one; the schooner is also very undistinguished. More interesting by far is the pulling boat, which seems to be a very large Whitehall boat, a type of rowing craft that originated in the boatshops of Whitehall Street, New York, and was used in great numbers for conveying people and goods around the harbor. Merchants and harbor officials used it as a water taxi; chandleries used larger versions to bring cordage and hardware out to ships; crimps

used the largest models to ply their nefarious trade-supplying vessels with crews "recruited" with liquor and two-fisted persuasion. Whitehall boats were similar to yawl boats, but of much finer model and lighter construction; they were designed and used as harbor craft, and were seldom carried as ships' boats, and then usually as a gig for the captain's personal use.[47]

The numbers and diversity of the ships and boats of Boston and New York harbors must have posed the most difficult sort of challenge to Lane in his efforts to depict these cities as recognizable seaports and not simply gatherings of ships against a detached coastline with a few recognizable features. To add to this problem, the scale of these seaport communities was matched by the scale of shipping activity, forcing the artist to portray the whole from a much greater distance. Inevitably, this resulted in a loss of the intimacy that we sense in his scenes of Cape Ann and Maine, and the city skylines, while instantly recognizable, no longer include the purposeful vignettes of waterfront activity that link the watercraft to the land. Perhaps in an effort to compensate for this, Lane gave a great deal of attention to the lesser craft, adding lively and occasionally humorous activity by their crews. We see the same kind of activity in his Gloucester views, but against a very different background, which harmonizes with it instead of offering stark contrasts. If Lane tired of the large scale of Boston and New York harbors, the endless di-

versity of vessel types, and the diminishing activities of the fishermen, it is no wonder that he turned to the tranquility and simplicity of Maine and Cape Ann harbors in his final years of painting.

In the last five years of his life, Lane produced what many art historians regard as his most interesting and perhaps most individualistic work. In terms of subject matter, there was a decided turning away from the busy harbor scenes and meticulous ship portraits to simpler compositions with only one or two vessels, and sometimes to subjects with no maritime theme whatever. Wrecked hulls were seldom seen in his earlier canvases; now, they were the dominant elements in many. Did these changes arise from a profound shift in Lane's outlook on life, or were there changes in the American shipping scene that caused him to turn to other subject matter?

In 1857, the fortunes of the American merchant fleet began to change, as iron shipbuilding in Britain and generally lower shipbuilding costs in the rest of Europe undercut the demand for American-built wooden ships, while iron-hulled steamers began to outperform the packets and clippers. American tonnage continued to rise until 1862, but the market for these vessels was glutted and profits from voyages were marginal to nonexistent. By the early 1860s, many merchants found it more profitable, and even expedient, to sell their ships to foreign firms and have their goods carried under foreign flags. The threat (however exaggerated) of Confederate commerce raiders transformed this trend into a stampede in 1863; two years later, the American fleet was barely more than half the size it had been at its peak.[48]

This did not mean that harbors like Boston were suddenly idle and deserted, for the wartime economy needed more foreign trade than ever, which was now handled by foreign shipping. Its volume rose to make up for the American tonnage deficit, and continued to grow as international commerce burgeoned as a result of wartime needs.[49]

The fisheries industries prospered throughout the war years as both civilian and military demands for fish increased steadily. Shipbuilding statistics in towns like Essex show a drop in productivity for these years, and this was likely due to a shortage of skilled workers and suitable timber as wartime needs diverted manpower and materials to the navy yards.[50] Severe storms took their toll on the fishing fleet, further exacerbating the problem of maintaining schooners in adequate numbers. Despite the dif-

ficulties, Gloucester Harbor was neither empty nor inactive in these years; those fishermen who did not enlist in the army or navy kept on at their work and prospered.[51] Nor is it likely that the character of the waterfront altered markedly, for the same reasons that few schooners were built. The greatest changes to the fleet and waterfront were to come about in the Reconstruction years and later.

If the content of Lane's paintings changed in his last years, it was not due to drastic alterations in the character of the harbors and vessels he once painted. If anything, wartime conditions may have arrested changes to the fisheries as the fishermen were forced to make do with the vessels and gear they already had. Gloucester Harbor would remain a familiar place to Lane until his death. If he sought new themes and subjects to paint, he must have done so in response to some inner need or drive, and the answer to this problem is not likely to be found by historians of ships.

Having examined Lane's drawing ability, his technical knowledge of ships, and his knowledge and understanding of maritime New England, an assessment of his accuracy has been attempted by comparing his work with surviving documentation of his subjects. Photographs have been the primary sources for this comparison with the conditions that the subjects be contemporaneous to the subjects in Lane's pictures, and that noncontemporaneous subjects demonstrate their relationship through close resemblance and demonstrable derivation. These provisions have narrowed the field of eligible material, and the sample at hand may be biased due to such narrow choices; however, there is a strong and consistent pattern of resemblance to Lane's pictures or elements in them.

This is not to say that there are no discrepancies between Lane's work and the photographic record. There are in fact numerous examples, particularly in the rigging of sailing vessels and in the placement and proportions of landmarks and buildings in coastal scenes. The former problem is largely a consequence of major changes to sailing ship rigs and their details following the Civil War; many older vessels were rerigged by the time they were photographed, hence their rigging leads and hardware were no longer reliable. In many such cases, the correct question to ask is: what did Lane know about local rigging methods that we don't? The latter problem is often one of artistic license, and Lane is no more guilty in this respect than his

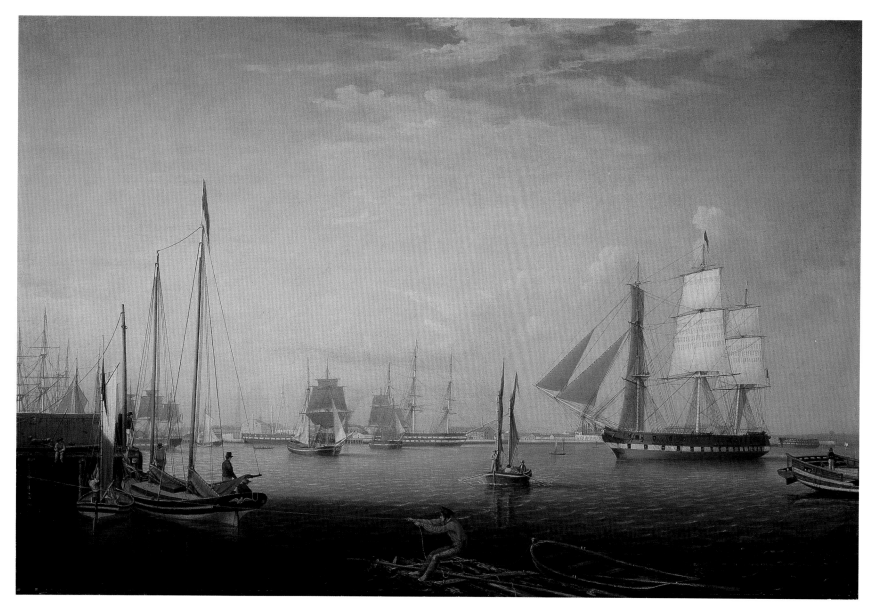

cat. 44. *Baltimore Harbor*, 1850, oil on canvas, 23¹⁵/₁₆ x 36¹/₈ in. [private collection]

contemporaries. The fact that so many of these differences are detectable and explainable from the viewpoint of artistic composition or a customer's wishes is ample ground for excusing them.

If critics cannot concede photographic precision to Lane's drawing, it is certainly very close to that—closer than Bradford's or Buttersworth's, and equaled in this country only by

Salmon's. We would have to resort to European masters like Huggins, Cooke, Mozin, and the Roux to find depictions of ships and harbors that some might fancy as being technically, if not esthetically, better. On balance, the evidence is compelling: Lane left an accurate and detailed pictorial record of the maritime world he witnessed.

1. John G.B. Hutchins, *The American Maritime Industries and Public Policy, 1789–1914* (Cambridge, Massachusetts, 1941), 257–263, 287–296. For a guide to nautical terms, see: *The Visual Encyclopedia of Nautical Terms under Sail* (New York, 1978).

2. Howard I. Chapelle, *The History of The American Sailing Navy: The Ships and Their Development* (New York, 1949), 312–314, 353–355.

3. Hutchins, *American Maritime Industries*, 287, 288.

4. Howard I. Chapelle, *The National Watercraft Collection, Second Edition* (Washington, D.C., 1976), 112–121.

5. Howard I. Chapelle, *The Search for Speed Under Sail, 1700–1855* (New York, 1967), 364, 365.

6. Lauchlan McKay, *The Practical Ship-Builder* (New York, 1839).

7. John W. Griffiths, *Treatise on Marine and Naval Architecture* (New York, 1849).

8. L.H. Boole, *The Shipwright's Handbook and Draughtsman's Guide* (Milwaukee, 1858).

9. William A. Baker, *A Maritime History of Bath, Maine, and the Kennebec River Region* (Bath, 1973), 338–340.

10. Chapelle, *Search for Speed*, 283–295.

11. An unfinished painting (M10101) by François Joseph Frederic Roux (1805–1870), with only the pencil drawing and sky wash, was found on the reverse side of a finished work (M9778) in the Peabody Museum of Salem. See Philip Chadwick Foster Smith, *The Artful Roux: Marine Painters of Marseilles* (Salem, Massachusetts, 1978), 48, 49, 54, 55.

12. John J. Babson, *History of the Town of Gloucester Cape Ann, Including the Town of Rockport* (Gloucester, Massachusetts, 1860), 254.

13. Augustin Jal, *Glossaire Nautique* (Paris, 1848).

14. Robert Bennett Forbes, *Personal Reminiscences*, 3d rev. ed. (Boston, 1892).

15. "The Japan and China Packet Propeller Antelope," *The U.S. Nautical Magazine and Naval Journal* (October 1855), 11–17.

16. W. Earle Geoghegan, "The Auxiliary Steam Packet Massachusetts," *Nautical Research Journal* (spring 1969), 27–35.

17. Paul F. Johnston, *Steam and the Sea* (Salem, 1983), 63–65.

18. Octavius T. Howe and Frederick C. Matthews, *American Clipper Ships, 1833–1858*, vol. 2 (Salem, 1927), 585–594. The *Boston Atlas* description of *Southern Cross* has been attributed to Duncan McLean.

19. M. V. Brewington, "Signal Systems and Ship Identification," *The American Neptune* (July, 1943), 211–214.

20. Ray Brighton, *Clippers of the Port of Portsmouth* (Portsmouth, 1985), 127–130.

21. Howard I. Chapelle, *The History of American Sailing Ships* (New York, 1935), 311, 312.

22. L. Francis Herreshoff, *An Introduction to Yachting* (New York, 1963), 60, 61.

23. Chapelle, *American Sailing Ships*, 304–311.

24. Howard I. Chapelle, *The American Fishing Schooners, 1825–1935* (New York, 1973), 58–75.

25. Samuel Eliot Morison, *The Martime History of Massachusetts* (Boston, 1921), 308–312.

26. Statistics compiled by the author from Stephen Willard Phillips, *Ship Registers of the District of Gloucester, Massachusetts, 1789–1875* (Essex, 1944).

27. "The Surinam Business," serial newspaper clipping in scrapbook, vol. 18, Cape Ann Historical Association.
Ships' data compiled by the author from Phillips, *Ship Registers*.

28. A. Howard Clark, "The Fisheries of Massachusetts" in *The Fisheries and Fisheries Industries of the United States*, Section II, ed. G. Brown Goode (Washington, 1887), 167–169.

29. William A. Baker, "Schooner Design and Construction," lecture given at Marine Symposium, Maine Maritime Museum, 1973.

30. William A. Baker, "Fishing Under Sail in the North Atlantic" in *The Atlantic World of Robert G. Albion*, ed. Benjamin W. Labaree (Middletown, 1975), 59, 60.

31. Chapelle, *American Sailing Ships*, 298–301.

32. Chapelle, *American Fishing Schooners*, 61–64.

33. Howard I. Chapelle, *American Sailing Craft* (New York, 1936), 125–132.

34. R. Edward Earll, "The Herring Fishery and the Sardine Industry" in *The Fisheries and Fisheries Industries of the United States*, Section V, ed. G. Brown Goode (Washington, 1887), 426–432.
Wesley George Pierce, *Goin' Fishin'* (Salem, 1934), 145–147.

35. Chapelle, *American Sailing Craft*, 112.

36. Howard I. Chapelle, *American Small Sailing Craft* (New York, 1951), 136–145.

37. Rigged model of fishing sloop *Susan* by George M. McClain, representing the first fishing boat he owned after moving to Cape Ann, late 1850s, collection of Sandy Bay Historical Society and Museum, Rockport, Massachusetts.

38. Chapelle, *American Small Sailing Craft*, 222, 223.

39. Chapelle, *American Small Sailing Craft*, 85.

40. John Wilmerding, *Fitz Hugh Lane* (New York, 1971), 69, 70.

41. John F. Leavitt, *Wake of the Coasters* (Mystic, 1970), 3.

42. William A. Baker, *A Maritime History*, 438–440.

43. Leavitt, *Wake of the Coasters*, 121.

44. George S. Wasson, *Sailing Days on the Penobscot* (Salem, 1932), 175–185.

45. Chapelle, *American Small Sailing Craft*, 152–155.

46. John Lyman, "Register Tonnage and its Measurement," *The American Neptune* (July 1945, October 1945), 223–234, 311–325.

47. Chapelle, *American Small Sailing Craft*, 195, 196.

48. Hutchins, *American Maritime Industries*, 316–322.

49. Hutchins, *American Maritime Industries*, 323.

50. Dana A. Story, *A Catalog of the Vessels, Boats, and Other Craft Built in the Town of Essex* (Essex, 1984).

51. James R. Pringle, *History of the Town and City of Gloucester* (Gloucester, 1892), 121.

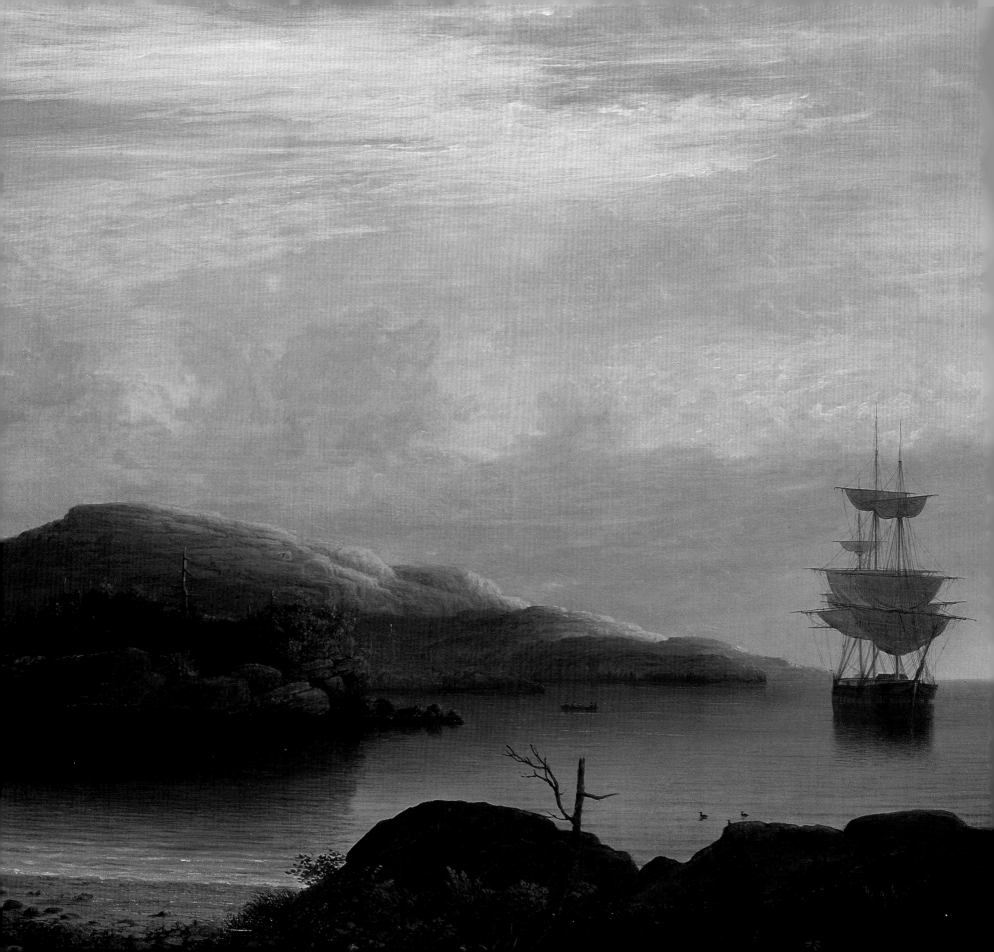

The Lure of Mount Desert and the Maine Coast

JOHN WILMERDING

AMERICAN GEOGRAPHY HAS ALWAYS SEIZED THE COLLECTIVE American imagination. From the time of discovery onward nature and nation have been mutually dependent in defining one another. The consciousness of a virgin wilderness of great and variable wonders helped create a national identity distinct from the old world of Europe, by definition newer and by conviction better. This was to be a landscape for democracy, where many of the country's great wilderness sites would be designated national parks for the people. Quite appropriately, as discovery and settlement moved westward, Americans could celebrate a multiplicity of natural wonders, some focal like the Natural Bridge in Virginia, others spatial like the great plains, some seemingly frozen in time like the Grand Canyon, others endlessly charged in motion like Niagara Falls. Rising in unique configuration from the sea, and containing America's only national park in the northeast, is Mount Desert Island on the Maine coast. Peculiar to its topography are the immemorial conjunctions of sheer cliffs and ocean plane, and of evergreen, pink granite, and northern light.

Fitz Hugh Lane made his first visit to the Maine coast in 1848 and returned on several trips thereafter during the summers of the 1850s. He sketched Mount Desert on at least three of these journeys, and painted views of the region over the entire fifteen-year period up to the end of his life. A number of these works now stand among his most sublime achievements.

By virtue of its location off the easterly running coastline, extending south some twenty miles into the open Gulf of Maine, Mount Desert possesses a certain image and actuality of isolation. Because its mountain summits slope off almost directly into the sea, a unique geological junction on the east coast of the north American continent, there is an additional visual drama to the island's silhouette against the horizon. From almost all approaching vantage points the intersecting lines of land and water appear clean and sharp, a characteristic that would have continuing appeal for artists recording the island's features over more than a century.

Another factor contributing to the sense of the island's singular presence is its relative inaccessibility. Situated on a rugged part of the northeast coast, Mount Desert lies approximately two-thirds of the way along the Maine shore from the New Hampshire to Canadian borders. Nearly three hundred miles from Boston, it is reached even today by a long overland trip from New England's largest population centers. During the early centuries of discovery and settlement the most common approach was by water, and as Samuel de Champlain was among the first to learn in the seventeenth century, coastwise travel was constantly endangered by sudden fogs, strong seas and tides, and treacherous unmarked ledges. Coming upon a place of such bold beauty after long distance and often arduous effort only heightened the visitor's feeling of reaching a New World island of Cythera.

Certainly for nineteenth-century America the wilderness frontier held a special lure for the national consciousness. As westward expansion moved that frontier ever across the continent, adventurers and artists alike sought increasingly distant horizons to find solace and solitude away from the axe of civilization. First steamboat and later rail travel reached to the farther sections of the New England coast. Mount Desert was one of several natural sites at once seemingly pure as wild nature and yet accessible for commerce and enjoyment. It was inevita-

ble that the island should evolve as both a national park and a summer resort.

Given Mount Desert's visual prominence on the edge of the coast, it has always afforded superb views of two types, which might be called focal and panoramic. Like the other solitary summits to the island's west, the Camden Hills and Blue Hill, and that of Mount Katahdin in central northern Maine—or for that matter like other singular peaks in New England such as Chocorua, Washington, and Mansfield—the totality of Mount Desert looms up as a single commanding form from a good distance off. Indeed, from the open sea its combined summits are readily visible at twenty miles or more away, making it one of the most distinctive landfalls in North America.

As trails made their way up its hills, and later in the nineteenth century when a carriage road and then a tram railway were built to the top of Green (now Cadillac) Mountain, the island's highest point, viewers were rewarded unsurpassed vistas in all directions. To the north lie the Gouldsboro hills and Tunk mountains; to the east the islands of Frenchman's Bay and Schoodic Point; to the south open ocean, then more small islands marking the entrances to Northeast and Southwest harbors; finally to the west larger islands again at the lower end of Blue Hill Bay and Blue Hill itself. On days of clearest light and air one can also make out the Camden Hills beyond, and turning back to sea, a sharp eye can find the lonely rockpile of Mount Desert Rock lighthouse twenty miles offshore due south. When American artists turned their attention to landscape for their primary subjects at the beginning of the nineteenth century, these natural vantage points of and from Mount Desert provided types of views that would remain continually vivid in defining both its physical and spiritual dimensions.

Perhaps one recurring sense about the island's character is that of fundamental contrasts or opposites, the first and most obvious one being the balance of water and rock. In artistic terms we shall see that this terrain has also naturally served the opposing conventions of the picturesque and the sublime. On the one hand, the island's inner harbors, meadows, and valleys well suited the romantic sensibilities of the picturesque formulas, which stressed modulation and balance, meditative calm in both subdued sound and motion, and overall feelings of gentle accommodation and well-being. By contrast, the precipitous outer shores perfectly embodied the features of the sublime:

they were rugged and threatening, and nature's forces were visible, its noises palpable. The human presence here was more precarious and the juxtaposition of forms intimidating. Altogether, the scenery inspired awe, wonder, and exhilaration. Lane would undertake almost the full range of this imagery in his drawings and paintings of the Mount Desert region.

Arguably, the most indelible contrast is that linking past and present, in which almost every experience of the moment is enhanced by some inevitable consciousness of the area's geological and historical past. There are few places in continental America, especially in the east, where the surface of earth so directly reveals the face of time. The bare mountain tops of Mount Desert not only evoked the precise observations of early explorers and later artists; they have also endured as the tangible record of their own creation and evolution. That story of course extends back into scarcely countable periods of time. Just rudimentary knowledge of geology indicates that these strikingly sloped hills were the result of prehistory's elemental polarities, namely fire and ice, volcano and glacier. Coming to this factual knowledge helps explain why so many feel they have also come to a timeless place. Certainly it helps explain the distilled poetry of Lane's Maine paintings and our conviction that his art caught the enduring power and serenity of this place.

First there was water, and geologists tell us that most of present New England was covered by sea around 450 million years ago.[1] Ever since, the forces of water and stone have engaged one another in shaping this landscape. In the long settling of the earth's crust there followed alternating periods of unstable lifting and sinking of the land mass. Underneath the sea, ash and sediment stratified; then as pressures arose from within the earth, land formations protruded above sea level and in turn were subjected to different patterns of erosion. One sequence of volcanic eruptions produced the Cranberry Islands off the southern coast of Mount Desert, only to be covered again by the sea during a settlement of crust. Today one can readily see the two basic rock types around the island: the rounded popplestones formed by constant erosion from the movements of the sea and the cubic blocks of rock walls created by ages of layered deposits.

Toward the end of this process (about sixty million years ago) the combination of volcanic eruption and resistance to erosion

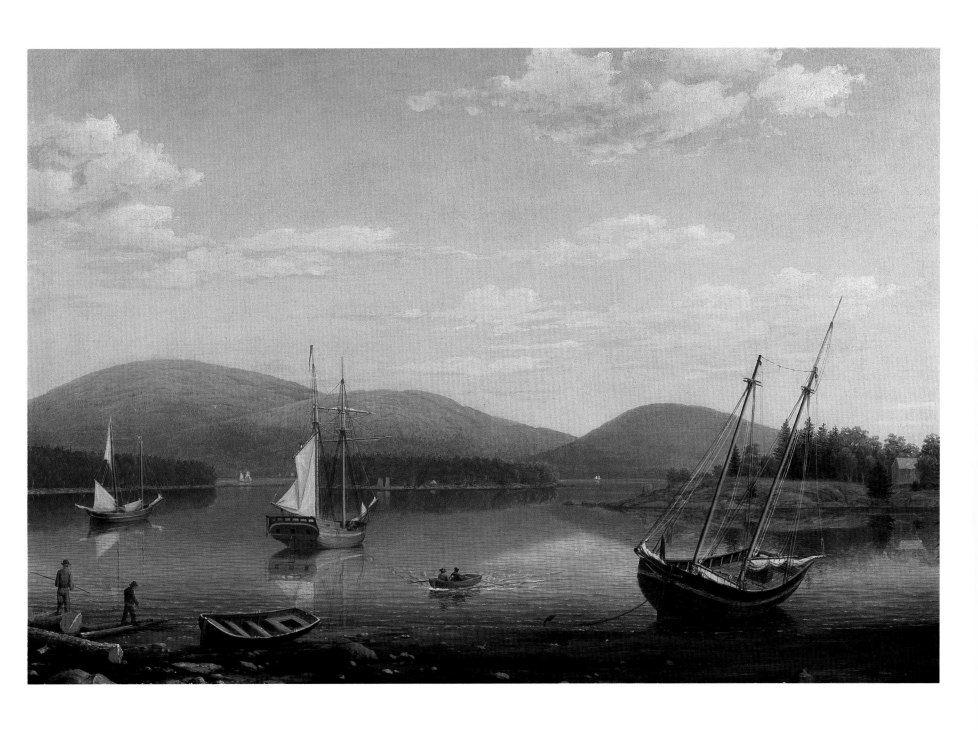

cat. 50. *Bar Island and Mt. Desert Mountains from Somes Settlement*, 1850,
oil on canvas, 20¹/₈ x 30¹/₈ in. [Erving and Joyce Wolf Collection]

by the strongest granite produced a nearly continuous mountain range along this part of the coast. Its crestline was almost even, and the ridge extended in an approximately straight east-west direction.[2] During another period of uplift in the earth's crust, what is now Mount Desert, as well as the offshore islands, were all joined to the mainland. Further upheaval resulted in the promontories and island formations we recognize today. The so-called Mount Desert mountain range was now subjected to a final great phase of geological action, that of the ice age beginning a million years ago.

Scientists believe at least four major continental glaciers spread southward from the polar icecap. The one that most recently covered New England began about one hundred thousand years ago and reached its maximum extent some eighteen thousand years ago. As it met the hard granite of the Mount Desert range, which extended across its path at right angles, the ice pack gradually ascended its ridges, thus accounting for the slow-curving rises of the island's north slopes today. Once reaching the summits, the glacier, at its fullest thickness more than two thousand feet, pressed down on the resisting rock beneath. The moving ice gouged deep valleys running north-south through the range.[3] When the glacier finally retreated, it left behind some dozen separate peaks of varying heights. Several of the valleys between them became deep freshwater lakes within the island, while the central one, scoured deeper and longer than the rest, was flooded by the sea. This cut of Somes Sound now reaches up the middle of Mount Desert as a unique coastal fjord. On the island's southern slopes the terminating glacier abruptly broke off granite blocks and deposited random piles of stony debris, prominently visible today in the sharp cliffs and massive seawalls of the present ocean coastline. No less than the average visitor, American artists from the early nineteenth century on have responded to these powerful primal formations.

The modern land formation that resulted after the cooling of the fire and the melting of the ice comprised about one hundred and eight square miles; the island is an irregular circle twelve miles across and fourteen miles long. Perhaps the most appropriate description of its outline comes from its earliest inhabitants, "the Indians, who called Mt. Desert 'Great Crab Island' in allusion to its shape."[4] Reference to the island's first natives moves us from natural to human history.

From evidence of arrowheads, shell heaps, and other surviving relics, historians estimate that there were three phases of Indian life on the island. The first culture dates to around 4000 B.C. and a second to around 1000 A.D. Closer to 1500 A.D., the more identifiable Penobscot and Passamaquoddy tribes of Abnaki Indians migrated to Mount Desert annually. These native Americans canoed down the northern rivers of Maine each summer to live off the local shellfish and wild berries, returning inland to spend their winters.[5]

The recorded history of the white man's presence does not begin until the early sixteenth century. The first documented sighting of the island occurred during the first ambitious explorations of the New World by the Spanish and Portugese, who were followed by the French and English. The Portugese reached this part of North America in 1525 and made the first map of the area in 1529, one that served explorers for almost a century following.[6] The most prominent European visitor and observer of this coast was to be Samuel de Champlain, whose extensive and distinguished career in North America began with his first voyage to Canada in 1603. Under the command of his countryman, Pierre du Gua, Sieur de Monts, Champlain not only pursued expeditions along the coasts of Nova Scotia and New England, but more important, kept written accounts and drew admirably accurate charts of the harbors and islands he passed.

De Monts gave Champlain independent authority to undertake explorations along the Bay of Fundy and New Brunswick coastline to consider sites for possible future settlements. He set forth in June 1604 and made his way to the south and west. Toward summer's end he left Sainte-Croix and sailed by the high cliffs of Grand Manan Island, now a Canadian possession at the southern end of the Bay of Fundy. The next point of land he made for was Schoodic Peninsula, where he evidently put in for the night, having sighted even more alluring eminences of land rising from the horizon beyond.

The following day, 6 September 1604, Champlain rounded the point of Schoodic and sailed across Frenchman's Bay for Mount Desert Island. Passing Great Head and Sand Beach on the southeast corner of the island, he came close to Otter Cliffs and there struck the offshore ledge usually submerged at high tide. Able to make his way around the headland, he put into the long mudflat inlet nearby of Otter Creek, where his men could

repair their vessel and take on fresh water. Next Champlain sailed along the rest of the island's southern coast, continuing his explorations through Penobscot Bay.[7] The changing panorama of the Mount Desert summits led to his bestowal upon this barren terrain of the name by which it has been known since:

The land is very high, intersected by passes, appearing from the sea like seven or eight mountains ranged near each other. The summits of the greater part of these are bare of trees, because they are nothing but rocks . . . I named it l'isle des Monts-deserts.[8]

Champlain's observations were noteworthy in other respects as well. He was the first European to record the fact, presumably learned from local Indians, that the island was clearly separated from the mainland. Besides leaving an evocative written account of his travels, he drew what have been called "remarkably accurate maps and harbor charts, the best ever of northern America in that century."[9] His passage here was only a part of his larger continuing explorations: he navigated much of Penobscot Bay again and farther south in the summer of 1605, and by the end of his life had crossed the Atlantic twenty-nine times.[10] But perhaps the most resonant chord he struck for all who have followed him was that "on arriving in summer everything is very pleasant owing to the woods, the fair landscape and the good fishing. . . ."[11]

Over the next century and a half the French and English struggled intermittently for the possession and settlement of eastern Maine and Canada. The French called this territory Acadia, memorialized today in the parklands on the island. Conflicts over its domain reached a climax with General Wolfe's triumph over the French in Quebec in 1758 and the conclusion of the French-Indian wars. Thereafter English interests were in the ascendency, passing to their own former colonists after the American Revolution two decades later.

Representative of this moment in the eighteenth century is the visit by the English governor of Massachusetts, Francis Bernard, who arrived by boat in 1762 on a surveying expedition. On October first, he recalled,

at daybreak entered Penobscot Bay . . . Between Fox Islands saw Mt Desert [sic] hills at near 30 miles distant . . . with a pilot boat proceeded for Mount desart [sic] . . . At first we came into a spacious bay formed by land of the great island on the left and of the Cranberry islands on the right. Toward the end of this bay, which we call the Great Harbour, we turned into a smaller bay called the southwest harbour. This last is about a mile long and three fourths of a mile wide. On the north side of it is a narrow opening to a river or sound which runs into this island eight miles and is visible in a straight line with uneven shores for nearly the whole length.[12]

After taking an observation of a sunrise a week later, Bernard sailed up Somes Sound, which he described as

a fine channel having several openings and bays of different breadths from a mile to a quarter of a mile in breadth. We passed through several hills covered with wood of different sorts. In some places the rocks were almost perpendicular to a great height.[13]

Bernard's interest was the beginning of increased visits and settlements by the English. After the Revolution the territory of Maine remained part of Massachusetts through the first quarter of the nineteenth century, when it gained separate admission to the Union. Thereafter a new phase of development and visitation began.

With the lingering disputes between the young republic and Great Britain finally settled by the War of 1812, commerce and well-being prospered along the entire Atlantic coast of the Union. In New England the architects Charles Bulfinch and Samuel McIntire built fashionable houses for the new merchant class of sea captains and ship owners. Immigrants from Europe swelled the population of east coast cities, and trade to distant oceans expanded the nation's horizons and pride at once. Now America's wilderness landscape not only called for exploration and settlement; by the second quarter of the nineteenth century it was also perceived to provide the substance of nothing less than national self-definition.

At this very juncture America's first great native writers and artists began their adventurous travels into the wilder tracts of the northeast. In 1836 Thomas Doughty, a founding figure of American landscape painting, completed the first major canvas of the Mount Desert area, and a decade later, Henry Thoreau, one of our primary writers and philosophers on American nature, made his first journey into the wild interior of Maine nearby. Thoreau made three excursions into the northern woods, in 1846, 1853, and 1857, traveling by steamer from Boston to Bangor via Monhegan Island. While he never visited Mount Desert directly, he would have had distant glimpses of her mountains as he sailed up Penobscot Bay and river to Bangor (cat. 49). "Next I remember that the Camden Hills attracted my eyes, and afterward the hills about Frankfort."[14]

cat. 47. *View of Indian Bar Cove, Brooksville*, 1850 (?), oil on canvas,
11¹/₂ x 18¹/₄ in. [Mr. and Mrs. Jefferson E. Davenport]

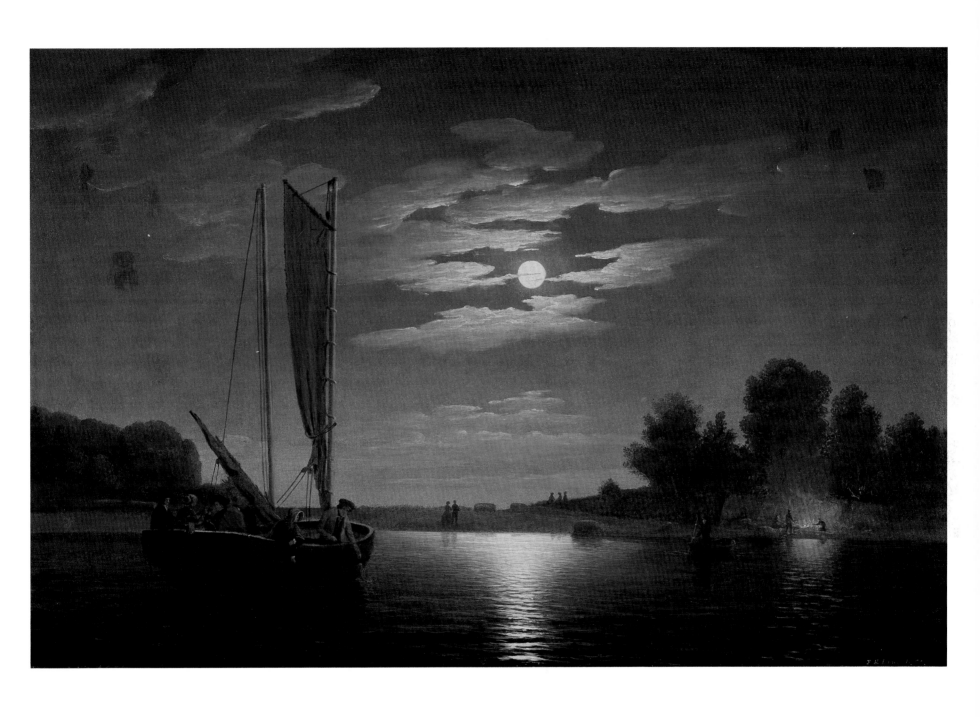

cat. 48. *Fishing Party*, 1850, oil on canvas, 20 x 30 in. [Museum of Fine Arts, Boston, Gift of Henry Lee Shattuck]

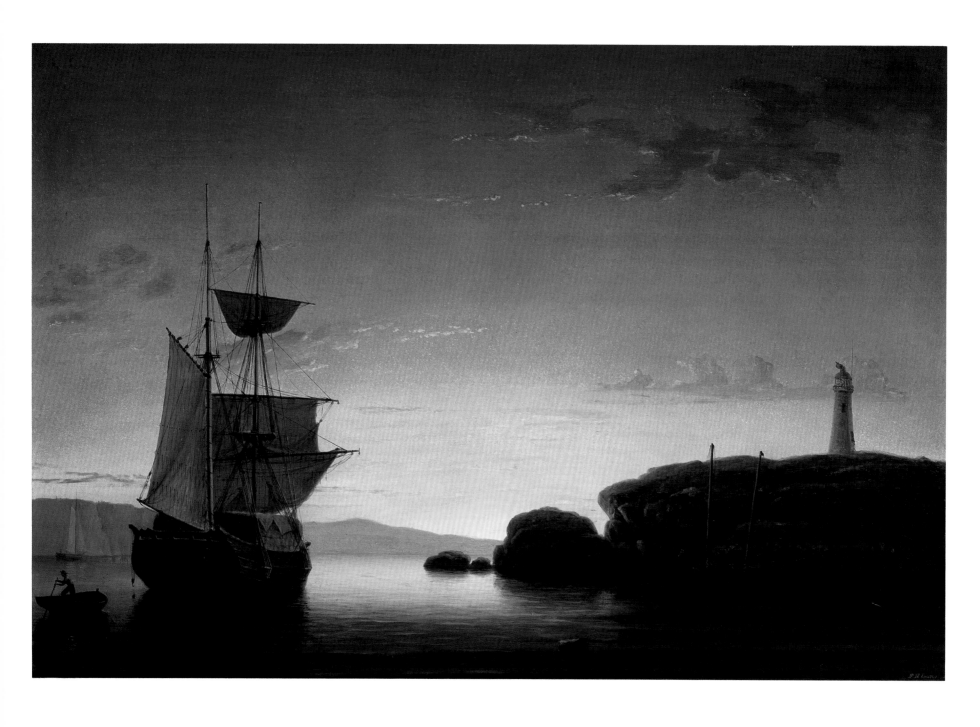

cat. 49. *Lighthouse at Camden, Maine*, 1850s, oil on canvas, 23 x 34 in. [private collection]

Reaching Bangor, Thoreau expressed sentiments presumably common for travelers in this time and place. He felt he was on the threshold of the wilderness, and this northern city was "like a star on the edge of night." Beyond, "the country is virtually unmapped and unexplored, and there still waves the virgin forest of the New World."[15] Others of his generation shared his acute awareness of balancing on the fulcrum between civilization and nature: "though the railroad and the telegraph have been established on the shores of Maine, the Indian still looks out from her interior mountains over all these to the sea."[16]

But Thoreau's journeys also prompted him to higher thoughts. He pondered the American paradox of having both an established identity and a destiny yet to be discovered: "While the republic has already acquired a history world-wide, America is still unsettled and unexplored . . . Have we even so much discovered and settled the shores?"[17] These sentiments, an extension of the original experience of exploration in the New World by voyagers three centuries before, animated American aspirations through much of the early nineteenth century. Thoreau was the first important writer to articulate the belief that an excursion to the Maine wilderness was more than a physical passage. It led, he exclaimed, to a glimpse of basic matter and of God's first nature.

To the Transcendentalist this was no less than "the fresh and natural surface of the planet Earth, as it was made for ever and ever . . . It was Matter, vast, terrific. . . ."[18] Thoreau was particularly impressed with the continuousness of the Maine forest. The farther he traveled inland, the more aware he became of uninterrupted woods—still, even timeless. By contrast, when he reached the mountains, he felt they were "among the unfinished parts of the globe . . . their tops are sacred and mysterious."[19] On climbing Katahdin, he expressed a reaction equally applicable to the hills of Mount Desert:

Here not even the surface had been scarred by man, but it was a specimen of what God saw fit to make this world. What is it to be admitted to a museum, to see a myriad of particular things, compared with being shown some star's surface, some hard matter in its home![20]

Travel along the coast was also arduous and memorable as one proceeded to the east. The first steamer service from Boston to Maine began about 1850. Runs were made to Portland and Rockland; from there the *Ulysses* ran to Southwest Harbor and Bar Harbor on Mount Desert. Subsequently, there was

service from Boston to Bucksport and Bangor, in turn the points "of departure for a journey of from thirty to forty miles by stage."[21] One of the first recorded accounts at this time was a trip by Charles Tracy of New York, father of Mrs. J. Pierrepont Morgan, Sr., who came for a month in the summer of 1855. He arrived by steamer in Southwest Harbor, accompanied by the family of Reverend Stone of Brookline, the writer Theodore Winthrop, and the painter Frederic Edwin Church, back for his fourth visit to sketch, this time with his sister along.[22]

Getting to this part of the coast on one's own, by chartered or privately owned vessel, would have been even more adventurous and demanding. In the same years as Church's visits, Fitz Hugh Lane reached Mount Desert, sailing with friends from Castine. Robert Carter, the Washington correspondent of the *New York Tribune*, kept an account of another independently undertaken voyage made in the summer of 1858. "Summer Cruise on the Coast of New England" described his trip by fishing smack from Boston to Bar Harbor. His reactions were not unique: "the approach to Mount Desert by sea is magnificent. It is difficult to conceive of any finer combination of land and water."[23]

For those who sailed the coast in modest sloops or schooners there was always the glory as well as the unpredictability of Maine summer weather. Besides the daily rush of tidal currents, torpid calm can alternate with forceful storms, dense fog with sparkling sunlight, favoring breezes with unmarked hazards. During the first half of the nineteenth century there were relatively few navigational aids along the Maine coast, though a number of the major offshore ledges and islands did have lighthouses. The oldest lighthouse in Maine is that at Portland Head, built in 1791 at the direction of George Washington. At least one other, that on Seguin Island marking the mouth of the Kennebec River, was constructed in the eighteenth century. More than two dozen others were built on sites between Portsmouth, New Hampshire, and Isle au Haut before the Civil War.[24]

East of the Mount Desert area at least half a dozen lights were put up between 1807 and 1856 on points from Narraguagus Bay to West Quoddy Head at the Canadian border. Around Mount Desert itself and the nearby approaches, seven lighthouses are known to have been constructed during the early nineteenth century: those of Bass Harbor Head, 1858; Mount

Desert Rock, 1830; Baker Island, 1828, and rebuilt in 1855; Bear Island, 1839; Winter Harbor, 1856; Prospect Harbor, 1850; and Petit Manan, 1817, also rebuilt in 1855. In addition, the government erected a stone beacon daymarker on East Bunkers Ledge off Seal Harbor in 1839–1840.[25] These obviously facilitated travel along the many treacherous passages leading down east, and made it possible for artists and others in increasing numbers to sail at their own leisure to Mount Desert by mid-century.

But these starkly simple stone towers served as more than fixed points of reference. For the early generation of adventurous travelers they also carried implicit symbolic and emotional connotations. They were emblems of safety and security, guidance and direction, and metaphors for spiritual salvation.[26] No wonder artists painting in a period of increasing national strife and anxiety should turn for solace to the imagery of lighthouses. For example, between the 1830s and the 1860s Doughty, Church, Lane, and Alvan Fisher all painted lighthouse views around Mount Desert. These towers were not mere factual features punctuating the physical landscape. They also were beacons of stability, founded on the literal rocks of ages of bold Maine granite.

Coastwise traffic of all sorts increased during the middle decades of the century. Mount Desert and the larger islands of Penobscot Bay were centers for a growing economy based on forest and sea. Shipping and shipbuilding flourished in the older fishing villages. The timber was cut from the lower slopes of Mount Desert more than once and loaded aboard sturdy schooners for transportation back to Portland and Boston. This rocky landscape also yielded up another element of its "basic matter": Maine's quarries provided much of the granite cut in great blocks for the new Greek revival buildings rising in Boston and elsewhere, and many of the smooth popplestones from its shores were removed for the streets of New England's cities.[27] Broad-bottomed schooners carried these loads of stone back to harbors to the west and south. Finally, the island's waters offered a bounty of fish, foremost herring, crab, and lobster, in a continuity from Indian to modern times.

Visitors to Mount Desert who came to see its splendors or stay for a few summer weeks found simple accommodations in private lodgings or taverns around the island. The painter Church, for example, stayed on his 1855 trip at the tavern in Somesville, while on another occasion he boarded at the Hig-

gins homestead in Bar Harbor.[28] One of the most popular places artists chose to stay was on Schooner Head, an especially dramatic site on the eastern side of the island overlooking Frenchman's Bay. This was

The Lynam Homestead, to which Cole, Gifford, Hart, Parsons, Warren, Bierstadt, and others renowned in American art have from time to time resorted to enrich their studies from the abounding wealth of the neighborhood.[29]

Among other painters making early excursions to the island who stayed at Somes Tavern, besides Church and William Hart, were Thomas Birch and Charles Dix.[30] After the Civil War accelerating prosperity and better transportation led to replacement of the taverns by larger hotels built in Bar Harbor, Southwest Harbor, and later Northeast Harbor. Correspondingly, during the 1870s and the 1880s new growth occurred in summer cruising and yachting, followed by the first wave in building large summer cottages, still familiar today.

Travel on the island itself was fairly primitive well into the middle of the nineteenth century. When the first artists arrived, most roads were rough tracks and the sea was "still the high road for the dwellers on the island."[31] However, by 1875 surveyors had laid out a carriage road to the summit of Green Mountain, and beginning in the 1880s for a few years a narrow-gauge railway also ascended nearby. Sightseers crossed Eagle Lake, in the center of the island, by steamer, landing on the west slope of Green Mountain where they could board the tram car for the ride up and back.[32]

Now Mount Desert attracted a host of prominent visitors, including vacationing clerics and academics, like Bishop Doane of Albany and Charles William Eliot, president of Harvard. The one distinguished writer of the nineteenth century who made the trip and recorded his observations was John Greenleaf Whittier. In contrast to the scientific and philosophical cast of Thoreau's journals, Whittier's lines bear the romantic sensibility of the later nineteenth century:

Beneath the westward turning eye
A thousand wooded islands lie,—
Gems of the waters! with each hue
Of brightness set in the ocean's blue . . .
There, gloomily against the sky
The Dark Isles rear their summits high;
And Desert Rock, abrupt and bare,
Lifts its gray turrets in the air.[33]

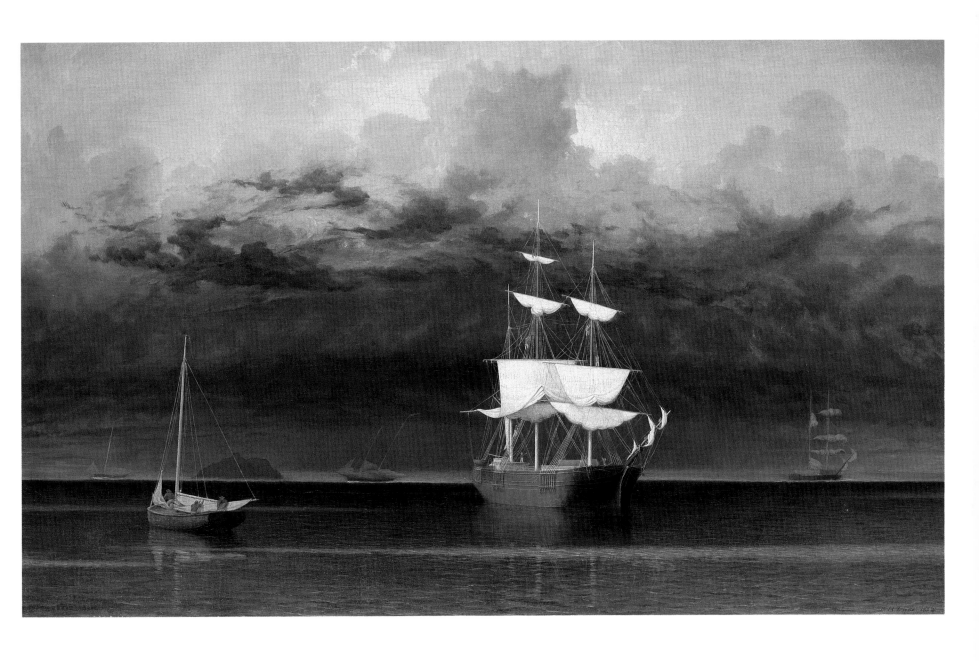

cat. 51. *Approaching Storm, Owl's Head*, 1860, oil on canvas, 24 x 39⅝ in.
[private collection]

The painters who visited the island over the last century and a half worked in an array of artistic styles and aims. Some, like John James Audubon and Thomas Eakins, intended to paint subjects quite different than the Maine landscape. Audubon came in search of local bird species he might include in his grand pictorial inventory, *The Birds of America*, completed in 1838. Eakins was a guest in Seal Harbor of Henry A. Rowland, a professor of physics at Johns Hopkins University in Baltimore and a summer resident; he worked on Rowland's portrait for several weeks in 1897.[34]

The Maine coast has also attracted other major American painters, in the nineteenth century Winslow Homer and in the twentieth Edward Hopper, both of whom worked in the southern part of the state, but were never lured farther east to the Mount Desert region. But those who did venture this far, whether for brief stays and single works, or for repeated visits and an extensive output, collectively give us an unusual and striking survey of American art. Indeed, part of the island's continuing allure is that a fixed point of geography can inspire such diverse visual responses and stylistic treatments as the romantic realism of the early Hudson River painters, the crystalline luminism of artists in the mid-nineteenth century, the variants of impressionism practiced at century's end, and the new modes of representation in the twentieth, approaching aspects of abstraction.

The figures most central to this chronology are first the pioneers, Thomas Doughty, Alvan Fisher, and Thomas Cole, who generalized and romanticized nature in their visits of the 1830s and 1840s. Next came Lane in the 1850s and Frederic Edwin Church in the 1850s and 1860s. Each drew and painted extensively at Mount Desert. In particular, they recorded the northern sunsets in forms that made Americans give serious thought to the significance of their country's geography and its destiny. After the Civil War William Stanley Haseltine produced a large group of refined drawings and watercolors around the southern shore of the island. Following him in the later decades of the century were numerous painters of varying stature who marked their stays for the most part with only one or two sketches. Some made drawings: William Trost Richards, John Henry Hill, Xanthus Smith, and Ralph A. Blakelock; others produced watercolors: Alfred Thompson Bricher; and still others painted singularly beautiful oils: Sanford Gifford and Childe Hassam. In the

fig. 1. Frederic Edwin Church, *Twilight on the Kennebec*, 1849, oil on canvas, 18 x 30 in. [private collection]

first half of the twentieth century Mount Desert commanded the attention of artists working in a range from traditional to modernist visions, among them Carol Tyson, N. C. Wyeth, Oscar Bluemner, Marsden Hartley, and John Marin.[35]

These artists in their time were favored with a glimpse of nature many felt to be God's first creation; with their own creativity they returned the favor by changing that nature into an American art for posterity.

Coming relatively early in this procession, Lane can be seen as playing a pivotal role in formulating this national imagery. In part, he took the dramatic elements of awe and majesty recorded by the first artists to visit, and gradually remolded the sublime landscape into a more purified and untroubled place conducive to resting and uplifting the spirit. He began by recording the quaint architecture and picturesque contours of Maine's coastal villages, in particular the town of Castine, where he regularly stayed with the family of his friend Joseph Stevens. Venturing by sailboat farther to the east, he became more observant of coastwise shipping, and recorded in careful detail the activities of the sturdy lumber schooners loading or transporting their weighty cargoes of Maine wood and granite. On later trips, crossing Penobscot and Blue Hill Bays, he explored more widely the approaches to Mount Desert. Increasingly, here, his paintings were studies of transcendent light and

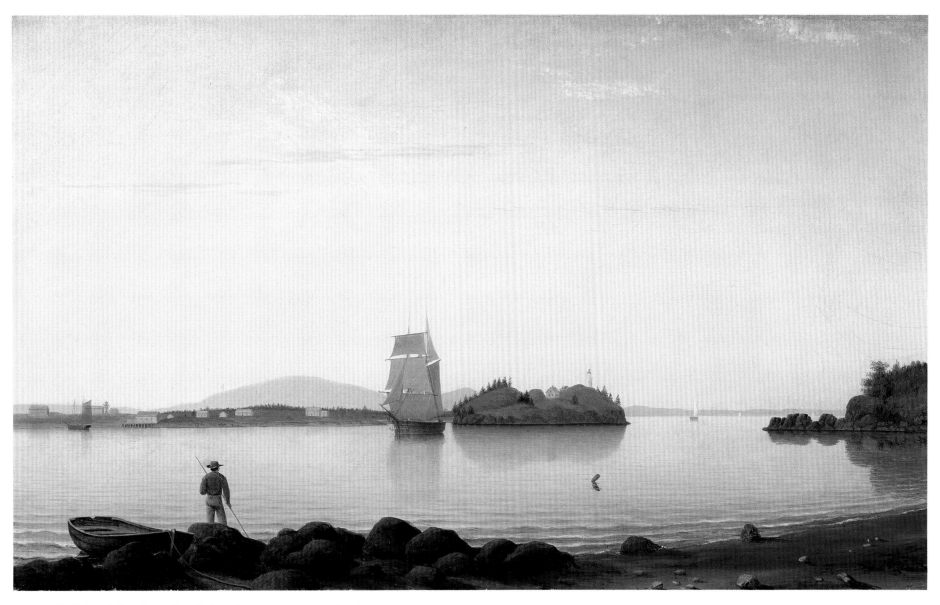

cat. 52. *Owl's Head, Penobscot Bay, Maine*, 1862, oil on canvas, 16 x 26 in. [Museum of Fine Arts, Boston, M. and M. Karolik Collection]

air almost more than records of temporal place.

No dated drawing or letter survives absolutely documenting Lane's first journey to Maine, though circumstantial evidence indicates he must have gone in the summer of 1848. As a result of what he saw, he completed, and exhibited in New York the following winter, two oil paintings, *Twilight on the Kennebec* (private collection, fig. 1) and *View on the Penobscot* (now lost).

The former carried the following description after its title in the American Art-Union catalogue of 1949: "The western sky is still glowing in the rays of the setting sun. In the foreground is a vessel lying in the shadow. The river stretches across the picture."[36] This would be the only time Lane ventured inland at all, though many of Maine's major rivers were navigable several miles upstream. Virtually all of his subsequent explorations were devoted to the myriad bays, inlets, and peninsulas along the coast well east of the Kennebec.

More than a hundred of Lane's drawings survive, most now in the collection of the Cape Ann Historical Association in Gloucester. These, with annotations both by Lane and Stevens, give us an unusually comprehensive summary of the dates and locations of their cruising trips. The first trip of any length was in August 1850, when the artist made a couple of drawings of Castine, which led to at least four subsequent oils and a half-dozen sketches at Mount Desert. These in turn served as the basis for pictures painted over the next year or two (cat. 50). In language reminiscent of Champlain, Bernard, and other predecessors, Stevens wrote an extensive account of this early trip with Lane:

This supposed barren and desolate place can boast of scenery so grand and beautiful as to be unsurpassed by any on the whole American coast. We had understood so much from hearsay of the remarkable and picturesque range of mountains on the islands, the fine harbors, and beautiful sound, that even abating liberally for enthusiastic exaggeration, we were certain of being amply repaid for a sail of fifty miles each way. . . .

It is a grand sight approaching Mount Desert from the westward, to behold the mountains gradually open upon the view. At first there seems to be only one upon the island. Then one after another they unfold themselves until at last some ten or twelve stand up there in grim outline. Sailing abreast the range, the beholder finds them assuming an infinite diversity of shapes, and it sometimes requires no great stretch of imagination to fancy them huge mammoth and mastodon wading out from the main. With such a beautiful prospect to wonder at and admire, now wafted along by light winds, then entirely becalmed for a time, we were slowly carried into Southwest Harbor. Here, from what seems to be a cave on the mountain side, is Somes Sound, reaching up through a great gorge seven miles into the heart of the island. It varies much in width, the extremes being perhaps a half mile and two miles, is of great depth, and contains no hindrance to free navigation. An intervening point concealed the entrance until we had nearly approached it, and the sails passing in before us disappeared as if by enchantment.

It was toward the close of as lovely an afternoon as summer can bestow that we entered this beautiful inlet. Much had been anticipated, the reality exceeded all expectations. There were none of those gusts which are said to dart suddenly down from the treacherous mountains to the dismay of unwary boatmen, but with breezes seldom strong enough to ripple the quiet water, the old boat went leisurely up the current, and so engrossed had we become in the grandness of the scenery on every hand, and so illusive the distances were that it seemed as if we could be but halfway up the inlet when we passed through the narrows into the basin forming the head of the Sound. Just as the sun was setting we encamped opposite the settlement, at the entrance of the miniature bay, on an island well wooded and covered with a profusion of berries. . . .

An attempt was made the next day to ascend the highest and boldest of the mountains that skirt the Sound. But after a long and laborious scramble up among the rocks and fallen trees we reached a peak but half way to the summit and stopped to rest there, when a thunder-storm burst with savage fury. We seemed to be in the very midst of cloud and tempest. Advance we could not, neither could one recede in such darkness and blinding rain. Here then, in the bleak surface of the mountain, with no shelter but a jagged rock against which we could crouch when the wind blew strongly from the opposite quarter, we were forced to receive the drenching of a pitiless storm. Yet it was a scene of such sublimity up where the lightnings seemed playing in their favorite haunts and the thunders reverberated in prolonged and deafening peals, among the trembling hills, that we were not unwilling occupants of this novel situation. . . .

It is a misnomer to call such an island Mount Desert. Some of the grand old mountains which have been burned over showing nothing but the large ledges of sienite and charred pine trees, with here and there a little shrubbery struggling for life look dreary and desolate, but they stand among others covered with a luxuriant growth. Our pilot told us of a Frenchman who once got lost here for some weeks, when his country held this region, and so gave the title to it. But it seems the island has begun to get its dues—one of its three townships is now called Eden. The beauties of this place is [sic] well known and appreciated among artists. We heard Bonfield and Williams who had reluctantly left but a short time before. Champney and Kensett were then in another part of the island and we have reason to believe that Church and some others were in the immediate vicinity. Lane who was with us, made good additions to his portfolio. But how unsatisfying a few days to an artist, when many months sketching would scarcely suffice amid such exhaustless wealth of scenery.[37]

Stevens' words not only reflect the descriptive phrases of earlier published narratives, but also carry their own mid-nineteenth-century flavor of sublime drama. The thunderstorm yields its awesome inspiration, while the contrast of dead and flourishing plant life attests to the powers of evolution and regeneration. The pattern and responses of this voyage were essentially repeated by the artist and his companion during the August weeks of the next two years. The 1851 cruise took them around the southern end of Penobscot Bay, where Lane made drawings of Owl's Head and Camden on its western side and of the Castine shore to the east. Paintings of all these areas followed later that year and the next. Stevens had earlier written Lane, extending his family's hospitality in Castine, and noted accurately: "You have not or did not exhaust all the beauties of Mt. Desert scenery, and perhaps there may be other spots in our Bay, that you may think worthy of the pencil."[38]

Sometimes Lane managed sketches while arriving at or departing from Rockland on the steamer; for example, he noted

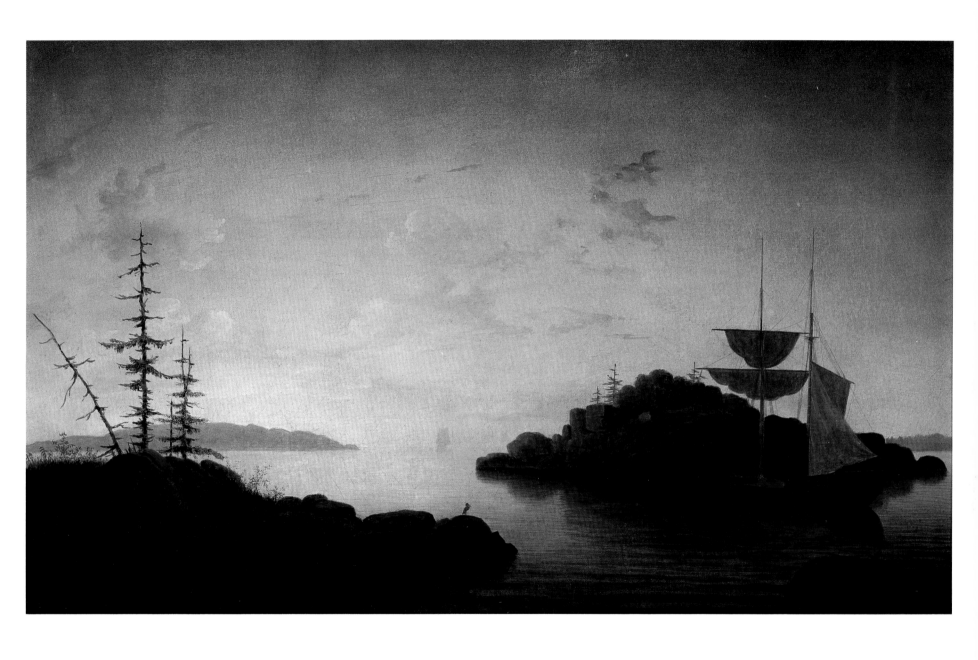

cat. 53. *Christmas Cove*, c. 1863, oil on canvas, 15¹/₂ x 24 in. [private collection]

that two of Owl's Head "were taken from the steamer's deck in passing." More often he made drawings on his sketchpad while sailing leisurely, conditions permitting, or at anchor with a favorable prospect before him, as in the *North Westerly View of Mount Desert Rock,* "August 1852, Taken from deck of Sloop Superior at anchor." For some panoramas, like the mountainous shores of Somes Sound, he pasted together two or more sheets end to end in order to capture the full extent and rolling geologic contours of a view. His friends recalled that on certain occasions he had himself tied around the waist by his vessel's main halyard and hauled part way up the mast so he might gain an even more elevated and expansive vista for his pencil.

Lane's August 1852 trip took him and several companions to the higher outer island of Isle au Haut, marking the passage from lower Penobscot to Blue Hill Bay, and thence out to the isolated Mount Desert Rock twenty miles offshore. Back in sheltered waters, Lane drew (and later painted) Blue Hill as well as a number of scenes around Southwest Harbor and Somes Sound.[39] One more trip, in September 1855, is also well documented by surviving drawings. This trip comprised two cruises, first around the southern shores of Penobscot Bay and then directly to Southwest Harbor on Mount Desert. Lane was now at his full maturity as an artist; he drew prolifically and confidently. From this voyage alone there were no less than four drawings of Owl's Head, four of Camden, three of Castine, two of Somes Sound, and four of Bear Island off Northeast Harbor. Almost all led to major canvases.

Only one other excursion to Maine is documented, that of a visit in August 1863 to Portland, where Lane ruled off in a pencil grid a photograph of the *Steamer "Harvest Moon" Lying at Wharf,* fig. 2, for use in a subsequent painting of the harbor. But there are dated and exhibited pictures of Maine views throughout the later 1850s and 1860s, indicating his continued use of earlier drawings and possibly further repeat visits to familiar sites. Among the most important and beautiful are *Sunrise at Mount Desert,* 1856; *Camden,* 1859; *Owl's Head, Penobscot Bay, Maine* (cat. 52), 1862; *Lumber Schooners at Evening on Penobscot Bay* (cat. 61) and *Approaching Storm, Owl's Head* (cat. 51), both 1860; and *Christmas Cove* (cat. 53) and *Fishing Party* (cat. 48), both 1863. These later paintings especially tend to be more generalized in location and poignant in feeling, perhaps because they were more detached images made from memory.

fig. 2. Lane, *Steamer "Harvest Moon" Lying at Wharf in Portland,* 1863, photograph and pencil on paper, 9³⁄₄ x 10¹⁄₂ in. [Cape Ann Historical Association]

But we need also to note that their elegiac twilight reds and stark tonal contrasts coincide with the literal storm clouds and civil fires of a nation at war with itself. However distant Lane may have been physically from his country's tribulations, his late work does express some hint of emotional and spiritual trauma. He, himself, was ill in his last years, and a lifetime of partial paralysis must have borne its own accumulated pain. On the whole, however, much of his life was passed, and much of his art realized, during an era of tranquil optimism. For him, as for others before and after, at least one special part of the Maine coast was worthy of the name Eden.

1. Useful summaries of the geological history of the Mount Desert Island area are to be found in Russell D. Butcher, *Field Guide to Acadia National Park, Maine* (New York, 1977), "Rocks and Landforms," 28–37; and Carleton A. Chapman, *The Geology of Acadia National Park* (Hulls Cove, Maine, 1962), "The Geologic Story of Mount Desert Island," 11–32.

2. See Butcher, *Field Guide*, 29; and Chapman, *Geology of Acadia National Park*, 28.

3. See Butcher, *Field Guide*, 34; and Chapman, *Geology of Acadia National Park*, 29.

4. *Northeast Harbor, Reminiscences, by an Old Summer Resident* (Hallowell, Maine, 1930), 12.

5. See Samuel Eliot Morison, *The Story of Mount Desert Island* (Boston, 1960), 3-4; and Butcher, *Field Guide*, 11. Today there is a similar flow and ebb of summer inhabitants, likewise attracted by the native delicacies of lobster, crab, and wild raspberries and blueberries.

6. Morison, *Mount Desert Island*, 7.

7. See Samuel Eliot Morison, *Samuel de Champlain, Father of New France* (Boston, 1972), 27-46. This biography is a full and sympathetic account of Champlain's life and achievements, and provides the basis for the précis of his encounter with Mount Desert related here.

8. Quoted in Samuel Adams Drake, *Nooks and Corners of The New England Coast* (New York, 1875), 29. A slightly different free translation appears in Morison, *Mount Desert Island*, 9. A facsimile of the relevant pages from Champlain's original published narrative is included in Charles Savage, *Mount Desert, The Early French Visits* (Northeast Harbor, Maine, 1973), 6-7.

9. Morison, *Champlain*, 46.

10. Morison, *Champlain*, 233.

11. Quoted in Morison, *Champlain*, 54-55.

12. Quoted in George E. Street, *Mount Desert, A History* (new ed., Boston, 1926), 108-109.

13. Quoted in Street, *Mount Desert*, 110.

14. Henry David Thoreau, *The Maine Woods* (Apollo ed., New York, 1961), 111.

15. Thoreau, *Maine Woods*, 108.

16. Thoreau, *Maine Woods*, 108.

17. Thoreau, *Maine Woods*, 107.

18. Thoreau, *Maine Woods*, 92.

19. Thoreau, *Maine Woods*, 84-85.

20. Thoreau, *Maine Woods*, 93.

21. Drake, *Nooks and Corners*, 30. See also Morison, *Mount Desert Island*, 61; and *Northeast Harbor, Reminiscences*, 45. The *Ulysses* sank in 1878, and all sidewheelers were replaced by the *Mount Desert*, until 1894 when the larger *J. T. Morse* covered the route to Mount Desert. During the later nineteenth century steamers operated by the Maine Central Railroad connected with train service to Hancock Point at the head of Frenchman's Bay. Local steamers operated between Bangor, Bar Harbor, and most of the villages around the coast of the island. See Morison, *Mount Desert Island*, 63. In the first quarter of the twentieth century ferry service operated from Trenton on the mainland, taking those who had arrived in Ellsworth by train, until a causeway was constructed across the narrows with the advent of the automobile.

22. See Street, *Mount Desert*, 295-296. Tracy's manuscript is now in the Morgan Library, New York City.

23. Quoted in Street, *Mount Desert*, 271.

24. See Wally Welch, *The Lighthouses of Maine* (Orlando, Florida, 1985), 8-45.

25. See Welch, *Lighthouses*, 49-59. Morison noted the construction of a lighthouse on Mount Desert Rock as early as 1830, and the subsequent erection of the East Bunkers Ledge daymarker, but believed that there were no other aids to navigation in the area before the Civil War. See Morison, *Mount Desert Island*, 38, 47.

26. See Welch, *Lighthouses*, 64.

27. See Morison, *Mount Desert Island*, 33.

28. See Street, *Mount Desert*, 281, 296.

29. Drake, *Nooks and Corners*, 49.

30. See Morison, *Mount Desert Island*, 45.

31. Street, *Mount Desert*, 296.

32. See Drake, *Nooks and Corners*, 42; and Butcher, *Field Guide*, 13.

33. Quoted in Street, *Mount Desert*, 32.

34. See Drake, *Nooks and Corners*, 48; and Lloyd Goodrich, *Thomas Eakins* (2 vols., Cambridge, Massachusetts, and Washington, D.C., 1982), 2:137. John Singer Sargent also visited the area in 1921-1922, and painted a portrait of his artist friend, Dwight Blaney, sketching deep in the woods on Ironbound Island in upper Frenchman's Bay. He also did an oil, *On the Verandah*, showing the Blaney family on the porch of their summer home on Ironbound. But both of these are essentially portraits, with neither really concerned with any of the panoramic vista of Mount Desert nearby. See Gertrud A. Mellon and Elizabeth F. Wilder, eds., *Maine and Its Role in American Art* 1740-1963 (New York, 1963), 108-109.

In addition, a few prominent photographers have produced a body of images in the Mount Desert region, for example, Seneca Ray Stoddard and Henry L. Rand at the end of the nineteenth century, and George A. Tice in the early 1970s. See John Wilmerding, *American Light, The Luminist Movement, 1850-1875* (Washington, D.C., 1980), 138-145; and Martin Dibner, *Seacost Maine, People and Places* (New York, 1973), 2, 8, 82, 122, 126, 128, 156, 178, 199, 202, and 206. Also in the late sixties Walker Evans visited the painter John Heliker, and photographed his kitchen, but no landscape, on Cranberry Island off the Mount Desert coast.

35. Moving toward greater abstraction in their responses to the island region since World War II have been such resident painters as William Thon, John Heliker, and William Kienbush. Today, one of the island's best-known painters, in residence much of the year, is Richard Estes, whose precise style of photorealism serves scenes not of wilderness but the street landscapes of New York City.

36. Mary B. Cowdrey and Theodore Sizer, *American Academy of Fine Arts and American Art-Union Exhibition Record 1816-1852* (New York, 1953), 221.

37. J. L. Stevens, Jr., in the *Gloucester Daily Telegraph*, 11 September 1850.

38. Letter from Stevens to Lane, 29 January 1851, in the Cape Ann Historical Association, Gloucester.

39. A charming and informative account of this voyage exists in a diary kept by a Castine companion of Lane's, William Howe Witherle, and is here reproduced as an appendix. The original is now in the Wilson Museum, Castine Historical Society.

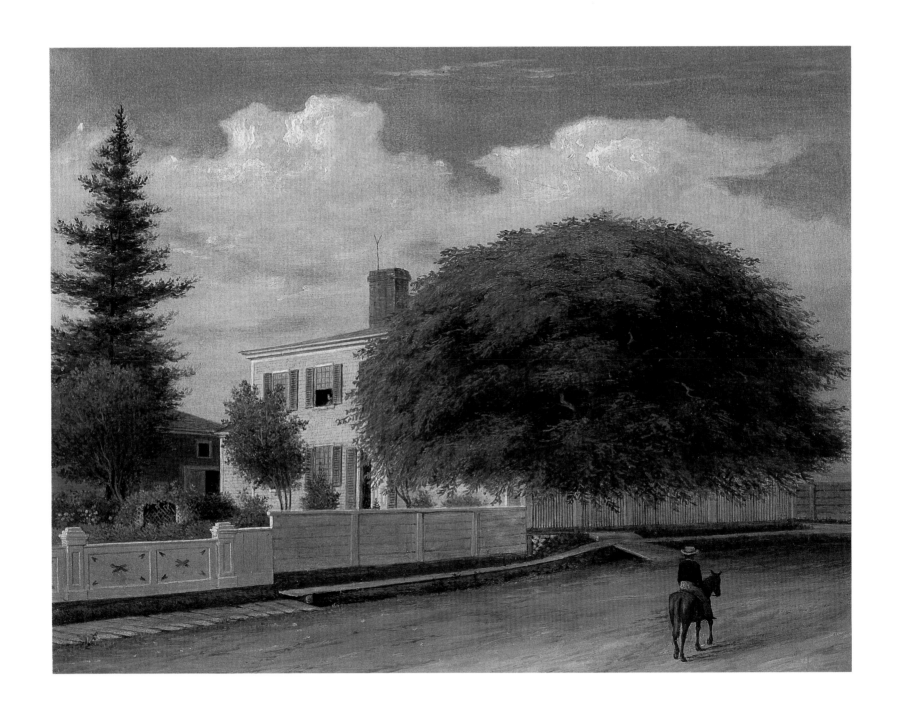

cat. 54. *Castine Homestead*, 1859, oil on canvas, 10³/₈ x 14¹/₈ in. [private collection]

Appendix

MONDAY AUGUST 16TH (1852) Our party consisting of F H Lane and Jos L Stevens Jr of Gloucester — Geo F Tilden, Saml Adams & myself and Mr Getchell - Pilot left Mr Tildens wharf at about 11 "clock in the good Sloop Superior — bound on an excursion among the Island of the Bay — the wind was northerly and the weather fine — And we had a charming run down the Ship Channel towards "Isle Au Haut" - anchóred off Isle Au Haut about 5 "clock and Fished till about sun down — when we put away for Kimballs Harbour — but the wind died away and the tide headed us — so we were obliged to anchor in Shoal Water near the entrance of the Harbour — this has been a most Auspicious commencement to our Excursion — and we have enjoyed it highly — have done our own cooking and made out first rate under the Superintendence of Geo Tilden — whose talents in that line are the most prominent — Mr Lane however has a decided knack for frying fish and gave us a specimen of fried cod for supper – which was most excellent – in the night we hoisted anchor and shifted our birth owing to the proximity of certain shoals and rocks —

TUESDAY MORNING AUG 17 — up early — prospect of another fine day — Sam A & I rowed ashore about 2 miles for wood — which article we did not lay in a stock of — which gave us a somewhat ravenous appetite for our Breakfast which came off in due time — and which we took on deck — as it was calm and beautiful — After breakfast we weighed Anchor and with a light breath of wind put for "Saddle Rock" some 10 miles off — but did not make much progress — and finding a chance to run into "duck Harbour" we took advantage of it and run in — a very pretty snug little place — dropped Anchor and landed and leaving Mr Lane to take a Sketch we took a climb on to a Hill — from which we had a fine view of the Sea and Bay — returning on board we Started with a fine breeze for Saddle Rock — which we reached between 1 & 2 o clock — anchored and leaving Mr Lane and Getchell on board landed and were met by old Mr Burgess Keeper of the light — who welcomed us and Showed us the lions of the Rock — we enjoyed the novelty of the Scene but did not stop long as our Sloop seemed to have a strong desire to come ashore after us — fearing probably to trust us on such a rough looking spot — so we embarked again and Sailing round the ledge — with a fine pleasant breeze — from the westward a smooth sea and one of the pleasant afternoons on record we put for "Lunts Long Island" passing out side of Isle Au Haut and all the Islands — we stretched ourselves out on deck spun yarns — and read a little and enjoyed our life on the Ocean Wave — under such pleasant circumstances — to our hearts content — about Sundown we reached Long Island Harbour — and anchored — and lowered our mainsail for the first time since leaving home — after getting our Supper it was dark — we played Backgammon — I enjoyed a "Smoke" — by myself — on deck before going to bed — the tinkoling of cow Bells on shore give promise of plenty of milk to fill our jug in the morning —

WEDNESDAY AUG 18 — up by sunrise another fine morning — no signs of fog — which we have been dreading — went ashore with our water cask and milk jug — landed near Squire Lunts wharf and went to his house — but after knocking at the door and could not suceed in rousing any body but a dog — went to two houses near by — but found them unoccupied — the place seemed to be deserted — but after a while we spied out a woman milking a cow on the opposite side of the harbour — and Joe & George steered off — in that direction - while Mr Getchell & I prowled round in pursuit of a well — to fill our water (cask) — but after diligent search not a well could be found — we finally filled our keg at a running brook — which we happened to discover — looked in to the windows of a meeting house which was set down in a wild spot without a road or signs of a path leading to it — the specimens of native Seen by Joe & George had a very ancient and Fish like appearance — their first enquiry was if they were traders — Altogether the aspect of this place is dismal — a little trading Sch had come in in the night and was at anchor near us — and after we had finished our breakfast the trader came on board and made us a call — but was soon hailed to come back by customers from the Shore — we started with a fresh Breeze for "Mount Desert Rock" 18 miles distant — it was rougher than we have yet had it — being considerable swell but we get on finely — with the exception of George" being sea sick — which however we comfort him with the opinion that it will do him good — About noon we arrive at the Rock — the Keeper of the light Mr King — came off in his boat and gave us the end of a buoy Rope to Moor to - he was expecting his wife off in a craft similar to ours and was disappointed to find his mistake but notwithstanding treated us most hospitably - we spent a couple of hours most pleasantly rambling about the Rock Examing a wreck of a Sch was lately cast away there — watching the seas dash up onto the windward side — and a Fin Back Whale dash every now and then into Shoals of Herring which almost surrounded the rock — and which Mr King had taken a large quantities — the light House is a fine Structure and was in most perfect order — Mr King has two sons & two daughters with him and seemed to have plenty of employment in fishing and the wreck which he had bought — he told us he had not been ashore for two years — we all consider this visit to the Rock as something not to be forgotten — we felt that we should have enjoyed two days there — but as we had proposed to reach Somes Sound that night we had to tear ourselves away — Mr Lane took two sketches while there — We had a fine free wind for the sound — and the view of the Mt. Desert Hills as we approached them was splendid — Mr Lane improved it to take a Sketch of their outlines — The Steamer Lawrence went in to the "Sound" an hour before us with a party from Penobscot Bay and River — said to be the first Steamboat that ever went up Somes Sound — we had a fine sail up between the high hills which in one place are perpendicular — and came to our anchorage above "Bar Island" just after Sunset — after supper we went up in the Boat to Somes — where we found the Party by the Lawrence and among them many of our acquaintances —

THURSDAY AUG. 19 — "our regular fine weather" Went to Somes this morning again and got a good breakfast — and sent letters home to our respective wives by — our Friend Mrs. Mary Lowe Kimball *4 who came in the Lawrence and returns this morning — When we got back to our Sloop we found

Lane and Getchell doing a brisk business catching mackerel — So we all rushed for our lines and were in for our share in short order — and had fine sport for an hour or so — when we packed up a luncheon and filled a jug with water and got into the Boat and rowed across the Sound two or three miles — to a favorable point to ascend one of the highest Mountains — we found a pretty good path about 3/4 the way up — we had to wait once in a while for Lane who with his crutches could not keep up with us — but got along better than we thought possible — the climb up after we left the path was somewhat severe — as it was very hot and not even at the top of the Mountain was there a breath of Air Stirring — Lane got up about an hour after the rest of us — felt about used when I first got up but Soon revived and I started off on a cruise — found some Lillies in a Pond near the Summit — the Atmosphere was Smoky so that our view was not very extensive — but it well repaid us for our labour — about the time we got ready to descend it began to thunder in the distance and clouds began to rise — and by the time we reached our boat it was evident that a shower was near at hand so we put in for a Smart row and our good Sloop Superior just as the rain began to fall — and it soon came down in torrents and after a hearty supper — and a good Smoke being pretty tired we turned in early —

FRIDAY AUG 20 — Our good luck again for weather — Hoisted Anchor — and dropped down with the tide — George and I went ashore and got some milk and we took our breakfast on deck drifting down the Sound — Surrounded by the noble Scenery — in this beautiful morning with a good cup of Coffee and good Substantial edibles to match — and famous appetites — this is the way to enjoy life said we! the wind breezed up and we put on all Sail and had a bit of a try with a Bangor Sloop called a crack Sailor but she didnt beat us much if any — ran in to North East Harbour looked about and ran out again and put for Bear Island — where we landed and visited the lighthouse - this is a high bluff little island - the Beach that we landed on appears from the top of Island of a perfect Crescent Shape — started again for Suttons Island — and landed Mr Lane to take a Sketch and then proceeded for Southards Cove — to afford our ancient Pilot an opportunity to visit his sister — We all landed and leaving Mr Getchell with his friends cruised up in the Hills after Blueberries — saw some girls there and approached them to buy their Berries — but they took fright and ran into the bushes — George T — being the longest limbed and fleetest of us gave chase while we get onto a Rock to watch the result — both pursued and pursuer disappeared from our view — but presently we caught Sight of the Calico flying through the trees — and next George at some distance astern Spring in to view and Snuffed the Air — but seeing the Chase had gained upon him so much he gave it up in dismay — the "Coup d' oeil" was very striking at the moment George emerged to view — with the Fluttering of Gowns and cape Bonnets in the distance — On returning to Mrs Bracys — the first object that met our sight was — our "Ancient Mariner" — stretched at full length upon the Grass — pallid and faint and groaning — he had been taken Suddenly in a few minutes after we left and fainted away and had recovered sufficently to crawl out thus — he had been complaining somewhat before — he was now so unwell that we concluded to leave him here to night and call for him in the morning — So we started to take in Mr Lane at Suttons Island and then run down to South

West Harbour and anchored — and went ashore and saw Mr Dugain & Mr Heath — Sarah & Crawford,? Stanley &c &c - George & Joe pitched the tent ashore to night and Slept there but the rest of us preferd the old Sloop —

SATURDAY — AUG 21 — *"Pleasant of course"* — George, Joe & myself took breakfast this morning at the Island House — and a fine one it was — price 25 cts — Mr Lane took 2 sketches here — it was calm till about 9 o clock when it freshed and we beat up to Southards Cove — and there found our "Ancient" recovered from his illness — So we took him on and about 11 o clock Started with a fair wind homeward bound over Bass Harbour Bar and through the Reach — but the wind is light — and we do not get along very fast — Caught a couple of Haddock and had a chowder for dinner — got up off Deer Island about Sundown and anchored — as the tide was ahead and no wind — on the turn of the tide we weighed Anchor and drifted along the rest of the night and Anchored again on the Sedgwick Shore towards morning —

SUNDAY — 22 AUG — pleasant as has been every day since we started and all feel certain that we have had the best time possible — The wind was light till about noon when it breezed up and we had a fine run home where we arrived about 1/2 past one o clock.

The 1852 account of Lane's cruise with Joseph Stevens, Jr. is reproduced with the kind permission of the Castine Scientific Society from the *Wilson Museum Bulletin*, Winter 1974–1975, vol. 2, no. 2.

cat. 55. *Old Stevens Homestead, Castine*, 1859, oil on canvas, 12 x 19¹/2 in.
[Andrew Wyeth]

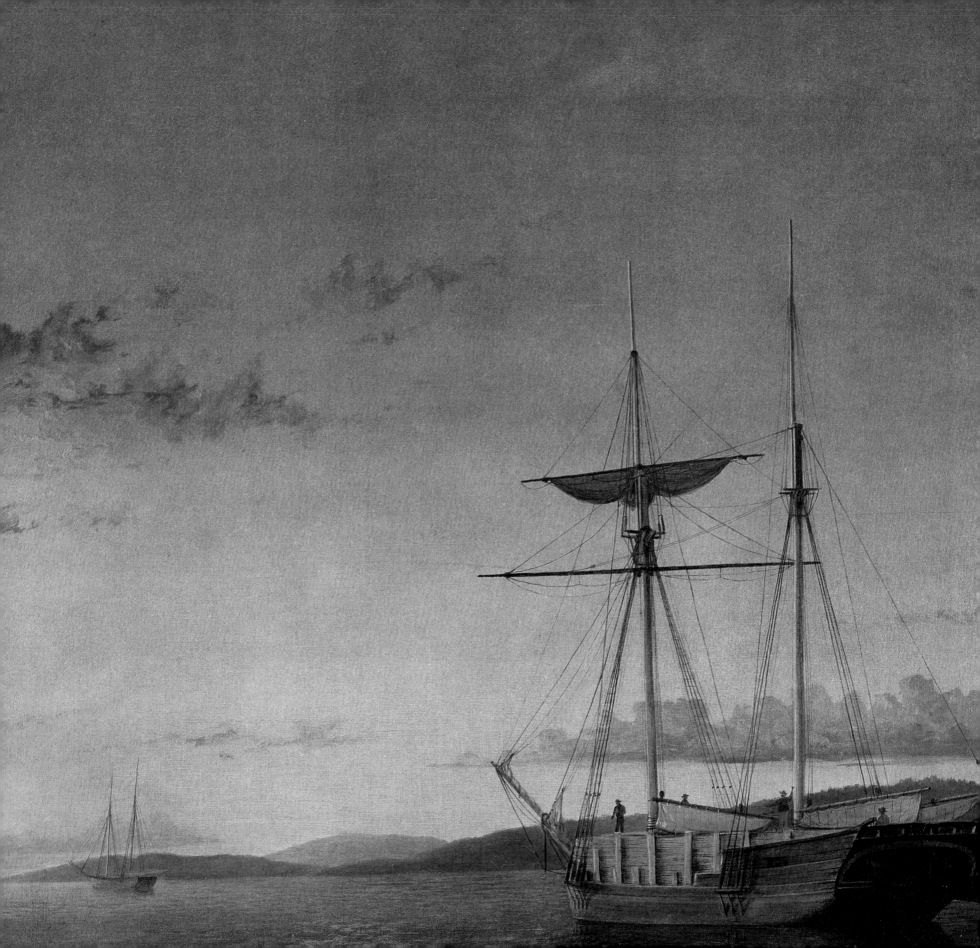

Lane and Church in Maine

FRANKLIN KELLY

The year 1860 saw the creation of two works that are widely recognized today as among the most beautiful of all nineteenth-century American paintings, Fitz Hugh Lane's *Lumber Schooners at Evening on Penobscot Bay* (fig. 1 [cat. 61]) and Frederic Edwin Church's *Twilight in the Wilderness* (fig. 2).[1] The two works seem to have little in common other than the time of day they depict—sunset. Church's painting is an intensely wrought, dramatic image of a hilly, heavily forested inland lake region; Lane's is a quietly contemplative, even poetic, representation of two ships on a calm expanse of water, with only a distant shoreline visible. These paintings seem to embody two commonly accepted polarities within the American landscape tradition, that of "baroque" high drama on the one hand, and calmer, more "classic" order on the other. The artistic personalities of their creators were also distinctly different. Church was the son of a prominent family and the pupil and heir apparent of Thomas Cole. He not only enjoyed financial and critical success early in his career, but went on to become perhaps the most famous American artist of his day. Lane, more than twenty years older than Church, came from somewhat humbler beginnings, served a long and not especially lucrative apprenticeship as a lithographer and producer of topographical views, and only attained what was essentially a local (that is, primarily in Boston and Gloucester) reputation comparatively late in life.[2]

All of these distinctions between the paintings and their painters are real and significant, and it is not the point of this essay to impose on these two very different men a perfectly equivalent artistic vision. But Lane and Church shared one particularly telling common interest. That was the state of Maine, to which they, unlike most of their contemporaries, were irresistibly drawn. Around 1850, both artists visited Maine for the first time, and in each case it was just at the crucial moment when they were moving toward their mature painting styles. What they saw in Maine, the effects of light, the rocks, waves, forests, and mountains, affected them deeply. Each would, over the course of the 1850s and early 1860s, return there often, finding inspiration for many memorable works that, by any measure, rank among their very greatest. Lane's and Church's paintings of Maine from the 1850s and 1860s thus present a compelling record of both decisive artistic change and ultimate aesthetic achievement. At the same time, they provide a remarkably complete picture, both from land and sea, of a state that has retained to this day a well-deserved reputation for having some of America's most distinctive and dramatic scenery. Not until the 1880s, when Winslow Homer turned his attention to the depiction of Maine scenery, would another artist equal the efforts of Lane and Church in capturing the unique character and beauty of the state.

Maine has long had a special place in the American psyche as a land of rugged sea coasts, deeply-channeled rivers, and vast forest wildernesses. Its enduring aura of remoteness has set it apart from the mainstream of American existence, and it has become known for its strongly individual, even slightly eccentric, inhabitants and for such memorable and unusual animals as the moose and the lobster. The state seal (fig. 3; adopted in 1820), with its archetypal Maine elements—waterman, farmer, water, moose, pine tree, and forest—shows that such commonly prevailing conceptions of the state have official sanction.

The Maine visited by Lane and Church in the mid-nineteenth century was an unfamiliar and remote place. Al-

fig. 1. Lane, *Lumber Schooners at Evening on Penobscot Bay*, 1860, oil on canvas, 24⅝ x 38⅛ in. [National Gallery of Art, Washington, Andrew W. Mellon Fund and Gift of Mr. and Mrs. Francis Hatch, Sr.]

though a mere recitation of facts and figures cannot adequately convey the character of Maine, it can help us fix an image of some of its more salient aspects.[3] Situated at the extreme northeast of the United States, Maine is the only state adjoined by only one other (New Hampshire), with its other boundaries being the Atlantic Ocean and Canada. The shoreline is extensive, measuring, if one includes the countless bays and inlets, something over 2,300 miles. The actual land of the state, however, does not stop abruptly at the ocean's edge, for hundreds of islands, some quite substantial, lie off shore. Nor is Maine's water restricted to its coast, because some 2,200 lakes and ponds and over 5,000 streams and rivers are scattered throughout the interior. Several major rivers, notably the Kennebec and the Penobscot, are navigable for considerable distances inland, providing important access to regions that in the nineteenth century were virtually impossible to reach by road or trail.

The interior of Maine was originally almost completely covered with pine forests, a fact celebrated in the state's nickname, The Pine Tree State. During much of the nineteenth century, vast tracts of wilderness remained throughout the state; as Thoreau noted on his first visit to Maine in 1846, it was a

. . . grim, untrodden wilderness, whose tangled labyrinth of living, fallen, and decaying trees only the deer and moose, the bear and wolf, can easily penetrate.[4]

Although inland Maine is not highly mountainous, there are ranges of large hills, and several distinctive mountains rise abruptly from the surrounding forests. The most famous is Mount Katahdin, or, Ktaadn, as it was often spelled in the nineteenth century (see fig. 22), which has an elevation of 5,268 feet, making it the highest point in the state.

The area that became Maine has been inhabited from the prehistoric era on, and substantial populations of various Indian tribes were there when Europeans first arrived. Maine was settled chiefly by people of English, Scotch Irish, French, and German stock, and the population grew at a steady, if not astounding, rate through the seventeenth and eighteenth centuries. By 1800 there were approximately 200,000 inhabitants, and by the late 1840s to the early 1850s, when Church and Lane first visited, there were more than half a million. This is a surprisingly small number for a state of over 33,000 square miles (by far the largest area of any New England state), but most inhabitants were concentrated in coastal settlements.[5] Few people other

fig. 2. Frederic Edwin Church, *Twilight in the Wilderness,* 1860, oil on canvas, 40 x 64 in. [Cleveland Museum of Art, Purchase, Mr. and Mrs. William H. Marlatt Fund]

fig. 3. Maine State seal, adopted 1820 [courtesy State of Maine, Office of the Governor, Washington, D.C.]

than lumbermen and hunters had ever even set foot into the wilderness areas of the state, and throughout much of the nineteenth century large areas of Maine were still relatively unexplored.

Maine's economy was, from the first, based on wood and water. Its vast resources of white pine (and later, spruce) were exploited early on, providing material for masts (many of which went to England's Royal Navy in the years before the American Revolution), ship construction, and lumber exports. The lumber industry expanded at a prodigious rate throughout the eighteenth and nineteenth centuries, leading Thoreau to remark that its very mission seemed to be "to drive the forest all out of the country, from every solitary beaver-swamp and mountainside, as soon as possible."[6] Maine, as one mid-nineteenth century lumberman put it, "was made for lumbering-work."[7] It had not only the timber, but also rivers and streams by which to reach it and then float it out, water power to drive sawmills to process it, and good harbors for ships to transport the finished products. Even the climate played an indispensable role.[8] The marshy ground of the forest froze in winter, enabling heavy sleds to operate, and spring thaws caused floods to float the logs.

Shipbuilding and shipping were Maine's other most important economic activities and they, of course, were made possible primarily because of the timber resources and the presence of so many fine harbors. Maine-built ships were found in ports all over the world, transporting lumber, granite, and other goods out of the state and returning with molasses, spices, sugar, and other commodities. Maine led the way in the construction of schooners, a type of sailing vessel much favored by American sailors, and countless other ships, both large and small.

Virtually every visitor to Maine during the mid-nineteenth century would have been aware of the importance of lumbering, ship construction, and shipping in the state's economy, because signs of these activities were apparent in any settled area. Although travel for sightseeing purposes became ever more popular with Americans in the nineteenth century, relatively few visitors ventured as far north as Maine.[9] Long after the Hudson Valley, the Catskills, the Adirondacks, and the White Mountains had become well-known resorts, Maine's reputation for remoteness and ruggedness continued to discourage casual tourists. As Thoreau wrote of the wilderness around Katahdin in 1846, "it will be a long time before the tide of fashionable travel sets that

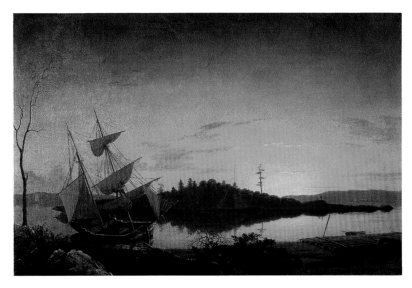

fig. 4. Lane, *Twilight on the Kennebec*, 1849, oil on canvas, 18 x 30 in. [private collection]

way."[10] Indeed, early visitors to the Maine coast and woodlands, from scientist J. W. Bailey, who ascended Katahdin in 1837, or the artist and writer Charles Lanman, who traveled up the Kennebec to Moosehead Lake in 1845, all agreed that a visit to the wildest areas of the state was equivalent to leaving civilization completely behind.[11] One regressed into a purer form of nature that seemed to exist outside of time, ultimately reaching a land like "that very America which the Northmen, and Cabot, and Gosnold, and Smith, and Raleigh visited."[12] Not everyone was prepared for the force of such an experience; Thoreau, for instance, returned to Concord after his first visit to inland Maine with a new respect for the ameliorating influences of civilization. Neither Lane nor Church initially tried to capture the full impact of the state's most dramatic scenery; most of their early Maine works portray some of Maine's more picturesque locales.

Lane first visited Maine in 1848 on a trip to Castine with his friend Joseph Stevens. Although there is little documentation concerning their visit, at least two paintings resulted, *Twilight on the Kennebec* (fig. 4) and *View on the Penobscot* (location unknown). Both were exhibited at the American Art-Union in New York in 1849, but neither seems to have excited much critical interest.[13] In these two paintings Lane had chosen subjects that very nearly marked the eastern and western boundaries of the area that would receive so much of his attention over the

next fifteen years. Between the two rivers were sites such as Owl's Head, Camden, Castine, and Penobscot Bay, which formed the subjects of many memorable works (cats. 52, 59, 61). If one expands the area slightly further eastward to take in Mount Desert and its vicinity, the entire range of Lane's known travels in Maine is embraced. By contrast, Church in his own Maine journeys would venture to many more places and cover much greater distances.[14]

By the mid-nineteenth century the area around the lower Kennebec was one of the more settled in Maine. According to one observer of 1851, it already had seen "advances in agricultural history and wealth" sufficient to "beautify, enrich, and enliven" its banks.[15] Running from Moosehead Lake to the sea, the Kennebec is a river rich in history.[16] The first ship built by Englishmen in the western hemisphere was launched by Popham colonists in 1608, and from that point on the river assumed an ever-increasing importance as a center for the ship building and lumber industries.

We do not know precisely how far Lane traveled on the Kennebec, nor why he did so, but the image he left us of is one of his most striking early works. Indeed, *Twilight on the Kennebec* has been deemed a crucial work in Lane's oeuvre, because of its new dramatic force and compositional simplification that went beyond the earlier, more descriptive Gloucester views (fig. 14).[17] The image is certainly powerful. In the foreground a lumber schooner lies aground; its status is unclear, for one of its bowsprits is broken and its sails and rigging hang loosely. Is this ship awaiting repair, or has it simply been left to molder, a forgotten and abandoned hulk? The painting seems to offer no further clues to its fate. The rocks and undergrowth of the riverbank suggest an area that had not seen many "advances in agricultural history and wealth," and the row of logs and small rowboat at the right suggest the presence of only rudimentary industry. In the river are several other sailing vessels and a pine-forested island; beyond, "The western sky is still glowing in the rays of the setting sun," and only a few clouds are seen.[18]

Without question, *Twilight on the Kennebec* represents a more intense vision of nature than is found in Lane's previous works, suggesting that the initial impact of Maine on the artist was indeed decisive. The force and clarity of artistic expression of *Twilight on the Kennebec* account for its traditional interpretation as a record of Lane's response to a nearly uninhabited

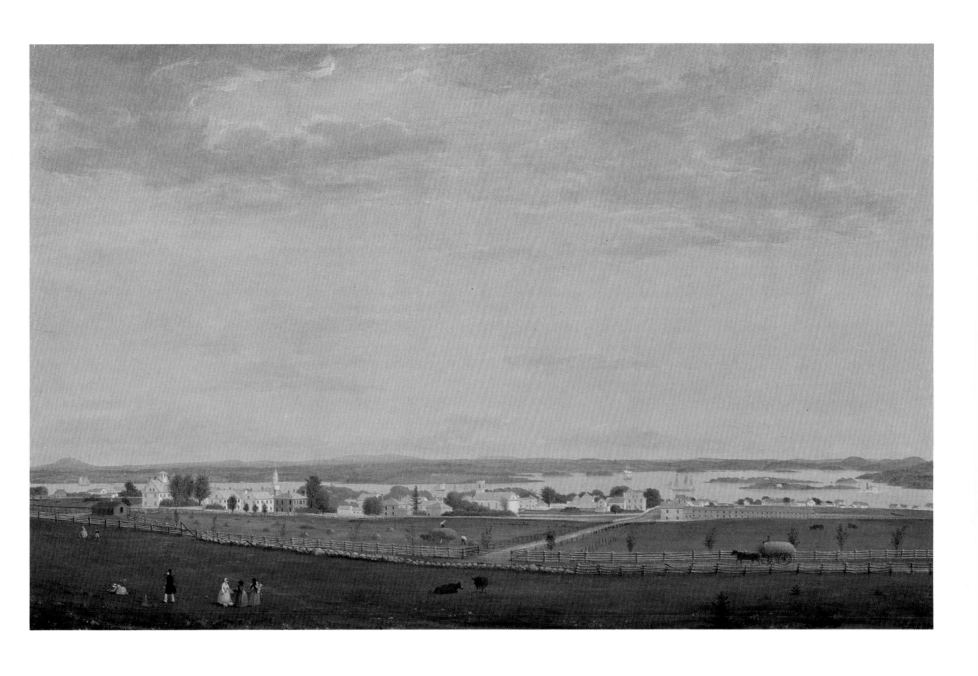

cat. 56. *Castine, Maine,* 1850, oil on canvas, 21 x 33¹/₂ in. [Museum of Fine
Arts, Boston, Bequest of Maxim Karolik]

wilderness, but close examination challenges that reading.[19] Two figures are on a rock at the right end of the island, their backs turned to us, suggesting that they, like other figures in Lane's paintings, are lost in the contemplation of nature's serene beauty.[20] In fact, they are contemplating something far more mundane than the glories of transcendent nature, but of considerable interest nonetheless. In the distance, in the channel between the island and the western bank of the river, a large steamboat is heading upriver. That it is a steam-powered vessel is beyond question, because its paddle wheels are churning the water and a smokestack rises from its mid-section. It swiftly passes through the calm waters of the river, in marked contrast to the virtually becalmed sailboats in the middle distance, and in even sharper contrast to the grounded schooner of the foreground.

Was Lane, like Turner in his famous *The 'Fighting Temeraire' tugged to her last Berth to be broken up* of 1838 (National Gallery, London), here giving witness to the passing of the era of sail to the era of steam? Perhaps he was. By 1848 steamships were regularly plying the coastal waters and navigable rivers of Maine, and Lane no doubt traveled on one (as did Thoreau) for at least part of his journey to the state. There was, in fact, steamboat service on the Kennebec as far as Augusta (forty-five miles upriver and at the head of navigation on the river) from 1826, and by the 1840s there was considerable traffic on the river.[21] But more to the point, *Twilight on the Kennebec* suggests that Lane had recognized an essential fact about life in mid-nineteenth century Maine. Signs of the confrontation between American civilization and American nature were found virtually everywhere in the coastal region. In the days before aggressive settlement had reached the lands of the far West, Maine represented the most rugged frontier of the young country, the very battleground where the American course of empire was most visibly enacted. Thoreau, describing the city of Bangor, noted that it was:

fifty miles up the Penobscot, at the head of navigation for vessels of the largest class, the principal lumber depot on this continent, with a population of twelve thousand, like a star on the edge of night, still hewing at the forests of which it is built, already overflowing with the luxuries and refinement of Europe, and sending its vessels to Spain, to England, and to the West Indies for its groceries,—and yet only a few axe-men have gone 'up river,' into the howling wilderness which feeds it.[22]

In his own terms, as one who knew and understood ships and maritime activities well, Lane expressed a similar vision. He too had ventured near the edge of the "howling wilderness" that lay "up river," and seen the penetration of one of civilization's emblematic machines into it.[23] *Twilight on the Kennebec*, then, is not solely about Lane's personal confrontation with rugged American nature; it is also about his awareness of the inevitable conflict between civilization and the wilderness. Many observers around 1850 were deeply troubled by the implications of that conflict, for they saw that the ultimate triumph of civilization could be achieved only at the expense of nature. But Lane, if we may judge from his art, apparently was unconcerned. After his glimpse of the fringe of the Maine wilderness he went on to more settled areas, painting scenes where man and nature existed in peaceful equillibrium.[24]

One of those who saw Lane's *Twilight on the Kennebec* at the Art-Union in the spring of 1849 was almost certainly Frederic Church. Church himself had seven works on view there, including the highly praised *Evening after a Storm*, and he had emerged as one of the Union's most promising younger artists.[25] He had from the first been drawn to portraying dramatic twilight effects in his own works, and it is easy to imagine that the radiant sky of Lane's work would have caught his eye. By 1849 Church, an indefatigable traveler, had already done extensive sketching in New York, Massachusetts, and Vermont, and had exhibited finished paintings of those areas at both the Art-Union and the National Academy of Design. In the summer of 1850 he set off in search of new material, this time across New Hampshire and into Maine. The experience of seeing Lane's paintings of Maine may well have been a catalyst in this decision, and Church no doubt also had in mind the memory of his teacher Cole's 1844 visit to the state.[26] One contemporary account, however, gives considerable weight to another factor:

Church, Gignoux, and Hubbard have gone to the coast of Maine, where it is said that the marine views are among the finest in the country. None of these artists, we believe, have hiterto attempted such subjects, and we look forward to the results of this journey. The exhibition of the magnificent Achenbach last year in the Art-Union Gallery seems to have directed the attention of our younger men to the grandeur of Coast scenery.[27]

Andreas Achenbach's painting, *Clearing Up—Coast of Sicily* (fig. 5) was much admired for "the fidelity with which natural appearances have been studied," even though it portrayed a

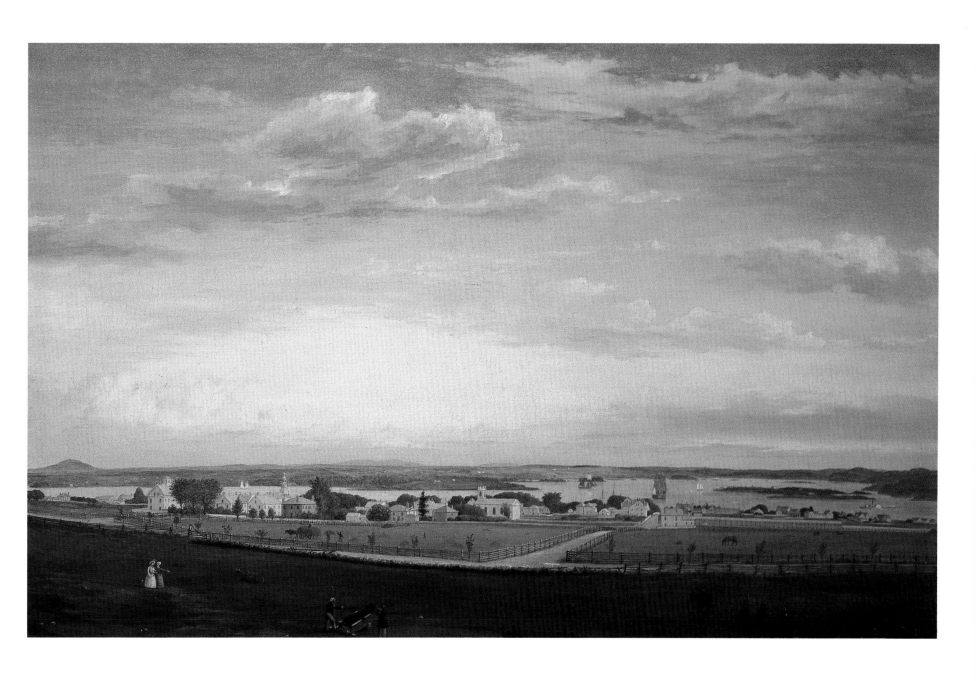

cat. 60. *Castine from Fort George*, 1856, oil on canvas, 20 x 32 in. [Thyssen-Bornemisza Collection, Lugano, Switzerland]

fig. 5. Andreas Achenbach, *Clearing Up, Coast of Sicily*, 1847, oil on canvas, 32¹/₄ x 45³/₄ in. [Walters Art Gallery, Baltimore]

fig. 6. Frederic Edwin Church, *Red Rocks, Mount Desert*, 1850, pencil and white gouache on paper, 11⁹/₁₆ x 15⁹/₁₆ in. [New York State, Office of Parks, Recreation and Historic Preservation, Olana State Historic Site]

place most Americans had never actually seen.[28] Young painters such as Church were cautioned against merely transferring "the warm coloring of the Sicilian shore to the colder rocks and sands" of the American Northeast, and were admonished to study such scenes themselves before attempting their own marine paintings.[29] That was precisely what Church set out to do, making his first trip to Mount Desert in the summer of 1850. And, in one of those intriguing coincidences that suggest far more than available evidence will allow us to document, Lane, too, turned up on the island that summer.

A series of four letters by Church printed in the *Bulletin of the American Art-Union* entitled "Mountain Views and Coast Scenery, By a Landscape Painter," enables us to follow him on this trip to Maine.[30] The first two letters, both dated July 1850, described the initial phase of the journey through Vermont and New Hampshire. The third, also dated in July, is postmarked "Mount Desert Island," and recounts how Church and his companions reached the island, via Castine, after traveling by train, fishing sloop, and steamer.

Mount Desert offered artists an unparalleled number of pleasing, and stirring, subjects for paintings:

It affords the only instance along our Atlantic coast where mountains stand in close neighborhood to the sea; here in one picture are beetling cliffs with the roar of restless breakers, far stretches of bay dotted with green islands, placid mountain-lakes mirroring the mountain-precipices that tower above them, rugged gorges clothed with primitive forests, and sheltered coves where the sea-waves ripple on the shelly beach. . . . It is a union of all these supreme fascinations of scenery, such as Nature, munificent as she is, rarely affords.[31]

Church, who had surely heard Cole extoll the beauties of the island and had certainly seen his paintings of Frenchman's Bay, assured his readers that he had "not come thus far to be disappointed."[32] Within only a few days Church had explored much of the island, "done considerable in sketching and painting," and found himself surprised "that some shrewd Bostonian" had not already "erected some sort of hotel" there.[33]

Church's numerous drawings and oil sketches from his 1850 visit to Mount Desert (figs. 6, 7) reveal that he had a highly productive summer, and they further suggest that his initial experience of Maine had a positive, even liberating, influence on his art. Church had been steadily progressing in his mastery of landscape, showing himself capable of both light-filled, expansive views such as *West Rock, New Haven* (1849, New Britain

fig. 7. Frederic Edwin Church, *Fog off Mount Desert Island*, 1850, oil on paper mounted on board, 11¹/₂ x 15³/₈ in. [private collection]

fig. 8. Frederic Edwin Church, *Otter Creek, Mount Desert*, c. 1850–1851, oil on canvas, 17¹/₄ x 24¹/₄ in. [Museum of Fine Arts, Boston, Seth K. Sweetser Fund, Tompkins Collection, Henry H. and Zoe Oliver Sherman Fund and Gift of Mrs. R. Amory Thorndike]

Museum of American Art, New Britain, Connecticut) and more brooding, intense scenes such as *Twilight, "Short arbiter 'twixt day and night"* (1850, Newark Museum). But now a new sensitivity to the flickering play of light in the atmosphere and across the land appeared in his work, giving his early Maine paintings a freshness that simply was not present in his art before. This is apparent in his pencil drawings, which often have white highlights (fig. 6), in his oil sketches of waves breaking against rocky coasts (fig. 7), and in many of his first oils of the island, such as *Otter Creek, Mount Desert* (fig. 8) and *Newport Mountain, Mount Desert* (fig. 9). The oil sketches, in particular, show a remarkably accomplished and sure handling of paint for so young an artist, indicating that Church had now reached a new level of confidence in his art. Painting the coast of Maine was obviously a difficult task—Church says as much in one passage in his letters to the Art-Union—but he rose to the challenge. Sketches such as *Fog off Mount Desert,* which Church thought well enough of to send for exhibition to the Art-Union in 1851, are at once wonderfully fluid in their handling and completely convincing in their depiction of the textures of water, sand, and rocks, and in their evocation of light-filled atmosphere.

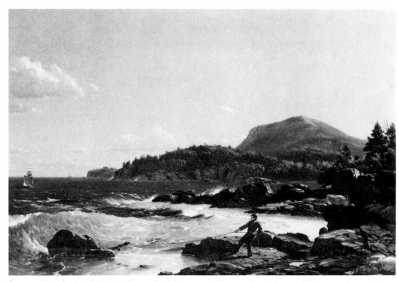

fig. 9. Frederic Edwin Church, *Newport Mountain, Mount Desert*, 1851, oil on canvas, 21¹/₄ x 31¹/₄ in. [private collection]

fig. 10. Frederic Edwin Church, *Beacon, off Mount Desert Island*, 1851, oil on canvas, 31 x 46 in. [private collection]

fig. 11. Frederic Edwin Church, *Study for The Deluge*, 1850, pencil on paper, 9⅞ x 14⅞ in. [New York State, Office of Parks, Recreation and Historic Preservation, Olana State Historic Site]

fig. 12. Harry Fenn, *The "Spouting Horn" in a Storm*, c. 1872, engraved by W. S. Linton for *Picturesque America* (New York, 1872)

Church employed many of the techniques from his oil sketches in finished paintings such as *Otter Creek* and *Newport Mountain*, giving them a corresponding feeling of vibrancy. This was also true, though to a somewhat lesser extent, of the most important Mount Desert oil resulting from his 1850 visit, *Beacon, off Mount Desert Island* (fig. 10). This dramatic painting of the day marker at Bunker's Ledge, near Seal Harbor, set against a fiery sunrise, was a great critical and popular success when it appeared at the National Academy of Design in the spring of 1851 and at the Art-Union that fall. *Beacon*, which was already deemed "famous" by the end of 1851, was larger and more tightly finished than Church's other early Mount Desert oils, and he obviously intended it to make a striking effect on the crowded walls of New York's exhibition galleries.[34] Even so, it did not match the dramatic power of his other major effort for 1851, *The Deluge* (location unknown; see fig. 11).[35] This work was reminiscent of Cole, yet nevertheless also owed much to Maine: it was quite possibly while sketching some "immense rollers" at the base of Schooner Head (see fig. 12) that Church first envisioned painting the subject.[36] Church, like Cole before him, had been awed by this demonstration of the sea's power. There was, he felt, "no such picture of wild, reckless, mad abandonment to its own impulses, as the fierce, frolicsome march of

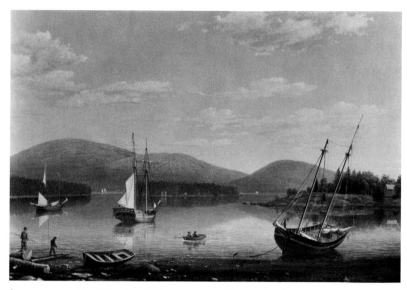

fig. 13. Lane, *Bar Island and Mount Desert Mountains from Somes Settlement,* 1850, oil on canvas, 20¹/₈ x 30¹/₈ in. [Erving and Joyce Wolf Collection]

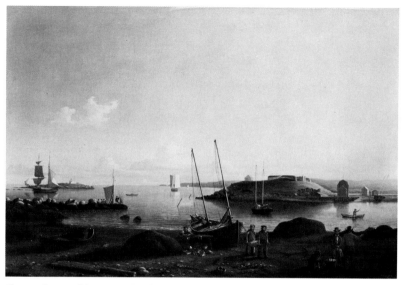

fig. 14. Lane, *Gloucester Harbor,* 1848, oil on canvas mounted on panel, 27 x 41 in. [Virginia Museum of Fine Arts, Richmond, The Williams Fund]

a gigantic wave."[37] Church's conception of *The Deluge,* which one reviewer found full of "unmitigated horror," centered on a series of rocky pinnacles surrounded by maelstroms and crashing waves.[38] Such an image, in fact, came close to the reality of Maine in one of her more dramatic moods (see figs. 11 and 12). That Church chose not to portray that aspect of Maine's character in a realistic painting suggests that he, like Thoreau and Lane, may initially have been somewhat overwhelmed by such evidence of nature's seemingly unlimited force and wildness.

Lane, as noted, was also on Mount Desert in August of 1850. His travels took him to some of the same spots visited by Church, but he saw most of them from offshore, giving him a decidedly different perspective on the island's scenery. Lane and his friend Stevens were aware of Church's presence, and at one time were sure he was in "the immediate vicinity."[39] Did the two artists actually meet? If so, there is no known record of it. They had, after all, come to Mount Desert in search of somewhat different subjects. Church, the landscape painter, had come seeking dramatic new scenery and to try his hand at painting the coast; Lane, the painter of ships and harbors, sought out examples of Maine's sea-going craft and explored the coves and rivers that sheltered them. Yet, at this moment the movements of Lane and Church were closely aligned. Even though we cannot document any definite artistic interchange

between them, and though their actual painting styles were ultimately rather different, the fact remains that each devoted much of his energy over the next few years to portraying the scenery of Maine.[40] This was something that none of their fellow painters felt compelled to do.

Lane's first paintings of Mount Desert, such as *Bar Island and Mount Desert Mountains from Somes Settlement* (fig. 13 [cat. 50]) were of very high quality. They did not, however, depart significantly from the compositional manner he had perfected slightly earlier in his views of Gloucester, which were inspired by Robert Salmon's harbor scenes. *Bar Island and Mount Desert Mountains* and *Gloucester Harbor* of 1848 (fig. 14 [cat. 6]) have obvious similarities, with a foreground beach animated by scattered rocks and pieces of wood, a few figures, a beached rowboat, and a small sailing vessel lying heeled over near the water's edge. The calm water beyond in each work is dotted with other boats and ships, and in each, islands with small buildings rise in the middle distance. The skies in the two are similarly radiant, with only a few clouds. To be sure, *Bar Island and Mount Desert Mountains from Somes Settlement* is less crowded and more spacious than *Gloucester Harbor,* but it does not manifest the extreme simplification and concentration of effect seen in *Twilight on the Kennebec.* In the same way, the view of *Castine, Maine* of 1850 (cat. 56), though open and light-filled, did not

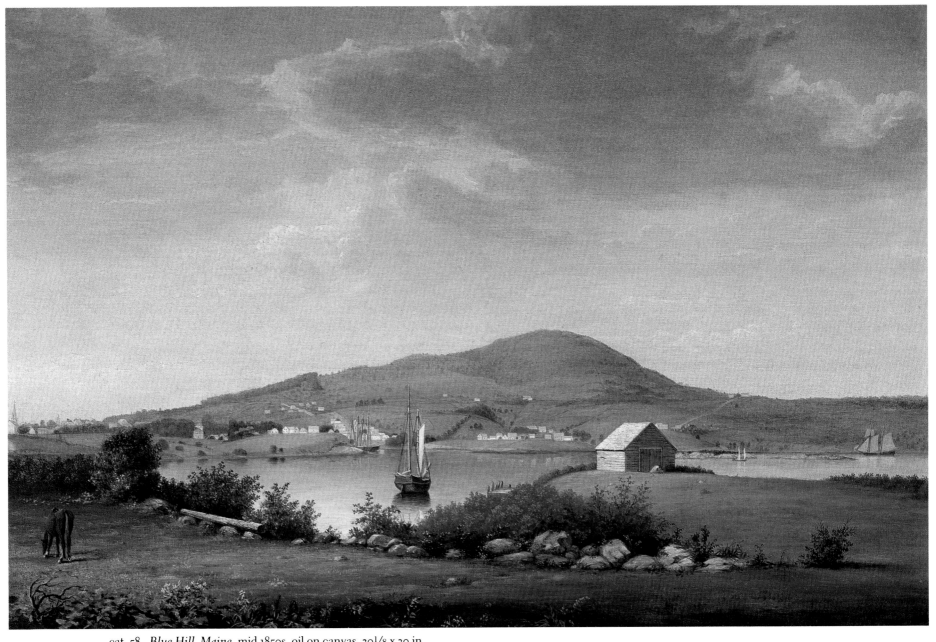

cat. 58. *Blue Hill, Maine,* mid 1850s, oil on canvas, 20 1/8 x 30 in.
[private collection]

mark a real departure from earlier topographical views such as
Gloucester Harbor from Rocky Neck, 1844 (cat. 2). Lane at this
point was content to rely on well-proven methods to interpret
the scenery of Maine, but he would gradually change his ap-
proach over the next few years.

Both Lane and Church were in Maine again the following
year (1851). Lane returned to Castine for the summer and also

fig. 15. Lane, *Northeast View of Owl's Head,* 1851, pencil on paper, 10½ x 16 in. [Cape Ann Historical Association]

fig. 16. Lane, *Camden Mountains from the Penobscot Bay,* 1851, pencil on paper, 10½ x 16 in. [Cape Ann Historical Association]

fig. 17. Lane, *Blue Hill, Maine,* 1851, pencil on paper, 10⁹/₁₆ x 27¹¹/₁₆ in. [The Harvard University Art Museums, Bequest of Francis L. Hofer]

made many sketches around Owl's Head (fig. 15), Camden and the lower Penobscot (fig. 16), and Blue Hill (fig. 17). Few works of real consequence seem to have immediately resulted from this trip, but Lane did paint the spirited, though not entirely successful, *Off Owl's Head, Maine* (1852, Cape Ann Historical Association). Given Lane's tendency not to date many of his paintings, we cannot be certain when he produced other works that derived from drawings of 1851, such as *Blue Hill, Maine*

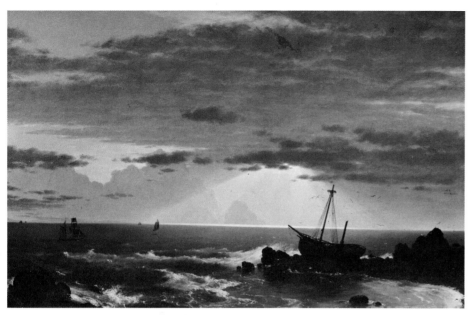

fig. 18. Frederic Edwin Church, *The Wreck*, 1852, oil on canvas, 30 x 46 in. [Cowan Collection, The Parthenon, Nashville, Tennessee]

fig. 19. Lane, *Duck Harbor, Isle au Haut, Penobscot Bay*, 1852, pencil on paper, 10¼ x 31 in. [Cape Ann Historical Association]

fig. 20. Lane, *Southwest Harbor, Mount Desert*, 1852, pencil on paper, 10½ x 31¾ in. [Cape Ann Historical Association]

(cat. 58), but it was doubtless within the next few years.

Church, ever eager to see new scenery and try his hand at new artistic challenges, actually went as far as the Bay of Fundy and Grand Manan Island in Canada in August of 1851 and then returned to Mount Desert in October. The most striking picture to result from this new look at the coast was *The Wreck* (fig. 18). Although not universally admired, as was his *Beacon* of the previous year, *The Wreck* gave sufficient evidence of Church's abilities for one leading critic to deem him "without doubt the first [that is, the best] of our marine painters."[41] We may only guess what Lane would have made of this assessment, but as it turned out, Church painted relatively few marines after this point, having seemingly exhausted his interest in them.

For both Lane and Church the year 1852 marked an important new phase in their visits to Maine. Lane, as usual in the company of Stevens, was back in Castine for the summer. In August Stevens chartered the sloop *Superior*, which was piloted by the same man who had sailed with them to Mount Desert in 1850.[42] The trip took them first to Isle au Haut, where Lane made sketches of Penobscot Bay and its islands from new vantage points (fig. 19). From there the group sailed to Mount Desert Rock, where they saw a wrecked schooner and watched a finback whale chasing fish. After a few hours, they set course

for Mount Desert and Somes Sound. They discovered that the steamer *Lawrence* had preceded them into the sound, apparently the first steam-powered vessel ever to sail those waters. Once again, Lane was witness to the intrusion of mechanized civilization into a formerly undisturbed world, but he left us no record of it in his known drawings from the trip.

Only a few paintings can be securely dated to the period immediately after the 1852 trip, making it difficult to establish the evolution of Lane's Maine views. But one signed and dated picture, *Entrance of Somes Sound from Southwest Harbor* (cat. 57) can tell us a great deal. This has long been one of Lane's most admired works, and a close look at how he created it will add to our understanding of its importance in his stylistic development. Fortunately, his drawing of the site survives (fig. 20). Like others from the 1852 cruise on the *Superior*, this drawing was almost certainly made on board the boat, as the absence of a foreground implies. Lane concentrated primarily on recording the buildings of Southwest Harbor, each of which he carefully delineated. The mountains beyond the town and to the right, up the sound, were less thoroughly worked, but their contours were carefully recorded. Other than a schooner lying in the waters off the town and a boat under sail in the distance at the far right, no vessels are present. Like most of Lane's drawings, this

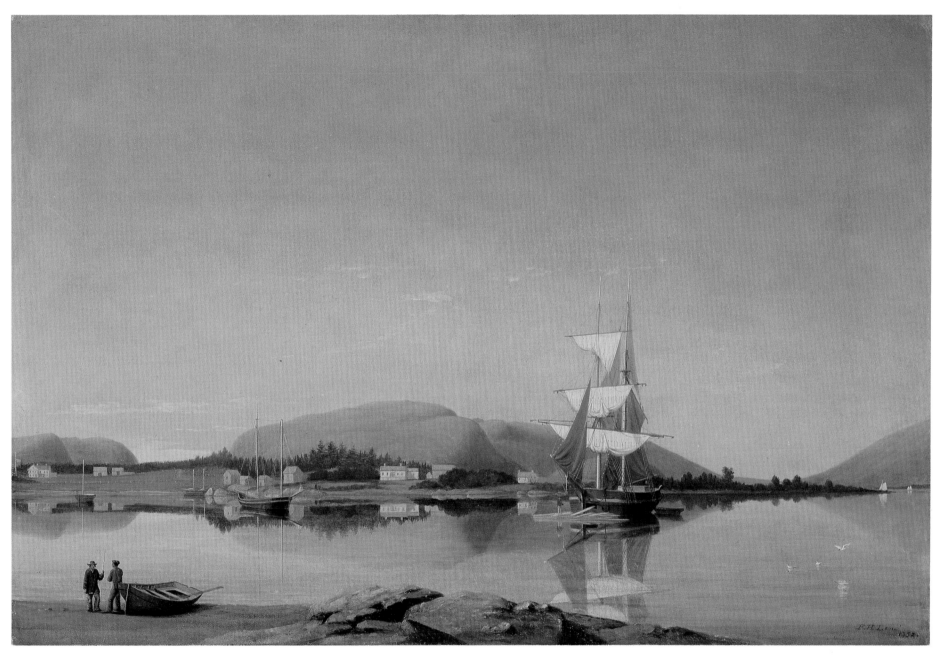

cat. 57. *Entrance of Somes Sound from Southwest Harbor*, 1852; oil on canvas,
23³/₄ x 35³/₄ in. [private collection]

is little more than a topographical view, with no particular com-
positional focus and without any carefully controlled recession
into space. It is an accurate record of the scene, but transform-
ing it into a finished work of art would require a number of sub-
tle adjustments and additions.

The most readily apparent change from drawing to painting
is the increased verticality of the canvas, which has a height to
width ratio of 2:3. Lane tightened the composition by eliminat-
ing most of the mountain at the far right. Two-thirds of the
painting are given over to sky, providing effective vertical bal-

ance for the lateral sweep of water across the lower section. Lane also added a small strip of beach and a cluster of rocks to the bottom edge, establishing a foreground. Two men, apparently conversing, stand on the beach by a rowboat. The schooner present in the drawing reappears, but it is joined at the left side of the composition by two other vessels, a small sailboat and another schooner. The most prominent addition, however, is the large brig that appears just to the right of the composition's center. Lane obviously gave great care to the placement of this beautifully conceived ship, for it plays the key role in binding together the horizontal and vertical elements of the painting.[43] The brig is located at a point two-thirds of the way across the canvas from the left, and the topmost yard of the forward mast creates a line that bisects the canvas horizontally. In addition, the position of the ship in the water places it perfectly in line with the diagonal running from the foreground rowboat to the distant hills and the setting sun. This insistent diagonal is complemented, and tempered somewhat, by a zig-zagging movement into space established by the play of lines from the figures on the beach, to the sailboat at the far left, to the two small schooners, across to the brig, and finally to the two distant sailboats heading up the sound. One can cite other evidence of Lane's mastery of pictorial structure, such as the way the rocks at the lower center mirror the central mountains, or the way the mountains themselves have been slightly heightened from the drawing, giving them more distinctive profiles. But such analysis cannot fully explain the effect of the painting, nor can recourse to the continually addressed, but perhaps ultimately unanswerable, question of what may or may not constitute a "luminist" painting. *Somes Sound* may be a masterpiece of structural harmony and balance, but it is also masterful in the way it portrays the rich complexity of the natural world.

The pictorial structure of *Somes Sound*, with its contained and controlled space, is paralleled by its content. Nothing in this scene of stasis and calm interrupts the sense of order. Once again, comparison with Lane's earlier views of Gloucester (fig. 14) or his *Bar Island and Mount Desert Mountains* (fig. 13 [cat. 50]) is instructive. In those works many more elements, both natural and manmade (ships, figures, and bits of incidental detail), attract attention and many are obviously in motion (rowboats being rowed, sails being raised or lowered). These early pictures retain the complexity of Lane's purely topographical

views, and an attendant narrative element. The implication is that they are but components of a larger world that lies just beyond their edges. One senses, for instance, that the rowboats or sailboats could easily pass out of the picture's space into another area immediately adjacent. By their comparative complexity, and most especially by their evocation of motion (no matter how limited), they remind the viewer of the real world, achieving a kind of verisimilitude that is, in itself, admirable. But *Somes Sound*, by contrast, is virtually self-contained, seeming to exist not as a part of some greater whole of similar scenes that make up a world, but purely, and perfectly, on its own. We sense that things happen in this world—men converse, ships are sailed, lumber is loaded, birds fly, and houses are lived in— but they do not seem to happen before our eyes. Everything is stilled and locked into place, both by the ordering geometry of Lane's composition, which locates objects securely in pictorial space, and by the incisive clarity of his light, which fixes every object indelibly in the implied atmosphere that surrounds it. In *Somes Sound* Lane achieved, arguably for the first time, a compelling synthesis of reality and imagination; from a mundane view of water and land he created a vision of a world so perfectly re-ordered by the process of artistic invention as to transcend altogether the literal and the familiar.

Somes Sound marked the beginning of a new phase in Lane's art. If in the following years he did not consistently pursue the implications of its elegant and spare style, he did begin on the course leading to the superb works of his late style. It has been suggested that Lane's interest in spiritualism might, in some measure, have accounted for the intensity of vision embodied in works such as *Somes Sound*, as if the artist were privy to a world that others simply could not see. But so elusive an idea cannot be proved.[44] Some other scholars, taking their cue more from the paintings themselves rather than from anything actually known about Lane's thoughts and beliefs, have equated his paintings with the transcendentalism of Emerson. That, too, is difficult to prove, although Elizabeth Ellis presents a stimulating case elsewhere in this catalogue that Lane and Emerson did share a common vision of history. Perhaps Lane—at least at this point in his career—was first and foremost a realist invariably concerned with portraying actual places and actual scenes, but one who also understood that the best means for doing so were not always strictly mimetic. As he became more and more famil-

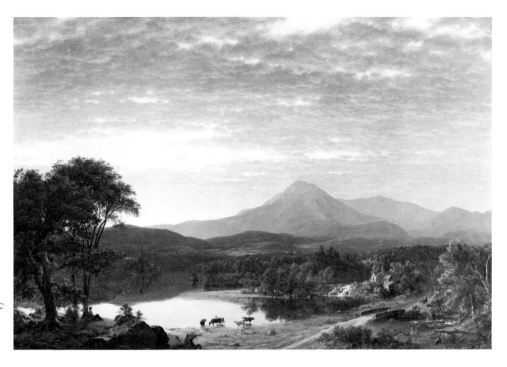

fig. 21. Frederic Edwin Church, *Ktaadn from Ktaadn Lake*, 1852, pencil on paper, 12 x 17³/4 in. [New York State, Office of Parks, Recreation and Historic Preservation, Olana State Historic Site]

fig. 22. Frederic Edwin Church, *Mount Ktaadn*, 1853, oil on canvas, 36¹/4 x 55¹/4 in. [Yale University Art Gallery, Stanley B. Resor, B.A. 1901, Fund]

iar with his subjects, he began to change his compositions so that they achieved a greater clarity and a more concentrated effect. It cannot be categorically stated that the experience of Maine led him to this new way of seeing and depicting the world. Such a stylistic evolution was not unique to Lane; it also occurred, for example, in the work of John Frederick Kensett. But it is true that Lane's only previous painting that had even approached this intensity of effect and economy of means was another Maine picture, *Twilight on the Kennebec*. Gradually, his efforts to recreate on canvas the special character and beauty of Maine's scenery were leading him to a new style that was, in essence, an elegant refinement of his earlier manner. The effects of the new aesthetic language Lane employed in *Somes Sound* were soon felt in a number of key works, including his classic views of Boston Harbor. That new language would also provide the basis for the finest Maine paintings he would execute during the rest of his career.

Church's 1852 visit to Maine was equally important in his artistic development, but it took him to an area of the state where the scenery was vastly different from that he and Lane had come to know on Mount Desert. After a second visit to Grand Manan in August, Church turned inland and traveled to Mount Katahdin the following month. Unfortunately, we know little

about this first visit to the area that would provide the subject matter for some of his most important North American landscapes, including *Twilight in the Wilderness*. According to Church's friend, Theodore Winthrop, he made the trip with "a squad of lumbermen."[45] Church managed to make the difficult ascent of Katahdin, but he and his companions had to spend "wet and ineffective days in the dripping woods."[46]

We know from contemporary accounts that the area Church had chosen to visit was the wildest in all of New England, with virtually no evidence of man other than traces left by loggers and hunters. What most forcibly struck Thoreau, who admitted it was "difficult to conceive of a region uninhabited by man," was "the continuousness of the forest," which he described as "immeasurable," with "no clearing, no house," and "countless lakes."[47] Finding the area "even more grim and wild" than he had anticipated, Thoreau came to the realization that "this was primeval, untamed, and forever untameable *Nature*. . . ."[48]

What had attracted Frederic Church to this rugged and desolate land? Perhaps his experiences on Mount Desert and Grand Manan had whetted his appetite for even more dramatic and sublime scenery. Perhaps, too, he was seeking a great geological wonder that would outshine all others he had previously seen, whether at West Rock, Natural Bridge, or Grand Manan. But

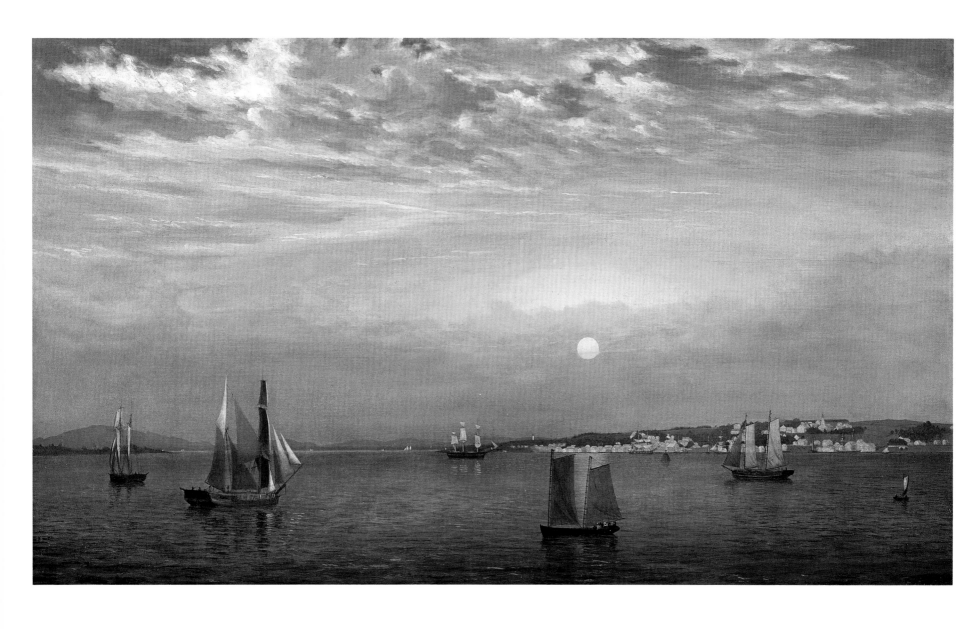

cat. 59. *Castine*, 1850s, oil on canvas, 20 x 33¹/₄ in. [Courtesy of The Putnam Foundation, Timken Art Gallery, San Diego, California]

whatever his reasons for going to Mount Katahdin, Church, like Thoreau, found the experience of its "primeval" wilderness overwhelming. His drawing, *Ktaadn from Ktaadn Lake* (fig. 21), records a landscape much like the one Thoreau described, but in the finished painting of 1853, *Mount Ktaadn* (fig. 22), Church completely transformed the scene. Below a rosy sunset sky filled with fleecy clouds the mountain presides over a pastoral scene. A young boy sits musing beneath a tree by a calm lake, dreamily gazing across space to a mill that stands by a stream. At the right a dirt road leads to a bridge with a man fishing, and a carriage drives off into the distance. Areas of cleared land are visible in the distance. One could hardly imagine a more peaceful, bucolic world than this, nor could one easily imagine one more at variance with the truth of the scene it supposedly portrayed. Church had, in essence, imagined on canvas a possible future for inland Maine, one in which American nature and American civilization were perfectly compatible. In the untempered idealism of his youth, Church believed in the primacy of man over nature and that man was capable of using and modifying the New World without destroying it. *Mount Ktaadn*, painted in response to the least civilized, most primeval world he had ever seen, was Church's eloquent statement of that belief. It was a belief destined to change in response to the realities of the later 1850s.

Even though Lane never came face to face with the Maine wilderness that had so deeply impressed Church and Thoreau, he too evolved in the mid-1850s a vision of landscape that celebrated the peaceful assimilation of American civilization into American nature. He did not, however, have to seek recourse in his imagination, as Church had done in *Mount Ktaadn*, for his travels in Maine had taken him to a few places that were the very embodiments of a pastoral ideal. Consider, for example, the radiantly beautiful world seen in *Blue Hill, Maine* (cat. 58), which Lane derived from his drawing of 1851 (fig. 17). Blue Hill was an active port and important shipbuilding and milling center when Lane visited it. As was the case with *Somes Sound*, Lane carefully adjusted the raw material of the drawing and added a few key elements in creating the finished painting. The result was a vision of balanced order in which natural and man-made elements coexist in harmony, a real equivalent of the imagined world of Church's *Mount Ktaadn*. Something of the same mood permeates other Maine works of these years, such

fig. 23. Lane, *South East View of Owl's Head, from the Island*, 1855, pencil on paper, 10³/4 x 25¹/2 in.; fig. 24. Lane, *Looking Westerly from Eastern Side of Somes Sound near the Entrance*, 1855, pencil on paper, 8³/4 x 26¹/4 in.; fig. 25. Lane, *Camden Mountains from the South Entrance to Harbor*, 1855, pencil on paper, 10¹/2 x 26 in. [All Cape Ann Historical Association]

as the fine *Castine* (cat. 59), and it also appears in some of his Gloucester paintings, such as *View of Gloucester from "Brookbank," the Sawyer Homestead* (cat. 11).

Lane had by now become thoroughly familiar with his chosen part of Maine, and he knew the scenery of the lower Penobscot and Mount Desert areas so well that he must have been able to paint much of it from memory. But he did not tire of seeing and sketching it anew. In 1855 Lane was once again in

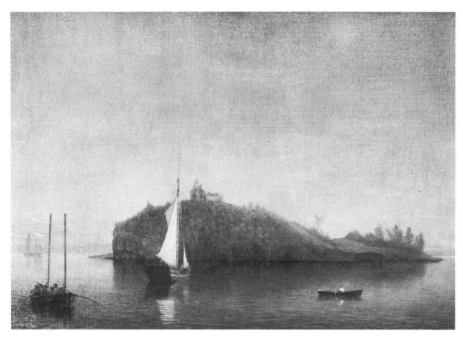

fig. 27. Lane, *Bear Island, Northeast Harbor*, 1855, oil on canvas, 14 x 21 in. [Cape Ann Historical Association]

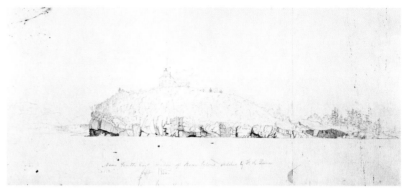

fig. 26. Lane, *Near Southeast View of Bear Island*, 1855, pencil on paper, 10³/₄ x 22³/₄ in. [Cape Ann Historical Association]

Castine (cat. 60) and he and Stevens sailed the waters around Camden, Rockland, and Mount Desert.[49] He sketched many places that he had drawn on earlier visits: Owl's Head (fig. 23), Somes Sound (fig. 24), and the Camden Mountains (fig. 25). One new site, however, did attract his attention. This was Bear Island, off Northeast Harbor on Mount Desert (fig. 26), which provided the inspiration for a striking small oil of 1855 (fig. 27) that shows a new interest for Lane in more rugged scenery and in more dramatic effects of light and dark.

Those interests are even more clearly evident in two works of the following year, *Sunrise on the Maine Coast* (private collection) and *Off Mount Desert Island* (fig. 28 [cat. 46]). Both are notable for their starkness, with rocky foregrounds and middlegrounds so sharply defined by contrasting areas of light and dark as to become almost surreal, even ominous. In *Off Mount Desert* dead trees and branches jut jaggedly into space, providing visual echoes of the two ships that frame the right and left sides of the composition. Nature may not have become threatening in these works, as it would in Lane's great *Approaching Storm, Owl's Head* of 1860 (fig. 30 [cat. 51]), but it had undeniably assumed a new, more intense edge.

For Church, too, the later 1850s represented a period of change and reassessment, and his own Maine paintings took on a markedly different character from that of his earlier works. Much had happened in his life during the intervening years, not the least of which was a visit to South America in 1853. From 1854 to 1856 Church devoted much of his energy to painting spectacular tropical scenery, creating a splendid series of landscapes unlike anything Americans had ever seen. Maine, though not forgotten, was less on his mind. He did visit Mount Desert again in the summers of 1854, 1855, and 1856, but these trips were more and more for spiritual and physical refreshment rather than for new artistic inspiration. Far more important in the implications it held for his art was Church's second visit to Mount Katahdin, made in the summer of 1856 with his friend Theodore Winthrop. Winthrop, an aspiring writer, kept detailed notes during the journey, which were later used as the basis for a fascinating account entitled *Life in the Open Air*.[50]

As we have seen, Church's first experience of Katahdin had left him overwhelmed by the spectacle of so much wild and untamed nature. By the time of his second visit, however, he had seen some of the world's most dramatic scenery, including Andean volcanoes, the Falls of Tequendama, and Niagara. He had also seen many of the places in New England where he had sketched in the previous decade radically changed by the encroachment of civilization. Whereas before he had looked on wild nature and envisioned it tempered by the pastoral benefits of man's coming, he now sought out precisely those areas that were the least disturbed by man. As Winthrop, who described

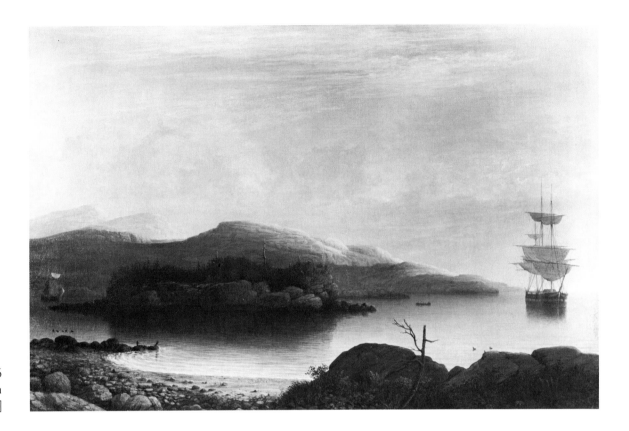

fig. 28. Lane, *Off Mount Desert Island*, 1856
oil on canvas, 23¼ x 36¼ in. [Brooklyn
Museum, Museum Collection Fund]

their visit to Katahdin in terms of a pilgrimage to pristine nature, wrote: "We both needed to be somewhere near the heart of New England's wildest wilderness."[51] No longer fully confident of America's stewardship of its natural heritage, Church reformulated his art so that it expressed a completely new view of nature. That vision found its first, and perhaps its most forceful, realization in new landscapes of Maine, which Church returned to painting after his 1856 trip to Katahdin.

The change is clearly evident in the dramatic *Sunset* (fig. 29). Like Lane's *Off Mount Desert* of the same year, *Sunset* portrays a more rugged and intense side of American nature, making it vastly different from the *Mount Ktaadn* of just three years earlier.[52] Man no longer assumes a dominant role in the landscape; the only hints of his presence are the rough dirt path and the sheep. The left side of the composition, with its blasted tree, spiky spruce, and tangled undergrowth, represents untouched, wild nature, and is emblematic of the world that lies beyond the calm lake. The very structure of the painting, with a middle-ground of water and wooded hills blocking easy passage into the

distance, represents a significant change from Church's earlier works, which generally established clear transitions from one zone of the landscape to the next. In *Sunset*, the viewer instinctively looks to the sky, where ranks of clouds lead a headlong rush into space. We are thus made aware of both the vastness of the American wilderness and of its dense impenetrability.

Four years later, in 1860, Church brought his new interpretation of Maine to a dramatic climax in *Twilight in the Wilderness* (fig. 2), in which all trace of man has been banished. This is an image of a world seemingly unchanged since its creation (like "that very America which the Northmen, and Cabot, and Gosnold, and Smith, and Raleigh visited"), a place with its own immutable laws and its own sensitive balance of forces. Church, like other Americans of his day who were alert to the ramifications of the nation's unchecked expansion, had become a champion of preserving at least a portion of the New World untouched by human change. Thoreau, too, had revisited Katahdin and found himself deeply disturbed now by the "motives which commonly carry men into the wilderness."[53] As he

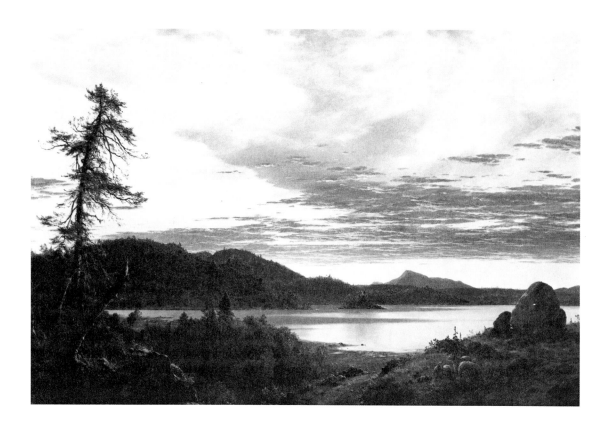

fig. 29. Frederic Edwin Church, *Sunset*, 1856, oil on canvas, 24 x 36 in. [Museum of Art, Munson-Williams-Proctor Institute, Utica, New York, Proctor Collection]

noted, "For one that comes with a pencil to sketch, or sing, a thousand come with an axe or rifle."[54] Upon his return to Bangor following his visit to the mountain, Thoreau saw vast numbers of trees "literally drawn and quartered" in the mills there, leading him to believe that Maine would "soon be where Massachusetts is."[55] Thoreau now found wilderness "necessary . . . for a resource and a background, the raw material of all our civilization."[56] Frederic Church, to judge from *Twilight in the Wilderness,* would have agreed with that sentiment.

Twilight in the Wilderness was one of the most complex and most richly meaningful paintings of Church's career, a highly public work whose significance went far beyond its expression of the positive value of untouched nature. It reflected the tension of a country on the verge of civil war, and addressed the spiritual trial that faced both the nation as a whole and each individual citizen.[57] In this work, and in others from the late 1850s and early 1860s, Church had perfected a kind of heroic landscape, one with meanings and implications that far transcended the significance of any geographical location. Although *Twilight in the Wilderness* had its genesis in the artist's experiences in

Maine, and though it captured the very essence of the state's wild interior, it was ultimately a work about matters of broader national concern.

Lane never attained a scope and ambition comparable to Church's, nor was it likely his wish to do so. He never consciously directed his art to the critics and connoisseurs in New York who in the late 1850s and early 1860s devoted so much attention to explicating the art of Church and other leading painters. Instead, Lane preferred to paint works on commission that went directly to friends and acquaintances in Gloucester and Boston. Even though others encouraged him to send paintings to New York for exhibition, he apparently only did so once after 1852.[58] Consequently, virtually no significant contemporary critical reactions to his works exist today to help us in interpretation. Nor do we know enough about Lane's thoughts and beliefs in his last years to speculate on his views of the developments that had so distressed Church, Thoreau, and many others. He surely saw that Maine, and his native Gloucester, for that matter, were changing under the inexorable pressures of civilization. Once untouched shores were being rapidly

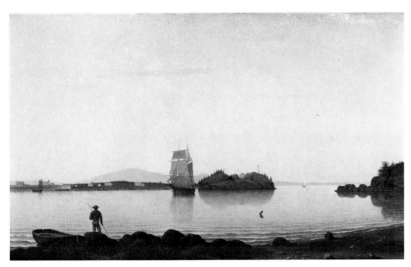

fig. 31. Lane, *Owl's Head, Penobscot Bay, Maine,* 1862, oil on canvas, 16 x 26 in. [Museum of Fine Arts, Boston, M. and M. Karolik Collection]

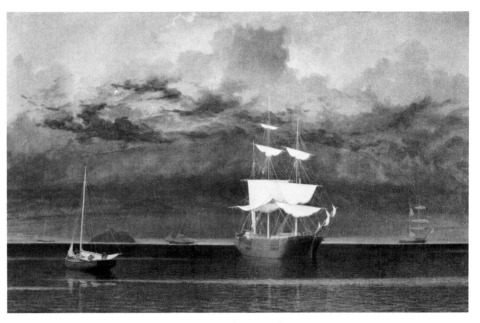

fig. 30. Lane, *Approaching Storm, Owl's Head,* 1860, oil on canvas, 24 x 39⅝ in. [private collection]

developed, and the waters where he sailed and sketched were becoming ever more crowded. Noisy and sooty steamships were beginning to replace the quiet sailing vessels he so loved to paint, and once thriving ports were beginning to lose business to the ever expanding railroads. Not even Maine could offer a refuge from such scenes forever.

Perhaps it was a reaction to the changes of time, or perhaps it was only the logical end of his progression toward simpler, more austere, images, but Lane's late works—those from 1860 on—are characterized by an increased refinement and elegance. Gradually, he distilled the essentials from long-familiar subjects. In *Lumber Schooners at Evening on Penobscot Bay* (cat. 61) Lane reduced the fundamentals of his art to such a minimum that comparable subjects from just a few years earlier, such as *Castine* (cat. 59) seem crowded in comparison. On a quiet expanse of water two lumber schooners, one quite close, the other far off in the distance, lie on a diagonal leading to the setting sun. No other signs of man are present. The shoreline of wooded hills is only minimally described, primarily through contour. The sky, which now takes up a full three quarters of the canvas, is serene, with only a few flattened, stylized clouds. Like *Somes Sound, Lumber Schooners* presents a seemingly self-contained world, but it is a world even further abstracted by the artist's controlling geometry and purified by the suppression of extraneous detail. Made all the more poignant by the rosy hues signi-

fying the close of day and by the implied descent of night upon this peaceful world, *Lumber Schooners* assumes an air of wistful reverie and, ever so slightly, a hint of nostalgia and sadness. In reality, the lower Penobscot had, by 1860, become considerably more crowded with shipping, and its shoreline considerably more developed, than the painting implies. Perhaps Lane, through this spare and evocative image, was indeed reacting to the passing of a world he knew and loved. For him, as for Church in *Twilight in the Wilderness,* the meaning of Maine was now best expressed through an image that said as little about man's impact as possible.

Approaching Storm, Owl's Head, also of 1860 (fig. 30 [cat. 51]) can be read as a stylistic and thematic pendant to *Lumber Schooners,* for it is similarly austere in composition and similarly evocative in mood. It, too, portrays a world poised on the brink of darkness, but under different and more dramatic circumstances. The approaching storm has momentarily stilled water and wind, but it will soon unleash its fury. Men hurry to lower sails and make ready for the bad weather. The viewer, however, is left only to contemplate the tension of those final moments, knowing that the storm will come. We may never know for cer-

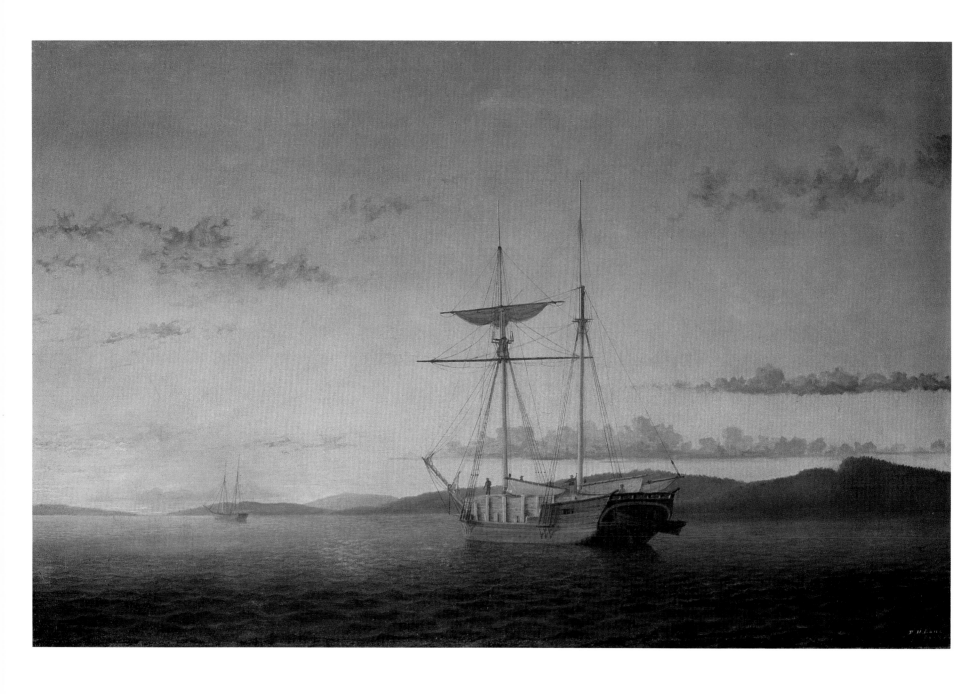

cat. 61. *Lumber Schooners at Evening on Penobscot Bay*, 1860, oil on canvas, 24⁵/₈ x 38¹/₈ in. [National Gallery of Art, Washington, Andrew W. Mellon Fund and Gift of Mr. and Mrs. Francis R. Hatch, Sr.]

tain whether or not this painting expressed Lane's apprehensions about the coming of the Civil War, as has sometimes been suggested, but it undeniably was the most intensely ominous work of his career.[59]

In such works, Lane's vision of Maine, although still grounded in actual experience, no longer represented an attempt to recreate experience, or specific place, in any purely literal or narrative way. These are images of memory based on more than ten years of accumulated experience. Unlike works such as *Somes Sound* or *Blue Hill,* which were closely derived from drawings recording actual sites from Lane's travels, *Lumber Schooners* and *Approaching Storm, Owl's Head* were independently conceived; no preliminary studies are known. The process of editing unnecessary and distracting detail had led Lane to a detachment indicative of an artist who was now painting what he knew and thought, or what he hoped to be, rather than what he saw. For all its calm clarity and all its balanced order, the well-known *Owl's Head* (fig. 31) of 1862 is so consciously reduced to essentials as to approach the ephemeral. Although its composition recalls that of *Somes Sound* of a decade earlier, it is far sparer. Elements such as the large ship and the houses and buildings of the shoreline have been pushed further into space, diminishing their importance. Light and atmosphere, both actual and reflected, dominate. It is no wonder, then, that modern viewers have so often turned to contemporary literature and philosophy in attempting to explain this seemingly eloquent, but curiously silent work. Even the figure in the foreground, which seems precisely the type of surrogate that usually encourages a viewer to identify with it and thus mentally enter the imagined space of the painting, has now become rigid, yet another element of the image's insistent geometry.[60] *Owl's Head* marked the final development of Lane's pictorial treatment of Maine, and it was one so finely perfected as to leave no further room for development.

For Church in the 1860s, Maine's importance as a source of inspiration also gradually began to wane, but he did paint one last superb work, *Coast Scene, Mount Desert* (fig. 32). Based on an oil sketch that probably dated from a visit in the early 1850s (Cooper-Hewitt Museum), this was Church's finest marine, a work of far more power and of far greater quality than the painting that had been its distant inspiration, Achenbach's *Clearing Up—Coast of Sicily.* Church, who would live out the century,

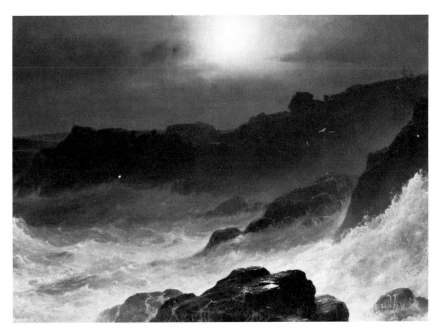

fig. 32. Frederic Edwin Church, *Coast Scene, Mount Desert (Storm at Mount Desert),* 1863, oil on canvas, 36⅛ x 48 in. [Wadsworth Atheneum, Hartford, Bequest of Clara Hinton Gould]

continued to visit Maine for much of the rest of his life, especially after 1876, when he acquired a wilderness camp on Lake Millinocket near Katahdin. Although paintings of Maine from the later 1860s and the 1870s do exist, none, unfortunately, carried the conviction and spirit of inventiveness that made his earlier works so memorable.

Lane made a final visit to Maine in 1863, but no significant paintings seem to have resulted. Perhaps he no longer had the strength and stamina for the rigors of coastal travel, for he only went as far as Portland, where he made at least one drawing of the harbor (Cape Ann Historical Association). During the last years of his life he concentrated on the shoreline of his native Gloucester and Cape Ann and in a few surprising instances, such as the *Riverdale* (cat. 19) of 1863, he explored pure landscape. But the lessons of Maine were not forgotten. The steady progression in his art toward a distilled, rarefied vision of the natural world came to a remarkable conclusion in the culminating *Brace's Rock* (cats. 21–23) series. Reducing now even the actual size of his canvases, Lane concentrated on a single motif, as if this one small place embodied the entire reality of the natural

world. The listing boat only hints of man's presence, and the serene environment seems otherwise undisturbed. As in *Somes Sound*, this is a world we can easily comprehend visually, but also one that somehow far transcends ordinary existence. The *Brace's Rock* paintings were the true successors to Lane's last Maine pictures.

For both Lane and Church the state of Maine had been not only a source of vital inspiration, but also one of artistic challenge. In their first Maine pictures, each attempted to move beyond the relatively conservative styles—the Hudson River School for Church, and topographical painting and the art of Robert Salmon for Lane—that had informed their early works. Both had modified their compositions, their handling of light, and their very selection of subjects in response to the Maine landscape. Church, the more restless of the two, traveled more widely, and changed his art perhaps more rapidly and more completely. But for Lane, the experience of Maine worked a slower, more profound, change leading him away from crowded, busy compositions toward the purified vision of his late style. Like Thoreau at Walden, who wished "to front only the essential facts of life," Lane had responded to the challenge of Maine by redefining the very essence of his art.

1. Both works were, for instance, included in the recent exhibition, *A New World: Masterpieces of American Painting, 1760–1910* (Boston, 1983), which purported to represent "the best of early American painting." The Lane was one of four (three of which were Maine subjects) included in the show; Church was represented by twice that number (three of which were Maine subjects).

2. See Clarence Cook's remarks of 1854: ". . . Mr. F. H. Lane, whose name ought to be known from Maine to Georgia as the best marine painter in the country," and ". . . Mr. Lane is not as well known as he ought to be. . . ." Quoted in William H. Gerdts, "'The Sea is His Home': Clarence Cook Visits Fitz Hugh Lane," *The American Art Journal* 17 (summer 1985), 47.

3. Descriptive texts about Maine abound, but a particularly useful one is *Maine: A Guide 'Down East'* (Boston, 1937), which was prepared by writers employed by the Works Progress Administration for the State of Maine.

4. Henry David Thoreau, "Ktaadn," in *The Maine Woods* (New York, 1966). 14. This article originally appeared in *The Union Magazine* in 1848.

5. By way of comparison, Massachusetts (approximately 8,250 square miles) had almost one million inhabitants in 1850; Vermont (9,600 square miles) and New Hampshire (9,300 square miles) each had about three hundred thousand.

6. "Ktaadn," 6. Thoreau's awareness of lumbering in Maine was heightened by the fact that he was traveling with a relative from Bangor who was engaged in the business. For an informative and entertaining account of mid-century lumbering in the state, see John S. Springer, *Forest Life and Forest Trees, Comprising Winter Camp-Life Among the Loggers, and Wild-Wood Adventure, with Descriptions of Lumbering Operations on the Various Rivers of Maine and New Brunswick* (New York, 1851). See also Richard G. Wood, *A History of Lumbering in Maine* (Orono, 1971; first published in 1935).

7. Theodore Winthrop, *Life in the Open Air and Other Papers* (Boston, 1863), 24.

8. Wood, *Lumbering in Maine*, 26.

9. For an overview of American travel during the first half of the nineteenth century, see Hans Huth, "The Poetry of Traveling," *The Art Quarterly* 19 (Winter 1956), 357–379.

10. "Ktaadn," 4.

11. See Bailey's "Account of an Excursion to Mount Katahdin, in Maine," *The American Journal of Science and Art* 32 (July 1837), 20–34, and Lanman's *Letters from a Landscape Painter* (Boston, 1845), 143–156. Bailey wrote that to enter the wilderness of Maine meant "bidding farewell to civilization," (22) and Lanman described Katahdin as "the grand center of the only wilderness region in New England, whose principal denizens are wild beasts" (143).

12. Thoreau, "Ktaadn," 106.

13. Mary Bartlett Cowdrey, *American Academy of Fine Art and American Art-Union Exhibition Record, 1816–1852* (New York, 1953), 221. Lane exhibited two other paintings at the Art-Union that year, *View in Boston Harbor* and *New York from Jersey City, New Jersey*, neither of which has been identified to date.

14. Such travel was more feasible for Church, of course, than for Lane, because the latter had only limited use of his legs. We know, however, that Lane was capable of making arduous journeys on land with the aid of crutches; see Witherle's account, reproduced in this catalogue on pages 125-126 as an appendix, of their ascent of "one of the highest Mountains" on Mount Desert.

Nevertheless, travel into the depths of the Maine wilderness would certainly have been impossible for Lane, especially given the frequent number of portages required and the often uneven terrain.

15. Springer, *Forest Life*, 186–187.

16. See Robert P. Tristram Coffin, *Kennebec: Cradle of Americans* (New York and Toronto, 1937).

17. John Wilmerding, *Fitz Hugh Lane* (New York, 1971), 47–50.

18. Cowdrey, *American Art-Union*, 221. The descriptions included in the Art-Union catalogues apparently were often written by the artists themselves, but we do not know if these were Lane's words.

19. Wilmerding, *Lane*, 47.

20. See Barbara Novak, *Nature and Culture: American Landscape and Painting, 1825–1875* (New York, 1980), 191–193, for a brief discussion of the role such figures play in paintings by Lane and Martin Johnson Heade.

21. *Maine: A Guide*, 120.

22. "Ktaadn," 108.

23. That other, and more familiar emblem of civilization, the railroad, reached Augusta in 1851 (*Maine: A Guide*, 120).

24. It would be helpful if we knew more about Lane's other early Maine picture, *View on the Penobscot*, but we lack even a description of it from the Art-Union catalogue. The Penobscot was considerably less settled than the Kennebec, and one can only wonder what "view" Lane selected. However, given his destination—Castine—it was likely a scene in that area, where civilization was already well-established.

25. Cowdrey, *Art-Union*, 70–71. For a discussion of *Evening after a Storm* and its possible identification as the work now in the Amon Carter Museum, see Franklin Kelly and Gerald L. Carr, *The Early Landscapes of Frederic Edwin Church, 1845–1854* (Fort Worth, 1987), 99–107. Much of the information on Church in this essay is drawn from my forthcoming *Frederic Edwin Church and the National Landscape* (Smithsonian Institution Press, *New Directions in American Art* series), which was, in turn, based on my unpublished dissertation "Frederic Edwin Church and the North American Landscape, 1845–1860" (University of Delaware, 1985).

26. Wilmerding, *Lane*, 49. Cole actually stopped in Hartford on his way to Maine in August 1844 and spent a day with Church.

27. "Chronicle of Facts and Opinions: American Art and Artists," *Bulletin of the American Art-Union*, series for 1850 (August 1850), 81. Although it might be argued that this praise for a painting shown in one of the Art-Union's own exhibitions might have been nothing more than good public relations, there is considerable evidence that the Achenbach was indeed widely admired. William Sidney Mount, for example, thought it "a very fine picture," and "enough to emortalize [sic] any painter;" quoted in Alfred Frankenstein, *William Sidney Mount* (New York, 1975), 187.

28. "Chronicle of Facts and Opinions," 81.

29. "Chronicle of Facts and Opinions," 81.

30. Series for 1850 (November 1850), 129–131. Although these letters are unsigned, David Huntington has convincingly attributed them to Church; see his "Frederic Edwin Church, 1826–1900: Painter of the Adamic New World Myth," unpublished Ph.D. diss., Yale University, 1960, 24.

31. O. B. Bunce, "On the Coast of Maine," in *Picturesque America; or, the Land We Live In*, William Cullen Bryant, ed. (Secaucus, 1974; first published in 1872), 1–2.

32. "Mountain Views and Coast Scenery," 130.

33. "Mountain Views and Coast Scenery," 130.

34. "Affairs of the Association," *Bulletin of the American Art-Union* 4 (December 1851), 153.

35. Even though *The Deluge* has been unlocated since the nineteenth century, we can form an idea of its appearance from contemporary descriptions and the two preliminary sketches that survive; see Kelly and Carr, *Early Landscapes*, 60–61 and figure 26.

36. "Mountain Views and Coast Scenery," 131.

37. "Mountain Views and Coast Scenery," 131.

38. "But this picture is the contemplation of unmitigated horror;" [George William Curtis], "The Fine Arts; The National Academy of Design, III," *New-York Daily Tribune*, 10 May 1851, 5.

39. Stevens, in the *Gloucester Daily Telegraph*, 11 September 1850; quoted in Wilmerding, *Lane*, 54.

40. It has been suggested that one bit of evidence in favor of Lane having influenced Church is the presence of similar figures in their works. Theodore E. Stebbins, Jr., for example, considers the man carrying a pair of oars in Church's *Grand Manan Island, Bay of Fundy* (1852, Wadsworth Atheneum, Hartford) to represent "homage to Lane"; (*Close Observation: Selected Oil Sketches by Frederic E. Church*, [Washington, 1978], 17). Although it is impossible to rule out such influence, these figures seem more likely to me to have had a common source in the typical staffage found in European marine paintings.

41. [George William Curtis], "The Fine Arts; Exhibition of the National Academy of Design," *New-York Daily Tribune*, 8 May 1852, 5. Church, however, never gave the careful attention to the depiction of ships that Lane did, and the ships and boats in his paintings are often obviously out of scale with the rest of the composition.

42. See pages 125–126 for an account of this trip.

43. For a discussion of the attention American artists paid to such compositional concerns, see Lisa Fellows Andrus, "Design and Measurement in Luminist Art," in John Wilmerding *et al.*, *American Light: The Luminist Movement, 1850–1875* (Washington, 1980), 31–56.

44. Gene E. McCormick, "Fitz Hugh Lane, Gloucester Artist, 1804–1865," *The Art Quarterly* 15 (Winter 1952), 295.

45. Winthrop, *Life in the Open Air*, 50.

46. Winthrop, *Life in the Open Air*, 97.

47. "Ktaadn," 91–92, 104, 86.

48. "Ktaadn," 91–92, 104.

49. Frederic Allan Sharf, "Fitz Hugh Lane: Visits to the Maine Coast, 1848–1855," *Essex Institute Historical Collections* 98 (April 1962), 118–119. Sharf's article provides a convenient and informative overview of Lane's most important visits to Maine. Much of Lane's activity in the summer of 1855 was devoted to the production of his lithograph, *Castine from Hospital Island*.

50. See n. 7.

51. *Life in the Open Air,* 50.

52. The sky and some of the configurations of the landscape were derived from a Mount Desert pencil sketch from September of 1854, and a subsequent oil study (both Olana State Historic Site, Hudson, New York). However, in painting the finished picture, Church transformed the setting to inland Maine, adding a Katahdin-like peak in the distance.

53. "Chesuncook," in *The Maine Woods,* 156. This article, based on Thoreau's trip of 1853, was published in *The Atlantic Magazine* in 1858.

54. "Chesuncook," 157.

55. "Chesuncook," 197, 201.

56. "Chesuncook," 203. Thoreau made a third trip to Maine in 1857, during which he saw even greater evidence of man's destruction of the wilderness: "Where there were but one or two houses, I now found quite a village, with saw-mills and a store, . . . and there was a stage road. . . ." See "The Allegash and East Branch," in *The Maine Woods,* 364.

57. These issues are more fully addressed in my *Frederic Edwin Church and the National Landscape,* chapter 6.

58. Lane sent a "Gloucester Fish[ing] Sch[oone]r on Georges Bank," owned by H. Hutchings to the National Academy of Design in 1859. Lane's name, however, was mispelled and no address was given; see Mary Bartlett Cowdrey, *National Academy of Design Exhibition Record, 1826–1860,* vol. 1 (New York, 1943), 283. Clarence Cook in 1854 urged Lane to send "a picture to New-York for exhibition," where he felt it "could not fail to make an impression and call forth criticism." See Gerdts, "'The Sea is His Home,'" 49.

59. Earl A. Powell, "Luminism and the American Sublime," in Wilmerding, *American Light,* 80.

60. This point has been made by Barbara Novak in *American Painting of the Nineteenth Century* (New York, 1969), 121.

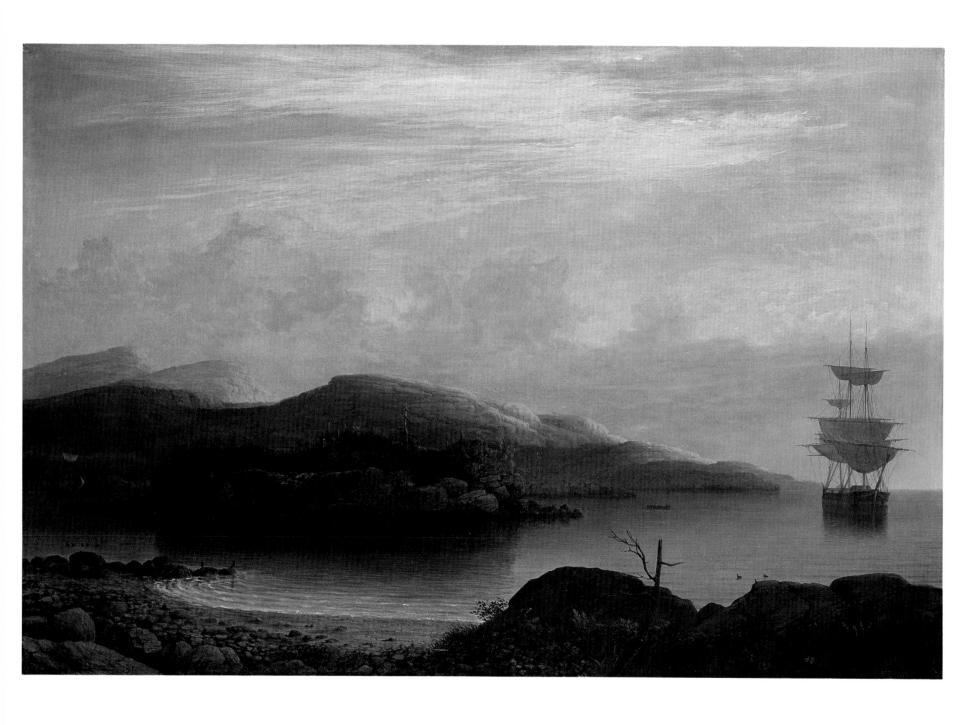

cat. 46. *Off Mount Desert*, 1856, oil on canvas, 23³/₁₆ x 36⁷/₁₆ in. [The Brooklyn Museum, Museum Collection Fund 47.114]

Lenders to the Exhibition

Mr. and Mrs. Harold Bell
The Brooklyn Museum
Cape Ann Historical Association, Gloucester, Massachusetts
The Carnegie Museum of Art, Pittsburgh
Mr. and Mrs. Jefferson E. Davenport
Mr. and Mrs. Thomas M. Evans
William A. Farnsworth Library and Art Museum, Rockland, Maine
Collection of Jo Ann and Julian Ganz, Jr.
Estate of Alletta Morris McBean
Collection of Mr. and Mrs. Paul Mellon, Upperville, Virginia
The Metropolitan Museum of Art, New York
Museum of Fine Arts, Boston
Peabody Museum of Salem, Massachusetts
Private Collections
Museum of Art, Rhode Island School of Design, Providence
Mr. and Mrs. Roger A. Saunders
The Board of Trustees of the Sawyer Free Library, Gloucester, Massachusetts
The Shelburne Museum, Shelburne, Vermont
Collection Mrs. Charles Shoemaker
Dr. and Mrs. Thomas Lane Stokes
Terra Museum of American Art, Chicago
Thyssen-Bornemisza Collection, Lugano, Switzerland
Timken Art Gallery, San Diego, California
Virginia Museum of Fine Arts, Richmond
White House Collection, Washington, D.C.
Erving and Joyce Wolf Collection
Andrew Wyeth

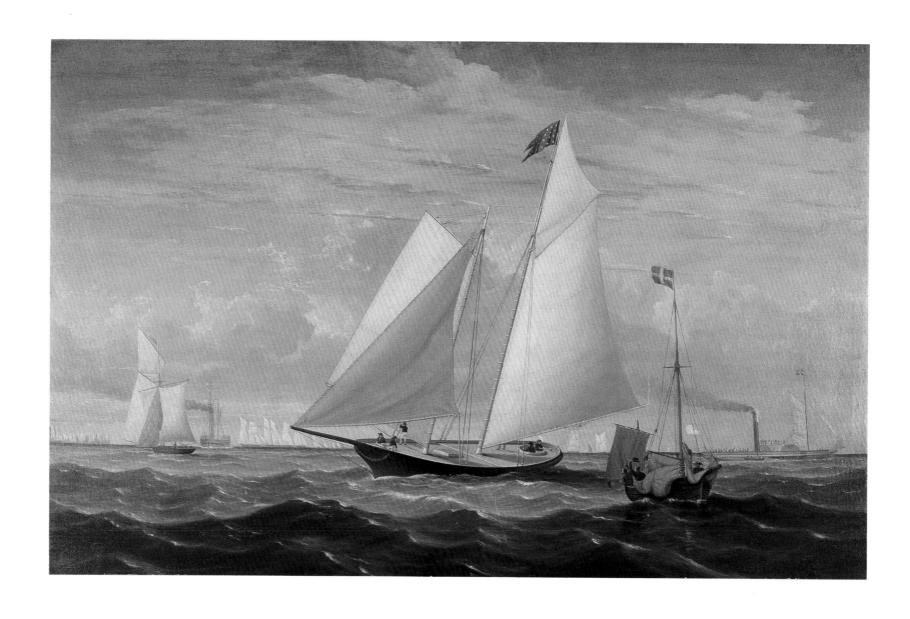

cat. 35. *The Yacht "America" Winning the International Race*, 1851, oil on canvas, 24 1/2 x 38 1/4 in. [Peabody Museum of Salem]

List of Works Exhibited

cat. 1. *New England Inlet with Self Portrait*, 1848, oil on canvas, 17³/4 x 25⁷/8 in. [Royal A. Basich]

cat. 2. *Gloucester from Rocky Neck*, 1844, oil on canvas, 29¹/2 x 41¹/2 in. [Cape Ann Historical Association]

cat. 3. *Ships in Ice off Ten Pound Island*, 1850s, oil on canvas, 12 x 19³/4 in. [Museum of Fine Arts, Boston, M. and M. Karolik Collection]

cat. 4. *Lanesville, The Mill*, 1849, oil on canvas, 18 x 26 in. [private collection]

cat. 5. *Good Harbor Beach, Cape Ann*, 1847, oil on canvas, 20³/16 x 30¹/8 in. [Museum of Art, Rhode Island School of Design, Jesse H. Metcalf Fund]

cat. 6. *Gloucester Harbor*, 1848, oil on canvas on panel, 27 x 41 in. [Virginia Museum of Fine Arts, the Williams Fund]

cat. 7. *Gloucester Harbor*, 1852, oil on canvas, 27¹/4 x 47¹/2 in. [Cape Ann Historical Association]

cat. 8. *Fresh Water Cove from Dolliver's Neck, Gloucester*, early 1850s, oil on canvas, 24 x 36 in. [Museum of Fine Arts, Boston, M. and M. Karolik Collection]

cat. 9. *Gloucester from Brookbank*, late 1840s, oil on canvas, 20 x 30 in. [Museum of Fine Arts, Boston, M. and M. Karolik Collection]

cat. 10. *Gloucester Harbor*, 1847, oil on canvas, 23 x 35¹/2 in. [Cape Ann Historical Association]

cat. 11. *View of Gloucester from "Brookbank," the Sawyer Homestead*, 1850s, oil on canvas, 18 x 30³/16 in. [The Carnegie Museum of Art, Pittsburgh, acquired through the generosity of the Sarah Mellon Scaife Family]

cat. 12. *Gloucester Harbor at Sunrise*, 1850s, oil on canvas, 24 x 36 in. [Cape Ann Historical Association]

cat. 13. *Gloucester Harbor at Sunset*, late 1850s, oil on canvas, 24¹/2 x 38¹/2 in. [private collection]

cat. 14. *Sawyer Homestead*, 1860, oil on canvas, 23¹/2 x 40 in. [The Board of Trustees of the Sawyer Free Library]

cat. 15. *Three-Master on a Rough Sea*, 1850s, oil on canvas, 15¹/2 x 23¹/2 in. [Cape Ann Historical Association]

cat. 16. *Stage Fort across Gloucester Harbor*, 1862, oil on canvas, 38 x 60 in. [Metropolitan Museum of Art, Rogers and Fletcher Funds, Erving and Joyce Wolf Fund, Raymond J. Horowitz Gift, Bequest of Richard De Wolfe Brixey, by exchange, and John Osgood and Elizabeth Amis Cameron Blanchard Memorial Fund, 1978]

cat. 17. *The Western Shore with Norman's Woe*, 1862, oil on canvas, 21¹/2 x 35¹/2 in. [Cape Ann Historical Association]

cat. 18. *Ipswich Bay*, 1862, oil on canvas, 20 x 33 in. [Museum of Fine Arts, Boston, Gift of Mrs. Barclay Tilton in memory of Dr. Herman E. Davidson]

cat. 19. *Riverdale*, 1863, oil on canvas, 21¹/2 x 35¹/4 in. [Cape Ann Historical Association]

cat. 20. *Babson and Ellery Houses, Gloucester*, 1863, oil on canvas, 21¹/4 x 35¹/4 in. [Cape Ann Historical Association]

cat. 21. *Brace's Rock*, 1864, oil on canvas, 10 x 15 in. [private collection]

cat. 22. *Brace's Rock, Brace's Cove*, 1864, oil on canvas, 10 x 15 in. [Daniel J. Terra Collection, Terra Museum of American Art, Chicago]

cat. 23. *Brace's Rock*, 1864, oil on canvas, 10 x 15 in. [Mr. and Mrs. Harold Bell]

cat. 24. *Boston Harbor at Sunset*, 1850–1855, oil on canvas, 26¼ x 42 in. [Museum of Fine Arts, Boston, M. and M. Karolik Collection by exchange]

cat. 25. *Boston Harbor at Sunset*, 1850–1855, oil on canvas, 24 x 39¼ in. [Collection of Jo Ann and Julian Ganz, Jr.]

cat. 26. *Yacht "Northern Light" in Boston Harbor*, 1845, oil on canvas, 18¾ x 26½ in. [The Shelburne Museum, Shelburne, Vermont]

cat. 27. *Salem Harbor*, 1853, oil on canvas, 26 x 42 in. [Museum of Fine Arts, Boston, M. and M. Karolik Collection]

cat. 28. *Boston Harbor at Sunset*, 1853, oil on canvas, 24 x 39 in. [private collection]

cat. 29. *Boston Harbor*, 1854, oil on canvas, 23¼ x 39¼ in. [White House Collection]

cat. 30. *The Britannia Entering Boston Harbor*, 1848, oil on canvas, 14¾ x 19¾ in. [Mr. and Mrs. Roger A. Saunders]

cat. 31. *Clipper Ship "Southern Cross" Leaving Boston Harbor*, 1851, oil on canvas, 25¼'x 38 in. [Peabody Museum of Salem]

cat. 32. *Shipping in Down East Waters*, c. 1850, oil on canvas, 17¾ x 30 in. [William A. Farnsworth Library and Art Museum, Rockland, Maine]

cat. 33. *New York Yacht Club Regatta*, mid 1850s, oil on canvas, 28 x 50¼ in. [private collection]

cat. 34. *New York Yacht Club Regatta*, mid 1850s, oil on canvas, 28⅛ x 50¼ in. [Estate of Alletta Morris McBean]

cat. 35. *The Yacht "America" Winning the International Race*, 1851, oil on canvas, 24½ x 38¼ in. [Peabody Museum of Salem]

cat. 36. *New York Yacht Club Regatta*, 1857, oil on canvas, 30 x 50 in. [Dr. and Mrs. Thomas Lane Stokes]

cat. 37. *New York Harbor*, mid 1850s, oil on canvas, approx. 23½ x 35½ in. [private collection]

cat. 38. *New York Harbor*, 1860, oil on canvas, 36 x 60 in. [Museum of Fine Arts, Boston, M. and M. Karolik Collection]

cat. 39. *Three-Master on the Gloucester Railway*, 1857, oil on canvas, 39¼ x 59¼ in. [Cape Ann Historical Association]

cat. 40. *Merchant Brig under Reefed Topsails*, 1863, oil on canvas, 24 x 36⅜ in. [Collection Mrs. Charles Shoemaker]

cat. 41. *Becalmed off Halfway Rock*, 1860, oil on canvas, 29 x 48½ in. [From the Collection of Mr. and Mrs. Paul Mellon, Upperville, Virginia]

cat. 42. *Sunrise through Mist*, 1852, oil on canvas, 24¼ x 36¼ in. [The Shelburne Museum, Shelburne, Vermont]

cat. 43. *View of Norwich, Connecticut*, 1847, oil on canvas, 12 x 16½ in. [Mr. and Mrs. Thomas M. Evans]

cat. 44. *Baltimore Harbor*, 1850, oil on canvas, 23¹⁵/₁₆ x 36⅛ in. [private collection]

cat. 45. *Ships off Massachusetts Coast*, late 1850s, oil on canvas, 15 x 23 in. [private collection, Virginia]

cat. 46. *Off Mount Desert*, 1856, oil on canvas, 23³/₁₆ x 36⁷/₁₆ in. [The Brooklyn Museum, Museum Collection Fund 47.114]

cat. 47. *View of Indian Bar Cove, Brooksville*, 1850 (?), oil on canvas, 11½ x 18¼ in. [Mr. and Mrs. Jefferson E. Davenport]

cat. 48. *Fishing Party*, 1850, oil on canvas, 20 x 30 in. [Museum of Fine Arts, Boston, Gift of Henry Lee Shattuck]

cat. 49. *Lighthouse at Camden, Maine*, 1850s, oil on canvas, 23 x 34 in. [private collection]

cat. 50. *Bar Island and Mt. Desert Mountains from Somes Settlement*, 1850, oil on canvas, 20⅛ x 30⅛ in. [Erving and Joyce Wolf Collection]

cat. 51. *Approaching Storm, Owl's Head*, 1860, oil on canvas, 24 x 39⅝ in. [private collection]

cat. 52. *Owl's Head, Penobscot Bay, Maine*, 1862, oil on canvas, 16 x 26 in. [Museum of Fine Arts, Boston, M. and M. Karolik Collection]

cat. 53. *Christmas Cove*, c. 1863, oil on canvas, 15½ x 24 in. [private collection]

cat. 54. *Castine Homestead*, 1859, oil on canvas, 10⅜ x 14⅛ in. [private collection]

cat. 55. *Old Stevens Homestead, Castine*, 1859, oil on canvas, 12 x 19½ in. [Andrew Wyeth]

cat. 56. *Castine, Maine*, 1850, oil on canvas, 21 x 33½ in. [Museum of Fine Arts, Boston, Bequest of Maxim Karolik]

cat. 57. *Entrance of Somes Sound from Southwest Harbor,* 1852, oil on canvas, 23³/4 x 35³/4 in. [private collection]

cat. 58. *Blue Hill, Maine,* mid 1850s, oil on canvas, 20¹/8 x 30 in. [private collection]

cat. 59. *Castine,* 1850s, oil on canvas, 20 x 33¹/4 in. [Courtesy of The Putnam Foundation, Timken Art Gallery, San Diego, California]

cat. 60. *Castine from Fort George,* 1856, oil on canvas, 20 x 32 in. [Thyssen-Bornemisza Collection, Lugano, Switzerland]

cat. 61. *Lumber Schooners at Evening on Penobscot Bay,* 1860, oil on canvas, 24⁵/8 x 38¹/8 in. [National Gallery of Art, Washington, Andrew W. Mellon Fund and Gift of Mr. and Mrs. Francis R. Hatch, Sr.]